# ART *What Thou* EAT

IMAGES OF FOOD IN AMERICAN ART

# ART *What Thou* EAT

## IMAGES OF FOOD IN AMERICAN ART

BY DONNA GUSTAFSON, NAN A. ROTHSCHILD, KENDALL TAYLOR, GILBERT T. VINCENT, LINDA WEINTRAUB

EDITED BY LINDA WEINTRAUB

THE EDITH C. BLUM ART INSTITUTE, BARD COLLEGE
ANNANDALE-ON-HUDSON, NEW YORK

MOYER BELL LIMITED: MOUNT KISCO, NEW YORK

*Art What Thou Eat: Images of Food in American Art* was produced in conjunction with an exhibition of the same name at the Edith C. Blum Art Institute, Bard College, Annandale-on-Hudson, New York 12504

Published by Moyer Bell Limited

Book Design:
Susanna Ronner Graphic Design,
Bearsville, New York

Copyright © 1991 by the
Edith C. Blum Art Institute.
All rights reserved. No part of this publication may be reproduced or transmitted in any form or by any means electronic or mechanical, including photocopying, recording or any information retrieval system, without permission in writing from Moyer Bell Limited, Colonial Hill, Mt. Kisco, New York 10549

First Edition

Photo credit: Douglas Baz, pages 70, 76, 85, 123.
Copy Editor: Lin Smith Vincent

Printed by Thorner-Sidney Press, Inc.,
Buffalo, New York

Distributed by Rizzoli

**Library of Congress
Cataloging-in-Publication Data**
Art what thou eat: Images of food in American art /
Linda Weintraub, editor
    Edith C. Blum Art Institute, Bard College
— 1st ed.
        p.    cm.
    Includes bibliographical references.
    ISBN 1-55921-051-6: $49.95
1. Art, American.   2. Art, Modern — 19th century
— United States.   3. Art, Modern — 20th century
— United States.   4. Food in art.   5. Dinners and
dining in art.   I. Weintraub, Linda   II. Edith C.
Blum Art Institute.
N6612.A763   1991                         90-21559
704.9′49641′0973-dc20                         CIP

THIS PROJECT HAS BEEN SUPPORTED BY GRANTS FROM
PHILIP MORRIS COMPANIES, INC., BARD COLLEGE, THE EDITH C. BLUM FOUNDATION,
BABCOCK GALLERIES, KENNEDY GALLERIES, HENRY AND ELAINE KAUFMAN FOUNDATION, INC.,
AND MARTIN AND RITA SKYLER. FUNDING HAS BEEN PROVIDED, IN PART, BY
THE NEW YORK STATE COUNCIL ON THE ARTS

**EXHIBITION TOUR**

EDITH C. BLUM ART INSTITUTE
SEPTEMBER 2–NOVEMBER 18, 1990

NEW-YORK HISTORICAL SOCIETY
DECEMBER 18–MARCH 22, 1991

# CONTENTS

# ACKNOWLEDGEMENTS

When a project requires six years of effort, acknowledgement of the contributions of the participants assumes a greatly magnified significance. This is the case regarding the book documenting the history of eating in America and the art exhibition which provided its occasion. Six years worth of appreciation has accrued to the following individuals. Their conscientious and loyal efforts have made this project possible.

Nan A. Rothschild, Gilbert T. Vincent, Donna Gustafson and Kendall Taylor not only contributed the first conceptual explorations of the subject of this exhibition, they pursued the project to its culminating refinements. It is the result of their research and their scholarship.

Karen Becker, Marci Acita, Tom Rendo, Marilyn Reynolds, Joanne Potter, Elaine Ring, and Iris Kufert, members of the staff of the Edith C. Blum Art Institute, have provided the essential ingredients of this undertaking, assembling and installing the works of art and designing the programs which make them meaningful to our visitors.

Susanna Ronner has designed and produced a handsome exhibition catalogue that deserves to become an important addition to both public and private libraries. Lin Smith Vincent is responsible for editing the text.

President Leon Botstein, Executive Vice President Dimitri Papadimitriou, Vice President Susan Gillespie, Chairman Wilbur Friedman, and the members of the Edith C. Blum Board of Overseers have made this ambitious undertaking possible through providing tangible support and encouragement.

We would like to acknowledge the generous support of Philip Morris Companies, Inc., Bard College, the Edith C. Blum Foundation, Babcock Galleries, Kennedy Galleries, Henry and Elaine Kaufman Foundation, Inc., and Martin and Rita Skyler. Funding has been provided, in part, by the New York State Council on the Arts.

The lenders have contributed the most crucial element of all—the beautiful works of art that comprise this exhibition. Their patience in arranging for the inclusion of the works of art from their collections is greatly appreciated. Each one is essential to conveying an aspect of our rich and complicated thematic exploration.

Linda Weintraub, Director
Edith C. Blum Art Institute

6

Adirondack Museum
Eleanor Antin
Sally M. Avery
Babcock Galleries
Michael Bidlo
Edith C. Blum Art Institute, Bard College
Amon Carter Museum
Chrysler Museum
Citicorp Art Corporation
Sterling and Francine Clark Art Institute
Aileen B. Cramer
Detroit Institute of Art
Terry Dintenfass Gallery
Dunkin Donuts
Ronald Feldman Fine Arts
Gemini G.E.L.
David Gilhooly
Gracie Mansion Gallery
Greca International Corporation
Mr. and Mrs. Ronald K. Greenberg
Heckscher Museum
Helen Elizabeth Hill Trust
Hirshhorn Museum and Sculpture Garden
Hood Museum of Art, Dartmouth College
Dr. Henry Kaufman and Co., Inc.
Kennedy Galleries, Inc.
Marisa del Re Gallery
Janet Marqusee Fine Arts
Ed McGowin
Metropolitan Museum of Art
Gil Michaels
Midtown Galleries, Inc.
Doug Milford
Robert Miller Gallery
Museum of Fine Arts, Boston

Museum of Modern Art
The Museums at Stony Brook
National Museum of American Art
New-York Historical Society
New York State Historical Association
Oakland Museum
Ohio Historical Society
Onondaga Historical Association
Marilyn Pearl Gallery
Pennsylvania Academy of Fine Arts
P.P.O.W.
Princeton University Art Museum
Private Collection
Michael Rosenfeld Gallery
Philip and Suzanne Schiller
B.Z. and Michael Schwartz
Andres Serrano
Sheldon Memorial Art Gallery, University
of Nebraska, Lincoln
Martin and Rita Skyler
Sonnabend Gallery
Steven Stokley
Stux Gallery
Terra Museum of American Art
Toledo Museum of Art
University of Arizona Museum of Art
Walker Art Center
Frederick R. Weisman Art Foundation
Whitney Museum of American Art
Gerold Wunderlich & Co.
Robert Yarber
Richard York Gallery
Jane Voorhees Zimmerli Art Museum
Brenda Zlamany
Rhonda Zwillinger

8

Artists are spokespersons for their era. They distill and give visual form to the economic, social, and historic characteristics of the period in which they work.

*Images of Food in American Art* is an experiment in making this fact explicit to the viewer of an art exhibition and to the reader of an art book. It is organized to demonstrate the wealth of information that can be derived from the study of art once its boundaries are opened and non-art issues are pursued. It is structured to encourage viewers and readers to perceive art as a living record of the facts and of the spirit of a time and place. This is accomplished by grouping paintings chronologically according to theme, so that the transformation of both style and subject becomes apparent to the viewer. The show presents a visual record of American social history through the eyes of each period's most astute observers, the artists.

*Images of Food in American Art* traces the changes in America's eating habits during the nineteenth and twentieth centuries. Information for this study is revealed on the canvases of this country's most respected artists. Although providing a sociological record was rarely their conscious intention, nonetheless each painting conveys fascinating insights into the economics of the food industry and the psychology of people's eating habits.

Although any subject might have been selected for this type of survey, food has proven to be a particularly ripe course of study.

## ART AND FOOD

Food and art are equally valued as a means to enhance life, to display skill, to serve as an opportunity for self expression. Involvement in these activities is universal, dictated not only by physical necessity, but by a basic human drive to form and transform the material environment so that it becomes spiritually fulfilling.

Throughout human history both art and food have traveled between the poles of "invention" and "tradition." Innovation is not necessarily a measure of value for either. It is, at times, substituted by the desire to perpetuate inherited properties and standards. But even in periods conducive to invention, change is often bound by the conventions of a social setting.

Both food and art are subject to the influence of foreign cultures and to the economic prosperity of an era. Likewise, both seem to be dictated by less measurable factors: they roll on the crest of fads and fashions. These factors dictate the ingredients—the content and the form—of each activity.

But beyond these necessities, there is an overriding element of individual taste that intervenes in judgements of both food and art. For this reason there is yet another scale to which both submit—they each have a populist and an elitist tradition: folk, kitsch, schlock, and fine traditions apply to both subjects. Folk food and folk art are custom-bound and produced by individuals without formal training. They tend to develop in rural areas. Kitsch food, like kitsch art, is the transposition of folk traditions to urban, industrial centers where mass-produced components determine the character of their products. A third category is designated "schlock" and indicates the extreme banality of art or food objects, distortions due to the

9

preference for quantity over quality, instant appeal over subtle perceptions, crudeness over refinement. All of these rejected values fit within the category of fine cuisine and fine art.

At this juncture these areas of human endeavor acquire an elitist quality. The connoisseur is one who has cultivated the ability to appreciate the style, nuance, and beauty of fine art and fine food. Both contribute to the social stature of the consumer, attesting to a high level of prestige and sophistication. Moreover, the person who is responsible for creating these fine products is honored by being designated an "artist."

These elements have appeared in varying degrees throughout the course of history. *Images of Food in American Art* project is based on the premise that these changes are neither erratic nor arbitrary. Indeed, they are a product of cultural shifts that encompass all aspects of a historic era. As a result, the changes that have occurred in the way individuals produce and consume food are correlated precisely to the way they have made art and sold art. The subject matter of a painting provides one source of information about the culinary habits of the era in which the artist lived. The color, form, and composition provide information about the attitudes which accompany these eating patterns. Art provides a living record of a cultural setting; food is an essential element of it. Together these subjects produce a compelling portrait of life in all its richness and diversity.

This social history becomes apparent due to the manner in which the works of art have been selected and are displayed. Sixteen individual categories were chosen which isolate particular topics related to food. These range from the expanded variety of foods due to technology, the changes in individual foods such as meat and fruit, the correlation between food and economics, food and sexuality, and food and death.

Works from the nineteenth century are discussed by Gilbert T. Vincent. Works of art created between 1900 and 1945 are addressed by Kendall Taylor. Donna Gustafson considers all pieces falling between 1945 and 1970. Contemporary pieces are dealt with by me. These essays provide an opportunity to relate the stylistic to the thematic elements of each individual work of art—scale, style, technique, composition are all decisions made by the artist. They reveal a point of view and, certainly, a relationship between the artist and the subject of the work of art. This relationship is not just personal. The organization of the text of this book has been designed to make this connection explicit. The art historians involved in this project have agreed to broaden their perspective. Their analysis of form and content encompasses the social implications of both.

The earliest works of art in the exhibition were created during an era when most farms produced little more food than what was needed to feed the family. It was a luxury to eat anything that was not grown on the homestead. Refrigeration, canning, freezing, and pesticides had not yet been invented. Even the eating of fish was usually reserved for the winter because it spoiled so quickly. Out-of-season foods were mostly dried or pickled.

The critical period of change came in the mid-nineteenth century, when the railroad and steam-ship made it possible to transport food quickly. For the first time citrus fruits, pineapples, bananas, lobsters, coconuts all took to the road and were available in markets far from the place where they originated. The distance between the field and the kitchen widened and the market exploded with new and exotic food choices.

These were also the years when refrigeration and canning were introduced. Mason jars were patented in 1850 and the first commercial canning took place in 1890. Furthermore, the first foods to be prepared in a factory appeared at the end of the nineteenth century. Quaker Oats is credited with having innovated the concept of mass producing ready-to-eat foods. It marked the first time that the food industry became fully industrialized, transforming the character of food production from the personal nature of home cooking to the impersonal techniques of the assembly line.

Mass production required that the food be packaged to protect it as it traveled from its place of origin to the market. The container came to serve as a handy surface to inform potential customers about its contents. In this way modern advertising was invented in the nineteenth century along with the techniques that have become standard in the industry. Quaker Oats distributed free samples, erected billboards, and offered magazine and newspaper premiums to promote sales to a mass market.

Grocery stores changed in response to the newly structured industry. In the nineteenth century items such as milk, cheese, butter, sugar, flour, beans, raisins, candies, spices, onions, potatoes, turnips, and eggs were all displayed in bulk containers. These barrels were replaced by mass-produced and packaged foods carrying such familiar brand names as Pillsbury flour, Domino sugar, Campbell soup, Heinz horseradish, and Kraft processed cheese.

Processing of food followed. Borden discovered how to concentrate milk while Swift and Armour took the juice out of meat and preserved it in a can and Birdseye invented techniques for quick-freezing vegetables. Americans developed a taste for labor-saving foods so that by the early years of the twentieth century the way had been paved for instant puddings and soups, cake mixes, and microwave TV dinners, coffee lighteners, artificial sour cream, and rectangular servings of fish. Food that is bleached, dyed, sulphured, refined, synthetic, dehydrated, adulterated, and emulsified had become the norm.

In 1974, a headline in the Wall Street Journal proclaimed, "Most people have no taste. It's been lost in the process." The process is defined by the commercialization of the food industry which has determined the character of American cuisine: like all mass-produced goods, food has come to appeal to popular taste. It is uniform, predictable, bold, simple, impersonal, and unnaturally perfect in its form and color.

The exhibition extends into the 1990s, an era that seems to be characterized by a widespread concern for the dominance of visual appeal, long shelf life, and minimal preparation time and the simultaneous neglect of nutritional value and culinary sophistication. Health-food stores, the oat bran craze, the cholesterol panic, and the interest in organic farms seem to characterize another shift in American food mores.

This long and fascinating narrative unfolds as the works of art are examined. Both the facts about food and the attitudes about eating are conveyed through the poignant expression of art.

*Linda Weintraub*

The need to eat is a basic human drive, but the way this drive is satisfied is tremendously variable among individuals and societies. And the process of eating involves a great deal more than simply putting food in the mouth. First, food must be acquired—by gathering it, growing it, hunting or fishing for it, or today, by paying for someone else's efforts in doing these things and getting it to a shop. Second, food needs to be stored between the time it is acquired and when it is eaten. This may involve very simple containers (a net bag to carry it home, or a jar), and a short time period, or it may require several steps, complex technology, and the conversion of the food to a different state (such as frozen). A third step prepares the food for eating. This again may require minimal effort, or may take hours and the addition of many other ingredients. A fourth step is the serving of the food, to oneself, to family and friends, to a large group, in public or private, with various formal or informal attendant details. And finally, eating, or the consumption of the food, takes place.

The items of food eaten vary widely throughout the world, as does the technology applied in each of the stages just mentioned. However, equally important differences exist in the social contexts within which food is consumed, and in the ritual aspects of eating. Some of the most interesting variations concern the division of labor in food acquisition, preparation, serving, and consumption, and these raise some interesting questions. Is this division always related to gender and age? For example, it has long been assumed that whenever people have lived, whether it was three million years ago or in the present, men have been the hunters and herders, taking care of meat in both wild and domestic forms. Women have been the gatherers and farmers, responsible for plant foods. It is likely that these ideas are partially true and partially untrue; however, they should be examined rather than assumed. Other questions about the structuring of work arise: Do the necessary tasks require specialized training? Does everyone cook, or only women? If men cook, do they get paid for it? And do they wear special clothing (barbecue aprons or tall hats)? What is the composition of the eating group? Does it include everyone from a family, or only adults, or only members of one sex? Are strangers welcome? How does eating relate to social rank and status? Do lower ranked people eat different foods, or foods cooked in different ways, than elite people? Do they eat fewer of the valued items; do they eat on different dishes? How are individual and cultural food preferences expressed, and do they relate to cooking methods, serving and consumption details, or only to the food items themselves?

The ritual part of eating is most clearly visible in the presentation of food, although it also pertains to its production (seen most clearly in agricultural systems) and preparation. Every society has ideas about the appearance and sequence of dishes in a meal, a formula for a meal (e.g., in the contemporary United States, the main course of a dinner should consist of one major item and two less important ones), and strong notions about foods that "go well" together and those that do not. But we also care about where we eat, with whom we eat—strangers or friends, people of the same social category—and when we eat. We expect to eat at certain times of the day, with some seasonal differences during the year, on weekends, or during feasts.

## THE EARLY AMERICAN FOOD SCENE

All these factors are seen in variation in foodways throughout the world today. The images in this book and exhibition come from a specific area of the world, and a particular time period, namely the United States, during the period of European and Euro-American settlement. This begins in the seventeenth century with the arrival of the first European settlers in the New World. American food habits developed in the context of three important factors. First, there was plenty of food. There may have been localized or temporary shortages, as in New Amsterdam when there were not enough cattle for cheese and milk production in the early days, but wild plants, game (deer and birds, fish and shellfish) were plentiful. Second, a native

American population had been eating some of these foods for centuries before Europeans arrived, and was willing to demonstrate their food-production, preparation, and consumption techniques. The native Americans themselves did not survive long in areas of European settlement. Epidemics decimated the population, and the combination of the more sophisticated technology, trade incentives and requirements, and land use needs of the new arrivals drastically affected aboriginal culture and social integrity through a combination of seduction and conquest.

The third crucial factor that contributes to the distinctively American set of foodways is its European ancestry. While there were differences among European cuisines, they translated in North America to a meat-heavy diet relying especially on pork and beef. Meat was both valued and plentiful. Pigs were very efficient animals for the conversion of feed to meat. Along with chickens they were useful since they can forage for themselves. In some parts of the country, cattle could graze on grasslands, making beef an inexpensive meat throughout much of the eighteenth century. This situation changed with increasing settlement and decreasing grassland. European preferences for vegetables were limited, with peas, onions, and cabbage traditional favorites, but certain changes took place in the New World. Corn became the basic vegetable crop in many parts of the United States, as it took much less time to mature than wheat or other cereals, a real advantage in a frontier situation where mobility is likely to be consistently higher. And other vegetables, such as carrots, lettuce, and other salad components became popular.

## CHANGES IN AMERICAN FOOD

Beginning with this early American food background, a number of significant modifications have occurred over time that affected the entire system of foodways, and continue to affect it as the social matrix of which they are a part evolves. Some of these changes occurred at the level of the kinds of foods eaten, as availability and fashion in food have influenced what is eaten. For example, the technological changes in transportation and preservation have made seasonal or regional availabilities significantly less variable over time. This has allowed a potential increase in the quantity of "fresh" foods in the diet, although paradoxically, today "freshness" is sometimes artificially maintained with preservatives. Food styles, or fads, reflect a desire for innovation; some are related to health, and prescribe or proscribe certain dietary and nutritional elements, new wonder foods (Kellogg's cereals, for example, which appear early in the twentieth century), or exercise and diet regimens. Other influences on style derive from considerations of prestige, status, and ethnic identity (ethnic fads in urban restaurants of the 1980s seem to change on a yearly basis).

Apart from what is eaten, other changes can be observed in the complex of foodways components described above. Much of this change is correlated with the increasing urbanization and industrialization of the nation, and while it has happened gradually, today we see the accumulated results of more than two centuries of technological innovation and social and economic alteration since the colonial era. The acquisition of foods has been drastically altered. Agribusiness has replaced small-scale farming, and people buy foods in supermarkets, in dispensing machines, on the streets, and in a greater variety of places than ever before. Food is stored in frozen and dehydrated forms, in individual or family-size portions, and some items may be preserved for years at a time.

Changes in food preparation began with the popularization of cookbooks in the eighteenth century in the United States, creating a self-consciousness about cooking that had not previously existed when it was mostly done in the vernacular tradition, among a primarily nonliterate body of people. Today, preparations involve major technological innovations—microwave ovens, convection stoves, and food processors—and an increasing professionalization and specialization in food craft matching the variety in ethnic cuisines and special techniques.

The serving of food has progressed through the equipment innovations of the eighteenth century, when individual plates, napkins, and utensils became common, to the increasing frequency of food served in public places which are less and less home-like and more mechanical and "efficient" (from automats to fast-food restaurants). Finally, the act of consumption has become a less private matter. In some contexts and societies, eating is viewed as analogous to sex; it is an important and to some extent dangerous activity that should be done in private, surrounded by appropriate ritual, with a few trusted individuals who are usually family members. City-dwellers today eat on the street, in the subway, and while doing other things. And whereas there may be ritual that accompanies eating, it may be more individual than corporate, thus reducing its social utility and integrative power.

## AMERICAN SOCIAL AND ECONOMIC CHANGE

Many of the variations in foodways just alluded to are set in the milieu of dramatic social and economic reorganization that began in the middle to late eighteenth century. They have occurred as concomitants of the Industrial Revolution and the appearance of industrial capitalism, and are manifest in the organization of work, family structure, and gender roles. In the seventeenth and eighteenth centuries, the family unit for most of American society was both a domestic and a work unit. Women and men were jointly involved in the production of goods, especially among the population of artisans that made up the largest segment of society. One building housed home and work, and family responsibilities were also shared, and fitted into the daily routine, although women had a larger burden. By the early nineteenth century (in northeastern urban centers, and somewhat later where industrialization had not yet occurred), home and workplace had become separated, roles within the family unit had become more specialized, and there was a developing idea that household activities had to be performed according to certain standards, resulting in the "cult of domesticity."

14

This attitude led to the creation of a body of literature on women's activities, "how-to" manuals for housekeeping, cooking, and mothering. Women's roles, at least in some classes, had become more limited, but also more "professionalized." The home continued as a focus of intense activity, but the activities that took place there were more limited, in the sense that economic production took place elsewhere. The home became primarily the center of biological and social reproduction. Women themselves, beginning in the eighteenth century and lasting through the Victorian period, were more separate from men than previously. They cooked but did not serve food when there were strange men in the house. They were also isolated from many things; from industry, poverty, and the exploitation that industrialization required. Some people feel that the cult of domesticity was created to fill women's lives; others think that the separation of women's and men's work was accompanied by the downgrading of women. Another view might be that women participated in and welcomed these changes, that they were eager for the easier life of the home. Diana Wall's recent study of New York City at the turn of the eighteenth century shows some women demonstrating increased interest in domestic life before home and workplace were separated, implying at least that women participated in the decision to make these changes.

Certain new eating practices accompanied these changes in family, gender, and work organization. For one thing, for the middle and upper classes, the family dinner became a significant focus. It was the time of day when the various elements of the family were united, and it became more significant, ritualized, and elaborate, with specific china and carefully prepared foods. Other changes in food consumption derive from the fact that industrialization meant a mobile and relatively impoverished work force, including both men and women, coming to the city from surrounding rural areas. These people lived in boarding houses or company housing, and ate together. Their food may have been less expensive, and sometimes more institutional than family food. As wealth became increasingly disparately distributed throughout society, a certain affluent sector of the population began eating conspicuously in elaborate restaurants (Delmonico's in New York City may be the prime example); this was particularly noticeable after the Civil War.

Many of the changes of the eighteenth and nineteenth centuries have disappeared in the twentieth as the organization of work, family, and gender roles has been rearranged further. The increasing importance of the consumer economy requires more income and work-time, while at the same time, women have entered the workplace in greater numbers than previously (although it is not clear whether this trend will be permanent). The typical nuclear family (a father, mother, and children, traditional since the early nineteenth century) is much less common now than it was 30, 40, or 50 years ago, as are the gender roles that were associated with that family form. These differences are manifested in foodways in the decline of family dinner as the central event of the day, in the increase in prepared foods, eaten in restaurants or at home but cooked by someone other than the wife/mother. The dominance of the consumer economy is also seen in the attention paid to "brands," and to the advertising of these brands. And efficiency becomes a yardstick of value, promoting fast foods (fast to buy, cook, and eat).

## THE INFLUENCE OF FOODWAYS IN ART

The mini-social history just presented can be compared with the presentation of foods in the images seen in the show. There are basically two classes of food images. In one set, the foods are seen alone, without people, even though there may be evidence of human life in some settings. The other class consists of images in which the food is seen in a social setting, and in which the food may even be incidental to the other activities in the painting or drawing. These two image types have the potential for revealing different kinds of information.

It may be assumed that part of what influences an artist to use a certain subject is that the subject is a part of the real world, or that it is part of a fantasy that may inform on the real world. But it should also be clear at the outset that an observer cannot know what is in an artist's mind when he/she is painting, or why a particular subject is selected, or what a subject "means" to an artist. To what degree are outside influences—socioeconomic factors and political forces—important? This is an unanswerable question, and will be tremendously variable from one individual to another. It will not be addressed here, and the images will be taken at face value, as if all were equally informed by or unrelated to the external cultural milieu. Another important and related question concerns the audience for art. While this has changed between the nineteenth century and the present, the "consumers" of art were and are still mostly a social and economic elite, and subject choice may be dictated in part by market considerations. While the interpretations offered here are influenced by knowledge of the social and economic change that has been documented historically, it is understood that they may not be relevant for any given artist who may have choosen food objects and social groupings solely on the basis of color, texture, shape, and other purely visual criteria.

## FOODS ALONE

When we look at single food items, or combinations of a few foods, we see some favorite subjects. In the late nineteenth century, the artists who painted exotic fruits such as pineapples, strawberries, and lemons, or combinations of a variety of fruits (Roesen), may have expressed wonder at these relatively scarce items, or the hope of increasing their presence, as is said to have been true of animals portrayed in the cave paintings of 20,000 to 30,000 years ago in western Europe. The fruit in these paintings is glowing, albeit occasionally marred by a worm or other natural defect (Prentice), but seems to reflect the bounty of nature.

Other still lifes portray combinations of food (Cramer, Francis), but in a different way, showing them in the setting of a meal about to be eaten, as food under human control. Some works seem to reflect a tension between nature and people. And still

others show food that has been captured, killed, or caught; these are animal foods such as meat or fish (Brookes, Pope), and reflect men's, rather than women's, food-getting activities.

The conflict between people and nature is expressed very strongly in a series of images showing distorted or damaged foods (Rupp, where the fish strikes back, or Murch and Sultan). It is interesting that the fish is used in so many of these, as if it represents quintessential natural purity being despoiled by humans. And it is also noteworthy that these ideas emerge in the late 1950s with the first stirrings of alarm about what the modern world is doing to the environment. The extreme expressions of this conflict and concern are visible in Indiana's *The Green Diamond Eat The Red Diamond Die* and *Nauman's Eat/Death*.

Another conflict between people and food comes in the form of contemporary images of desserts and sweets. (Thiebaud, Watts, Oldenburg, Kostabi, and Lasch all portray unreal treats, normally desirable, but not as shown here, although some of them are humorous.) The plastic quality of modern food is also referred to (Gilhooly and Lichtenstein). Here food has become unreal, so that its appearance is the important element, not its naturalness or taste. The extension of this idea takes us to advertising, which began in the pre-World War II era, but really boomed after the war. Now marketing and brand names become crucial (Warhol, and Bidlo's take-off on Warhol's soup cans). This type of image demonstrates the change in definition of what was considered an appropriate subject of art (exemplified by Weber's careful documentation of garbage and unromantic street images).

## FOODS IN SOCIAL SETTINGS

Socioeconomic aspects of the division of labor, changes in gender role and image, the centrality of the family in American life, the practical details of the acquisition of food, and elements of the division of American society by ethnic and class affiliation are all alluded to in the images in this show. We see only women in the kitchen (Gikow, Zwillinger, Spencer, Albright) and almost always with a badge (the apron) signifying that they are working there. We see this same badge in some of the market scenes (di Gioia, Markham), with both men and women working, and again this role is signified by the apron. It is interesting that customers in these market scenes are all women, some with children, representing a change from the early (seventeenth- and eighteenth-century) history of food acquisition in at least one eastern city (New York), when men did most of the food marketing.

Gender role is manifest in a number of details in these images. Women's functions in relation to the acquisition and preparation of food are clearly demonstrated, and we can also see a temporal change in these works in the appearance of women in public eating places. In the nineteenth and early twentieth centuries, men are seen in restaurants and bars (Hawthorne, Maurer). The only female in the former is a child, presumably trying to get her father to come home; in the latter a woman is seen as a waitress. Other nineteenth century images (Sargent) show that even dinner parties in the home did not include women, who were more likely to be portrayed drinking tea (Cassatt), or in domestic scenes with children and servants (Gikow). However, from the 1920s onward (Lawrence, Bishop) women are seen eating in public, alone, or with male or female company.

Stereotypic gender images are portrayed in some of the works. There is a frequent association between nude women, as seductive Eves, and apples (Simkhovitch, Sloan, McGowin), although women are also associated with sweets (Hansen, Kostabi). Men are portrayed as violent butchers (Rattner, Serrano, Dinnerstein, Coe) who enjoy killing food.

Social contexts for the consumption of food may also be seen in terms of statements they make about the importance of the family, whether positive or negative (Pickens). It is not clear whether or not the absence of such images in more current art is a reflection of the changes in (and decreasing frequency of) the traditional nuclear family, a sociological reality. However, a number of other social changes mirrored in foodways can be seen in these works. The increasingly impersonal aspect of society, dominated by mass culture, is seen both in eating contexts (Tooker, Bishop, Stokley), and in the places one buys food (Estes). The contrast is especially striking in comparison to the lunch scene in Mount's painting, or the market scenes of di Gioia, or Wood. Eating has gone from a focal and highly structured activity embedded within the family or other small intimate group, to a solitary and mechanical one. One might even see the substitution of tastes determined by the media, identified by certain brands, for other kinds of choices, as part of this trend. This is not to say that this type of eating is without social and cultural importance. It has been suggested, for example, that eating "fast food" in a place such as McDonald's is as ritualized as any other eating, with the verbal exchange between buyer and seller following a formula, and predictable, consistent food. While this may be true, the context of the ritual, and its power to integrate a social group, has certainly changed.

Finally, the last area in which the images seen here make social statements through food relate to the social sub-divisions of society, particularly to those reflecting ethnic and class identities. Ethnicity is hinted at (Markham, Lawrence, Dinnerstein) without either approval or disapproval. Perhaps these images are seen as documenting variability, or as "colorful" scenes. Some of the works that refer to class, on the other hand, seem a bit more romanticized, and focus particularly on laborers (Hirsch, Mount), while Evergood's *One Meatball* and Jules's *Desire* create another kind of comment on hunger and poverty. While these are mostly from the Depression era, they are quite relevant to today.

There are other images in this show that may be interpreted in relation to the social and cultural matrix within which they were created. Each viewer may bring his/her own sociological expertise to bear when examining them. While this may not be the most common way to look at art, a socially and historically informed perspective can enrich the works and complement an aesthetic approach.

*Nan Rothschild*

17

Cummings, Richard O.

1941 *The American and His Food.*
University of Chicago Press, Chicago.

Douglas, Mary, ed.

1984 *Food in the Social Order.*
Russell Sage Foundation, New York.

Farb, Peter and George Armelagos

1980 *Consuming Passions, the Anthropology of Eating.*
Houghton Mifflin Company, Boston.

Goody, Jack

1982 *Cooking, Cuisine, and Class: A Study in Comparative Sociology.*
Cambridge University Press, Cambridge.

Margolis, Maxine

1985 *Mothers and Such: Views of American Women and Why They Changed.*
University of California Press, Berkeley.

Mennell, Stephen

1985 *All Manners of Food.*
Basil Blackwell, Oxford.

Rothschild, Nan A.

1990 *New York City Neighborhoods: The Eighteenth Century.*
Academic Press, New York.

Van der Donck, Adrian

1968 *A Description of the New Netherlands.*
Edited by P.F. O'Donnell, Syracuse
University Press, Syracuse.

Wall, Diana diZerega

1987 *At Home in New York: Changing Middle Class and Elite Family Life in the Late Eighteenth and Early Nineteenth Century.*
Ph.D. Dissertation, New York University.

Yentsch, Anne

n.d. "Why George Washington's Dishes Were His and Not Martha's." Paper presented at The Society for Historical Archaeology Meeting, Savannah, Ga. 1987.

18

# Rituals for Victuals

The expression of hunger and its satisfaction is the original route that an infant takes in establishing his or her social relationship with the world. Although the nature of this first social exchange is one of complete dependence on a nurturing provider, the physical act of eating establishes a basis for all human relationships that will be formed throughout the course of an individual's life. Mealtime is a communal and familial occasion, and provides a daily opportunity for bonding, instructing, and socialization.

Over the course of the past 150 years, a mealtime format has evolved, synchronized with the changes in the organization of the family, the division of responsibilities between the sexes, and the economic structure of society. Some of these changes have congealed into categories of eating that convey the very nature of the relationship between the individuals involved. For instance, a large cocktail party suggests a gathering of individuals who are acquaintances, but not necessarily intimate friends. An invitation to lunch is less important than one to dinner. A "sit-down" dinner is a formal occasion, but a buffet, a cookout, or a picnic is less socially codified. A morning "Koffee Klatch" connotes extreme familiarity, while an afternoon tea party is ceremonial.

Henry Sargent was a member of the Boston mercantile and political elite for whom fashionable, private dinners were a common social occurrence. In fact, *The Dinner Party* is thought to depict the elegant dining room of Sargent's own townhouse on Franklin Place in Boston. Traditionally, the occasion has been identified as a meeting of the Wednesday Evening Club, a social group founded in 1777 which was comprised of men from different professions who met for dinner and conversation.

Dinner in Boston in the 1820s began between two-thirty and three o'clock in the afternoon. It was the major meal of the day, often a social affair consisting of three courses. Sargent chose to paint the last, or dessert, course. The table-cloth has been removed, the sitters have been served various fresh fruits, nuts, and a cake, and decanters and wine bottles are scattered about. A single candle is available for those who might wish to smoke. The entire setting is a period encyclopedia of the dining and furnishing habits of well-to-do Bostonians, and almost every detail can be found in the writings of contemporary pundits of fashion. Most recently, the painting has been used as a source for recreated interiors in several museums.

The atmosphere is mellow. Late afternoon sun streams in the windows, a fire burns in the fireplace and the numerous bottles emphasize the conviviality of this decorous group of well-dressed gentlemen. Sargent gives visual imagery to the age-old concept of good food and drink being welcome inducements to fellowship and conversation. No drunkenness, gluttony or sexual innuendo can be seen. Instead, the scene is proper and quiet, although its very decorum may explain why so few interiors of this nature were depicted in paint.

Among American artists, Sargent was particularly well suited as the recorder of such a scene. The son of a successful merchant family, he began working in his father's office, and discovered a natural drawing ability quite by chance. He worked briefly with John Johnston, a provincial portrait painter in Boston, and in 1793 he went to London to study under Benjamin West. Sargent returned to Boston in 1799, and although interested in painting the complex, idealized historical and religious scenes so strongly advocated by West, he retained the simple, linear style of Johnston. Sargent did not receive a great deal of support for his artistic pursuits. He maintained an active career in politics and the military, where he attained the rank of colonel in the Massachusetts militia. He never abandoned his interest in the arts, however, and in 1840, near the end of his life, was elected an honorary member of the National Academy of Design.

*The Dinner Party* is virtually unique in recording a genteel midday meal among upper-class men. It is unusually large, a

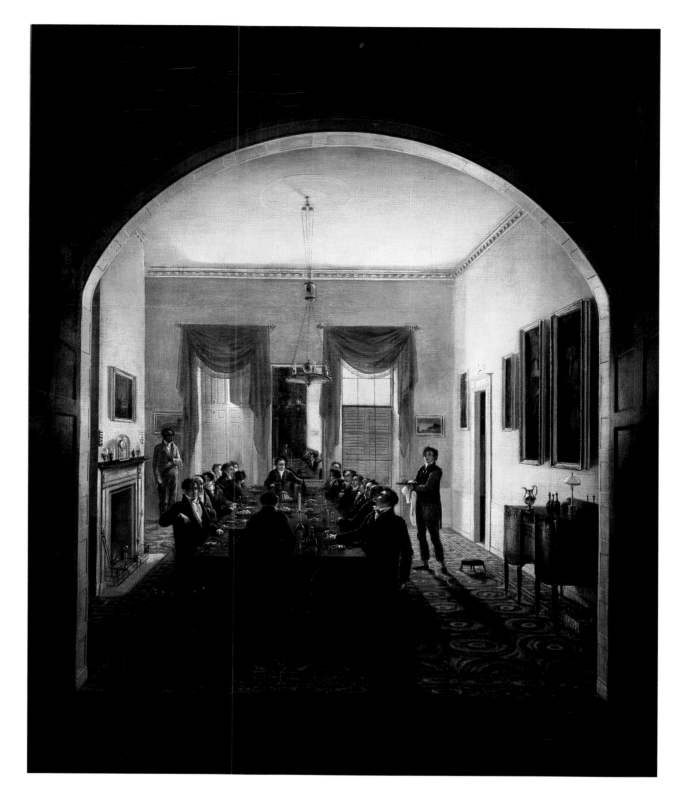

Henry Sargent
(1770–1845)
*The Dinner Party*
Oil on canvas
59 1/2 x 48″
Courtesy Museum of Fine Arts, Boston,
Gift of Mrs. Horatio A. Lamb in memory of
Mr. and Mrs. Winthrop Sargent

direct result of its original commission from David L. Brown, who had decided to take advantage of the fad for exhibiting large oil paintings which was then sweeping the country. Charging an entrance fee of twenty-five cents, several artist-entrepreneurs had turned a handsome profit with traveling exhibitions. Brown was evidently successful in his endeavor with *The Dinner Party*.

Whereas *The Dinner Party* describes a masculine social gathering and is painted by a man, *Five O'Clock Tea* depicts an essentially feminine social gathering and is painted by a woman, Mary Cassatt. Together these paintings capture eating and drinking rituals common among the upper classes in nineteenth-century America.

The daughter of an old and prominent Pennsylvania family, Mary Cassatt was raised in the milieu accustomed to afternoon tea. Her painting strongly reflects this background. Although set in Paris, where Cassatt was living with her sister and parents, *Five O'Clock Tea* records a ceremony that was certainly a mark of their Anglo-American heritage. The French viewed afternoon tea as a foreign, indeed British, custom. Unconsciously reinforcing the non-French occasion, Cassatt prominently features an ancestral tea set, made in Philadelphia in 1813 for her grandmother, and reverently brought to the Cassatts' Parisian home.

By the end of the seventeenth century, tea-drinking had become extremely fashionable, particularly in conjunction with dessert. During the eighteenth century, tea began to appear at all meals, although in emulation of the oriental tea ceremony, the British evolved a special custom that dictated tea-drinking in the late afternoon.

Afternoon tea was well established in the American colonies until, with the imposition of what the colonists felt were unjust taxes in the 1760s, boycotting tea became a patriotic

duty, and the custom of afternoon tea waned. It underwent a revival in the mid-nineteenth century. American and British books about cooking, household management and etiquette began listing appropriate foods and codes of behavior related to tea-drinking. Among members of the professional classes, afternoon tea presented a suitable meeting place for ladies as well as for eligible members of the opposite sex. The Centennial celebrations of 1876 brought a renewed interest in many things from the American past, and "Lady Washington teas"—given in the presumed style, and even the dress, of Martha Washington—became a popular institution.

While *Five O'Clock Tea* may be Anglo-American in subject, the style of the painting is indubitably French. The fluid brushwork and pastel colors reflect the Impressionist movement in Paris, and Cassatt exhibited this painting in both the fifth and sixth Impressionist exhibits. Similarly Impressionist is the fragmentary composition of the scene where two women focus their attention on someone off the canvas. One sitter even holds a tea cup to her mouth in a momentary and somewhat awkward pose. This type of composition, derived from the arbitrary framing of the camera, reflects the artistic philosophy of Edouard Manet, who was Cassatt's close friend and advisor at this time. In using this technique, Cassatt captures an immediacy of action in a time-honored ritual, and represents her world in the most intimate way.

Alfred Maurer's *Café Interior* depicts a darkened café and the people who regularly inhabit it, posed in a story-telling manner. Although this café may have been located in Paris since it was painted during Maurer's second visit there, the time-honored combination of food, drink, and male camaraderie in *Café Interior* is universal. It is a quiet, moody painting that captures the atmosphere of the somewhat dirty but well-warmed café where two men have come to sit and talk into the night. This is an extension of their home, and it serves many functions: a place to meet friends, to do a little business, and to share a meal or some talk over drinks.

22

*Café Interior* is one of the last works that Maurer painted in the conservative salon tradition of John Singer Sargent and William Merritt Chase. Completed in 1904, the year he began to explore the avant-garde techniques of Matisse and Picasso, it represents a turning point in Maurer's artistic career.

Maurer was a frequent patron of cafés such as the one he has here depicted, and his days in Paris were his happiest. He was forced by his father, Louis Maurer, the well-known Currier and Ives artist, to return to the United States at the outbreak of World War I. In 1932, feeling neglected by both critics and patrons, he tragically hanged himself.

By 1950, men and women in intellectual circles, like those depicted in Lucille Corcos's painting, *Oyster Party,* had grown accustomed to casual social gatherings. The formal decorum, attire, table service and manners of the nineteenth century had been replaced by the improvised and incidental nature of the twentieth. In this work, animated exchanges are taking place, men and women are grouped together. Not only do they enjoy each other's company and share food and drink, but the duties of food preparation and serving seem equally divided between the sexes.

*Oyster Party* illustrates the power of food and drink to bring people together. Braving a winter's storm, no fewer than twenty-seven people have shown up at this country farmhouse to crack oysters, prepare chowder, make pies, and join in conversation. Someone has recently arrived; he is still in his heavy coat and scarf. Two fireplaces throw off heat as clusters of people, all of whom seem to know each other, talk in convivial groups.

Corcos's characters are real people—well-known writers, artists, critics, and singers, and this is a real oyster party in the dead of winter, 1950. Portrayed in a light and fanciful manner, the work is nonetheless complex in detail and epitomizes the delights offered by such gatherings: good food, good company and good talk.

Born in New York City in 1908, Corcos began painting professionally in 1929, dividing her artistic career between commercial and fine art. Her commercial career concentrated on book illustrations, and her best-known publications are *A Treasury of Gilbert and Sullivan* and four volumes of *Grimm's Fairy Tales.* She was also commissioned to produce murals for the Waldorf Astoria Hotel. An artist of broad appeal, she studied at the Art Students League and was married to the artist Edgar Levy.

Corcos populates *Oyster Party* with people who are enjoying the good humor and gregarious atmosphere that are induced by appetizing food and an ample supply of drinks. In contrast, no one is present in *Football,* Janet Fish's compelling painting of an unoccupied interior of a home. It is mealtime, and the details of the setting in which the food is placed provide sufficient evidence to deduce the lifestyle and sex of the absent resident.

This person eats alone, and probably lives alone. The social nature of family dining is here replaced by the television set which, because it is tuned into a football game, suggests that the watcher is male. Magazine-reading also provides an insight into the personality of the mysterious occupant.

For this person, eating has assumed the character of a prolonged snack. It occurs without the sequence of events that constitutes the ritual of family dining—preparing the food, setting the table, serving the portions, clearing the table, and cleaning the kitchen. From the painting, it is clear that the meal is consumed in the living room (not in the kitchen), on the couch (not at a table), with fingers (there is no silverware), and from packages (there are no plates). The food is brought into the home ready-to-eat, either mass-produced or prepared in a neighboring delicatessen.

Mealtime is reduced to munching and nibbling, an absentminded accompaniment to the other activities of reading

23

24

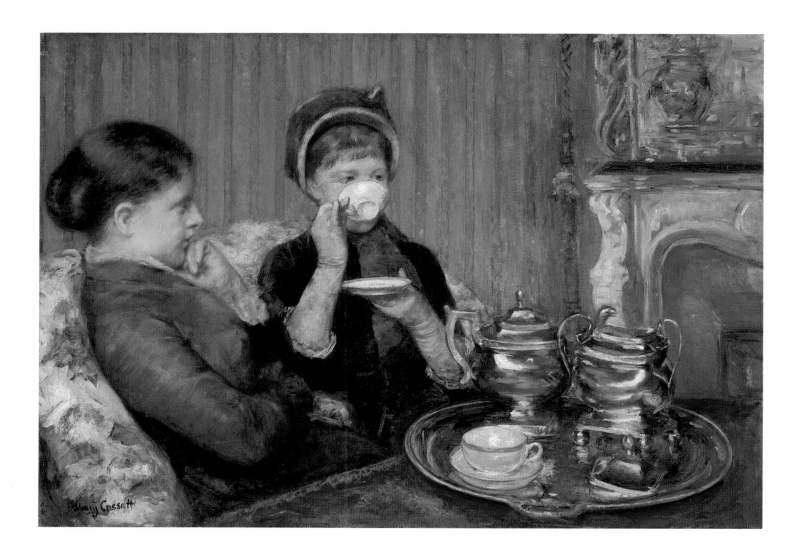

Mary Cassatt
(1844–1926)
*Five O'Clock Tea*
Oil on canvas
25 1/2 x 36 1/2"
Courtesy Museum of Fine Arts, Boston,
M. Theresa B. Hopkins Fund

25

Alfred Maurer
(1868–1932)
*Cafe Interior*
1904
Oil on canvas
30 x 31"
Courtesy Nebraska Art Association,
Thomas C. Woods Memorial Collection,
University of Nebraska Lincoln

and watching television. The individual indulges in a meal of chips, beer, and processed cheese spread on processed white bread, but he is deprived of other pleasures offered by food: the social component of dining with family and friends or in public, and the pleasure of tasting and preparing wholesome food.

Fish is best known for her still lifes which, ironically, never appear to be still at all. Although the objects she paints are most often inert, she discovers in them the dazzling interplay between transparency, translucency, and reflection, the distortions caused by concavity and convexity, the shadows cast and the lusters projected. These effects are layered, intensified, and bathed in a flickering light that unifies the scene. It is the visual, not the tactile, sense that she celebrates.

*Football* is a departure from Fish's familiar style. Although the objects remain within the category of still life painting, this work seems less singularly devoted to visual complexity and more concerned with narrative. The style is neutral, revealing in meticulous detail the dining habits of a sedentary, middle-class, sports fan. It places this work in a new category—that of social realism or, perhaps, social satire.

Richard Artschwager also addresses mealtime in a single-person household. His portrayal of a single place-setting, a metaphor for the lifestyle of an individual who lives and dines alone, is a desolate image made all the more lonesome by the title, which identifies the meal as dinner, the most socially oriented and ritualistically served meal. Flat, linear, schematic, and monochromatic, it embodies the reality of the dissolution of the modern American family. Prepared meals packaged in individual servings are intended for scenes such as this.

The poignant visual testimony is achieved without direct reference to the person living it. Artschwager's sculptures and paintings are never populated. He has limited his depictions to common objects and the settings in which they are found. Throughout the 1960s he produced pseudo-furniture,

carefully crafted objects that deviated in scale and design from their functional counterpart, but still retained their identifying characteristics. The works combined the matter-of-fact banality of the Pop artists with the hard-edged precision and the conceptual clarity of minimalism, but Artschwager belongs to neither school. His insouciant social commentary is his own.

These iconic tables, chairs, doors, cradles, and pianos are often fabricated of formica. The surfaces are painted to imitate the crude exaggerations of fake wood grain used in popular furnishings. In this way Artschwager relates the artifice of art, particularly representational art, to kitsch design. He utilizes the meticulous techniques of fine craftsmanship to imitate mass-produced articles that are often reviled as cheap and tasteless. The refined skill with which he manipulates the material elements is placed, ironically, in the service of impersonal, manufactured objects.

Artschwager's confounding of two disparate worlds not only enriches the meaning of the work, but it reflects his early career experience. He was already a skilled craftsman who made custom- and mass-produced furniture for the Work Bench when he enrolled in the studio school of Amedee Ozenfant, and it was not until 1959 that he became a full-time artist.

Just as Artschwager's three-dimensional work is both abstract form and representational art, so his two-dimensional art occupies double categories. He paints on celotex board, a rough-textured material used in the building trade for dropped ceilings. Its active texture draws attention to the surface, contradicting any illusory effects of the images drawn upon it.

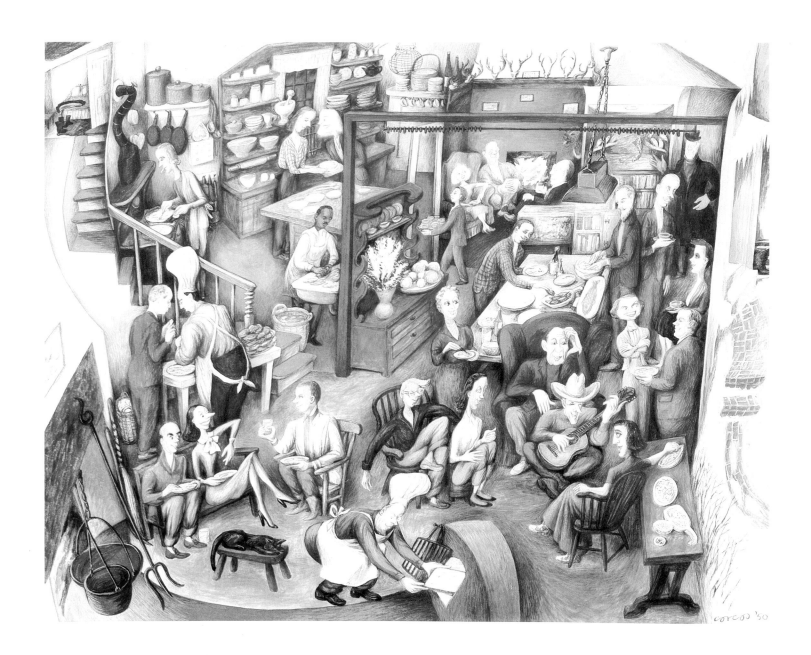

27

Lucille Corcos
(1908–1973)
*Oyster Party*
1950
Gouache on paper
18 1/4 x 22″
Courtesy Babcock Galleries,
New York

28

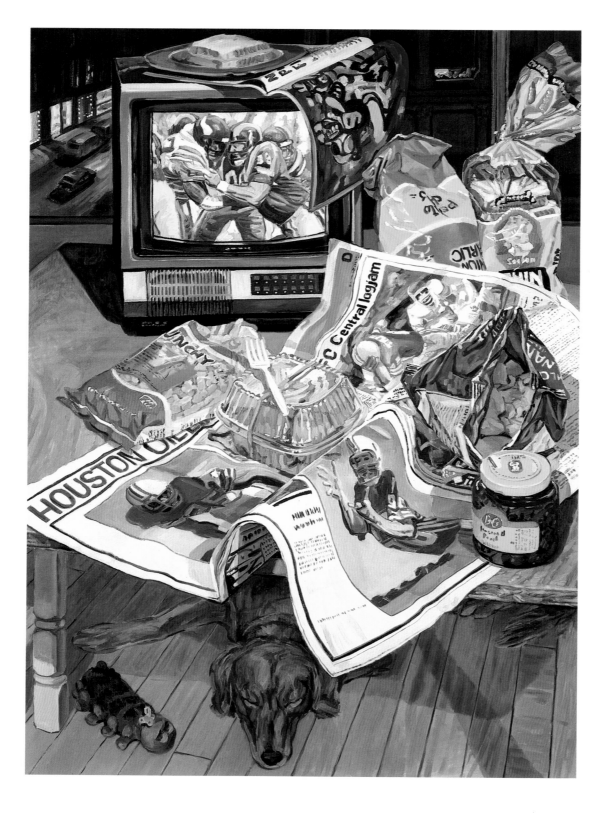

Janet Fish
(b. 1938)
*Football*
1986
Oil on canvas
70 x 50"
Courtesy Robert Miller Gallery,
New York

29

Richard Artschwager
(b. 1923)
*Dinner*
1984–85
Liquitex on Celotex
(C) Richard Artschwager/
VAGA New York 1990

# Wonder Bread

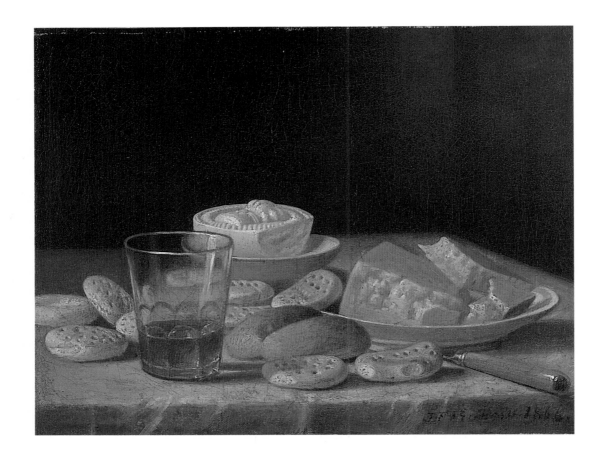

32

John Francis
(ca. 1810–1885)
*Still Life*
1866
Oil on canvas
16 3/4" x 19 3/4"
Courtesy Princeton University Art Museum

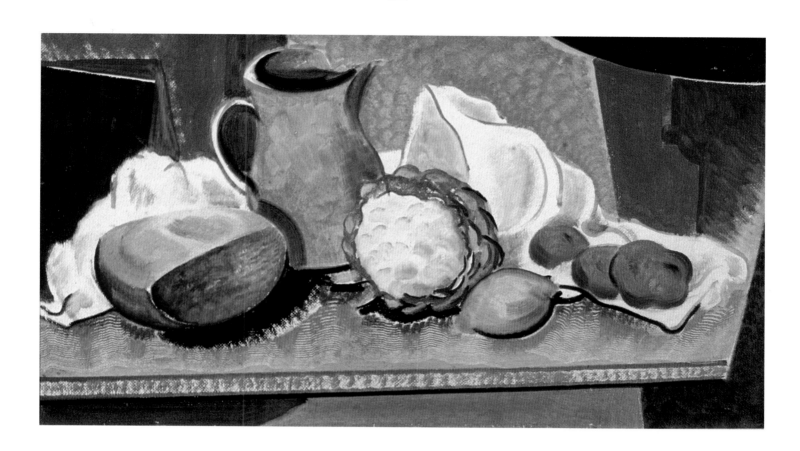

Konrad Cramer
(1888–1963)
*Italian Still Life #1*
c. 1930
Oil on board
20″ x 36″
Courtesy Aileen B. Cramer

When Ralph Waldo Emerson wrote *Romantic Philosophy of Nature*, he used as his example of the moral law which lies at the center of nature "the chaff and the wheat." To him they were sacred emblems. Emerson reflects the vital role that wheat has assumed, not only in the nineteenth century, but throughout the history of civilization. Great honor has been bestowed on those who were capable of transforming wheat into a quality loaf of bread.

As the "staff of life," bread is surprisingly under represented in nineteenth-century American still-life painting. Fruits and vegetables, fish and fowl, drink and cake, are more frequently depicted foodstuffs. The masterful paintings of bread by such seventeenth-century artists as Claesz and Chardin must have been known to American painters by the 1850s through travel and print sources. Yet bread, the most universal of Western foods, "the very foundation of a good table," according to Catherine Beecher and Harriet Beecher Stowe, is a rare subject matter.

Victorian Americans admired and hung still-life paintings of food in their dining rooms as visual stimuli to their diners. Highly carved furniture of the period even displayed sculptural representations of fruit, game, and fish. Cut-glass decanters and goblets might be decorated with leafy clusters of grapes, and the porcelain service for the fish course might have realistically painted trout swimming in the center.

Cheese and bread was one of the succession of courses in the classic nineteenth-century formal menu, although it could be viewed in itself as a light supper or lunch. For formal occasions, there was an ongoing debate as to whether cheese should follow or precede dessert. Regardless of when it was served, different types of cheeses were available, and each was carefully chosen to complement particular wines or sherries. Then, as now, white wine was considered a better accompaniment to most cheeses.

Cheese and wine was also a popular combination for masculine get-togethers. It became a symbol for a certain informal conviviality. James Fenimore Cooper joined with fellow authors and artists in the famous Bread and Cheese Club in New York in the 1820s. These meetings eventually led to the founding of the Century Association, still New York's most prestigious club.

In *Cake and Champagne*, John Francis depicts what could be either one course in a larger dinner or a complete meal in itself. This is not a meager repast for one who could afford no better. The white porcelain plate with its gold rim implies a certain level of wealth. The bread is in the form of two rolls and several crackers. Crackers were an invention of late eighteenth-century New England, where bread that would not grow moldy in a few days was needed for the maritime fleet. Small, crisply baked breads made without yeast were the answer, and the cracker caught on among the general public.

Butter was sent to market in large wooden tubs. It was often divided into smaller amounts at the market and, following European precedence, formed into small squares or circles with decorative designs on the top. Such molded patterns were thought to make the butter more attractive to the buyer, and it was served directly on the table with these small raised images intact, as can be seen here. The amber liquid in the bar tumbler could be wine, sherry, Madeira or tawny port, all thought to be good combinations with cheese.

The process of baking bread remained concentrated in the home kitchen well into the twentieth century. In 1900, 95 percent of all flour sold in the United States was still being bought for domestic cooking. Konrad Cramer's *Italian Still Life #2* presents a loaf of bread that retains not only the appearance of home production, but also the hearty look of flours that have not been refined. The naive-like quality of this loaf of bread mirrors the elements of American folk art that Cramer integrated into his canvases. This painting, completed around 1930, not only adopts the bold color and inventive shapes of that style, but depicts a peasant's fare: a cauliflower, onion, potatoes. This is a no-nonsense inven-

tory, and the ingredients, placed against a rumpled white tablecloth, will soon make their way into a farmer's soup that will gratefully be eaten along with the dark brown bread that has long been the peasant's staff of life and the water from the cracked pitcher.

Cramer was born in Würzburg, Germany, in 1888, the son of a well-known actress who was a close friend of Johannes Brahms. At an early age, Cramer was encouraged by his mother to pursue art, and in 1908 he enrolled at the Academy of Fine Arts in Karlsruhe. He continued his studies in Munich, interacting with Der Blaue Reiter group that included Franz Marc and Wassily Kandinsky.

During that year he also met an American art student, Florence Ballin, who had attended the Art Students League in New York. They married in 1911 and immediately embarked for the United States, settling in New York City and Woodstock, New York, then a fledgling artists' colony. Cramer's familiarity with the modern European artists, and his wife's associations in New York City that included Alfred Steiglitz and Mabel Dodge, placed the young couple at the center of Manhattan's art scene.

While his early work was influenced by the Munich avant-garde of the late 1920s, Cramer later switched to a stylized mode of cubist realism. Concentrating on still lifes inspired by Cézanne, Cramer often combined cubism with elements from American folk art.

The subsequent success of commercial bread is evidence of the victory of the industrial economy. This phenomenon not only drew women out of their homes and into the workplace so that they no longer had time to undergo the lengthy process of baking bread, it also brought about a more efficiently produced, more uniform and more predictable form of bread. This process is clearly represented in the lead relief, *Bread*, by Jasper Johns.

Flags, targets, ale cans, and a slice of white bread are among Johns's subjects. He is interested in these objects because, as he said in an interview in "What is Pop Art? (Part II)," Gene Swenson, *Art News*, February 1964, they

are "the things the mind already knows." In Johns's art, intellectual interest and sensual enjoyment depend on the perceptual and analytic abilities of the individual viewer. The artist leaves the definitions of his art and his intentions to his audience: "What it is—subject matter—is simply determined by what you are willing to say it is. What it means is simply a question of what you are willing to let it do."

Johns began working in graphic media in 1960 at Tatyana Grossman's lithography studio on Long Island. Almost all of his prints, of which there are lithographs, etchings, and lead reliefs, are explorations of themes found in his paintings, sculpture, and drawings. *Bread* is a notable exception; it is a subject that occurs only in lead relief.

*Bread* is a work that upsets the divisions between artifice and reality, and between painting, sculpture, and printmaking. The lead relief of the slice of bread, the sculpture of the Ballantine ale cans, and the Savarin coffee can, are all equivalents of the actual objects, and as such, they are understood as illusions of reality, in the tradition of *trompe l'oeil* painting. In *Bread*, however, the shifting of identities continues in the definition of the art object; *Bread* is a lead relief, made with a printer's press in a multiple run, therefore it is defined as a print, but the lead ground gives an illusion of weight to the object which is more like our experience of sculpture than of printmaking. In addition, the illusionary slice of bread, which is spatially distinct from the ground, is dependent for its realistic effect on the paper and the paint which has been applied by the artist's hand, giving the work the unique status of a painting.

While Johns's intention in *Bread* is unknown, his choice of a slice of white bread as a subject for a carefully crafted illusion is temptingly symbolic. Bread is a staple of human experience and has been the subject of still-life painters of all ages. Johns's realistic portrayal is specifically identifiable as a product of the assembly line.

35

36

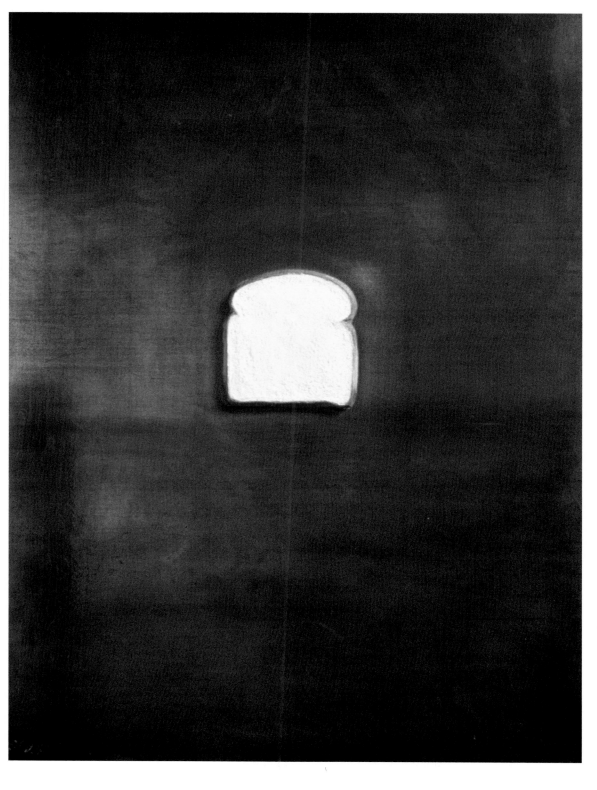

Jasper Johns
(b. 1930)
*Bread*
1969
Lead relief with paper and paint
23″ x 17″
Courtesy Gemini G.E.L., Los Angeles

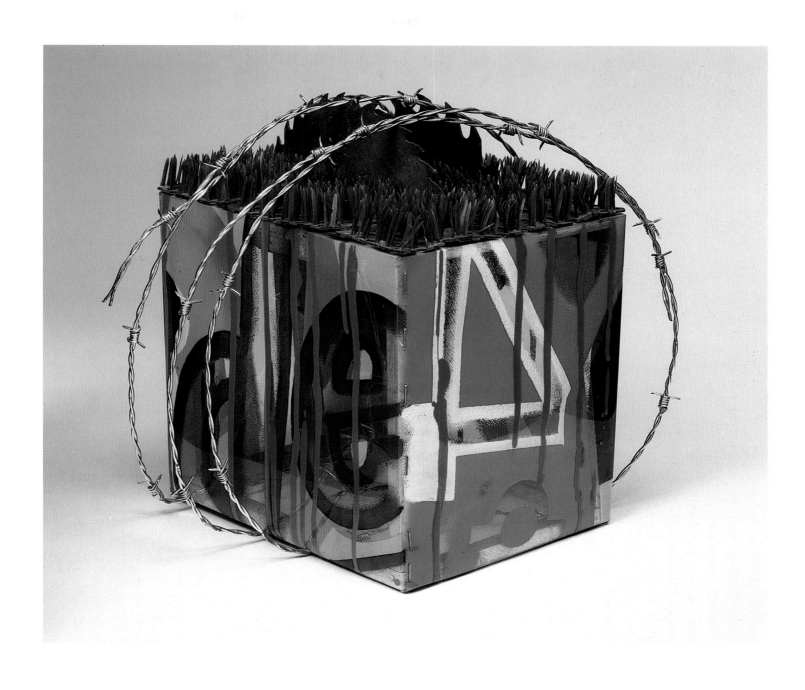

37

James Rosenquist
(b. 1933)
*Toaster*
1963
Mixed media construction
11 3/4 x 9 1/8 x 12 1/2″
Courtesy Frederick R. Weisman
Art Foundation, Los Angeles

38

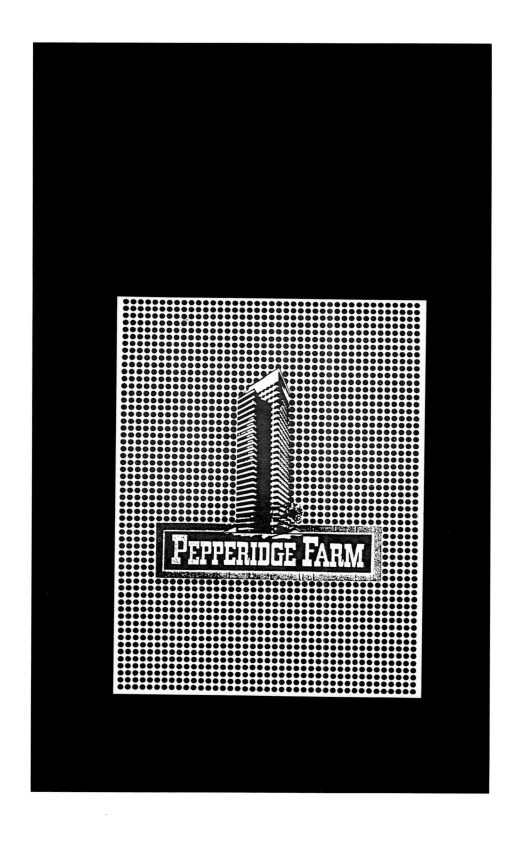

Peter Nagy
(b. 1959)
*EST Graduate*
1984
Xerox on canvas
39 1/2″ x 24″
Courtesy B.Z. and Michael Schwartz

This slice of American processed bread is so far the single example of food in Johns's *oeuvre*. The purpose behind his choice is as elusive as that which lies behind his choice of the American flag. Like the flag, each slice of white bread is flat, man-made, and tied to a specific time and place. On the other hand, any slice of white bread is like any other slice of white bread, and perhaps the fact that the same principle of multiplicity is involved in printmaking was of interest to Johns. White bread is also like textured white paper, and the artist takes advantage of this similarity in his *trompe l'oeil*. Whatever Johns's intention, he has taken a common object and transformed it by changing its context. As the mass-produced slice of white bread becomes an art object, its purpose shifts from an item to be consumed to an object to be presented, fooling not only the eye, but the mind as well.

James Rosenquist came to prominence as a Pop artist in 1962. Both he and Andy Warhol had had careers in commercial art, and the apparent connection between Rosenquist's fine art and his commercial art inflamed the critics. Rosenquist had worked as a billboard painter, and scholars like to find parallels between the large-scale, cropped Pop images and the enormous advertising signs. Rosenquist's manner of composition, similar to collage, also involves the found-object aesthetic that is a legacy of Dada and surrealism.

With few exceptions, initial critical reaction to Pop art was hostile to both the processed image and the vernacular subject matter. Looking back on the period of the 1960s with the advantage of historical detachment, however, it is clear that much of Pop art itself, criticized for its simple acceptance of the vulgarities of middle-class American existence, is more critical than had been assumed. In *Toaster*, for example, Rosenquist uses the subject of food to reflect America's anxieties about the nuclear age and the possibility of worldwide annihilation. *Toaster*, 1963, which looks more like a time bomb than an innocuous kitchen appliance, expresses the tension of those days of waiting while President Kennedy and Soviet Premier Khrushchev stood poised for war, the U.S.S.R. having begun to equip Cuba with nuclear missiles, the U.S. determined to reject any attempt by its cold-war opponent to establish a missile base within striking distance of home. Khrushchev finally backed down, and while the immediate threat of war between the superpowers receded, an uneasy peace reigned in the world.

In *Toaster*, Rosenquist combines a variety of sharp-edged and dangerous tools with paint and barbed wire. By ironically calling this violent box a "toaster," the artist draws attention to the double-edged sword of technological advancement. Science can be used to make everyday lives more comfortable, but at the same time, science can be an advocate of destruction.

*Toaster* is a death device. A box, covered with the numbers that eventually wind down to detonation time, supports a lawn of plastic vegetation. Two rotary saw blades stand erect among the blades of grass in the approximate positions of the slices of bread that would pop out of a real toaster. Streams of red paint bleed over and down the sides of the box. Completing the violent metaphor, a strand of barbed wire wraps in several loops around the assemblage.

Rosenquist is the Pop artist who plays with puns and surrealist metaphor most frequently. He uses language to disrupt the visual signs communicated by the appearance of the art object. *Toaster* subverts the innocence of a household object, and by extension, a way of life. It bristles with political purpose. By making the connection between the action of a bomb and the internal, timed mechanism that heats, and then ejects the toasted slice of bread, Rosenquist implicates all of our technological devices. Like much of the art produced in the 1960s, a warning accompanies this reference to everyday life.

Johns acknowledges that the home-baked loaf of bread has been replaced by one produced in the factory. Rosenquist provides evidence that the technology that assures a perfect slice of toast is also capable of wreaking mass destruction. Peter Nagy extends this analysis by indicating that the center of bread-baking in America today is not located in the factory, but in the corporate headquarters of a multinational firm. It is behind these towering walls that the essential ingredients of a modern loaf of bread are discovered—not flour and yeast, but marketing decisions, promotion devices, advertising techniques, profit-margin calculations, and stock-market strategies.

39

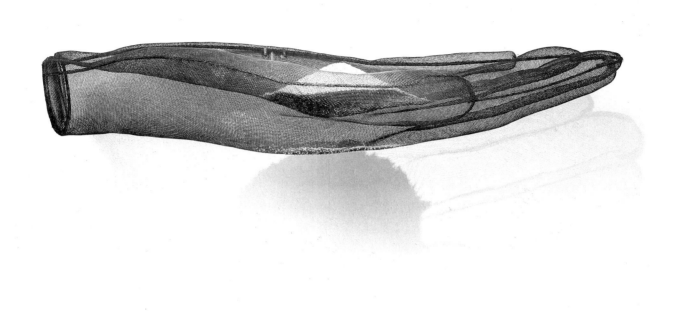

40

Kathleen McCarthy
(b. 1953)
*Gathering Hand I*
1989
Patinated copper wire mesh, steel, wheat
76 x 73 x 36"
Courtesy Gracie Mansion, New York

The dichotomy between the synthetic nature of the food thereby created and the wholesome, rural connotation suggested by the name "Pepperidge Farm" in this work by Peter Nagy demonstrates the willful restructuring of reality common in the advertising sector. The blocky, ranch-style lettering further conveys the impression of a small, family-oriented business, conveniently distracting the purchaser from thoughts regarding the distrust of the means and devices of megabusiness practices.

The dichotomy between the old-fashioned and the modern loaf of bread is reflected by Nagy in his choice of medium. This work was created by a Xerox machine. It has as little relation to traditional easel painting as pre-sliced, cellophane-packaged bread has to a home-baked loaf. In both instances the personal involvement in the production has been replaced by efficient, quick, sanitized, and technologically advanced methods. Through these devices both bread and art have become producible in unlimited editions, undermining craft and artistry, and obfuscating the difference between a replica and an original.

Nagy has placed his image of the Pepperidge Farm corporate building against a field of enlarged black dots, exaggerating the pattern of half-tone newspaper reproductions. The intentionally "unfine" print produces a graphic reminder that the images we behold are as processed as the food we ingest. The title, *EST Graduate*, extends Nagy's conflation of art and commercialism. E (Erhard) S (Sensitivity) T (Training) was designed as a fail-safe, short-cut route to enlightenment. It was devised in the 1960s by Werner G. Erhard, a salesman who applied the techniques of marketing persuasion to the pursuit of spiritual fulfillment.

Nagy has established a triad of correspondences. Food, art, and enlightenment have all come to conform to the values of modern technological society. All three have been accomplished in a labor-saving manner, and all are subject to the same model—an ultra-efficient form of production, exaggerated claims, and a frenzy of consumption.

The gesture of the hand that comprises the work of art by Kathleen McCarthy is inconclusive and suggests states of opposition. It may be offering or begging. The kernels of wheat that it holds are falling to the ground. Will they sprout and regenerate? Will they shrivel and die there? McCarthy suggests that "the subject of this piece is the impossibility of attaining or grasping the ideal and the struggle that occurs as we attempt it."

Her ideal is representative of the change of sensibility that has occurred at the end of the 1980s. Instead of a brandishing of big business slogans and corporate maneuvers, bread, once again, has come to represent a precious, nourishing food. McCarthy explains, "The wheat is capable of feeding and nourishing. It is a sign of plenty, and has become a major bargaining agent in East-West eco-politics. The wheat I am using still contains the chaff. It is the same wheat that is piled up perennially on farms in our midwest."

Seeds that do not sprout signify the barren earth, the loss of its ability to sustain life. Scattered wheat is a compelling image of waste and want. The hand, because it is overscaled and highly simplified, seems to belong to an almighty being. The screening out of which it is constructed is semitransparent, making it appear dematerialized. The wheat, on the other hand, is real and suggests the cycle of planting, germination, growth, and harvest.

41

McCarthy's work has a formality that places it within the tradition of religious art. It is otherworldly, weightless, ceremonial. This quality is, perhaps, a result of her trip in 1978 to Europe where she was particularly impressed by the altarpieces of Northern Italy. The hierarchic stance of Italian religious art has here been transposed and applied to new subject matter: wheat, the material which the threat of ecological disaster in the modern world has returned to the holy status it had in Biblical days, as a precious and symbolic commodity.

# Technology of Fruit

It is difficult to imagine the delight which must have accompanied the ripening of fruit in the autumn prior to the development of refrigeration, canning, freezing, and transportation. The only fruit that was available during the winters, springs, and summers of the pre-industrial era was either dried, consumed in the form of cider, or distilled. The pleasure of eating fresh grapes, apples, pears, and peaches must have been intensified by the knowledge that the long anticipation of their harvest would be followed by another year of deprivation. The harvest once inspired heartfelt thankfulness. Today these foods are a daily staple, available everywhere in every season.

*Basket of Apples*, by Levi Wells Prentice, reveals the attitude typical until the end of the nineteenth century that held fruit to be a gift from God and a reward for hard labor. For this reason, it was considered an act of arrogance for the artist to improve upon the version presented by the Creator Himself. This belief explains the realistic, hard-edged intensity of Prentice's work.

As a still-life artist, Prentice usually painted fruits and berries, and plums and apples were his undoubted favorites. His painting unconsciously records in sharp detail the subtle differences in shape, size, and color of the various fruits of his time. Throughout the nineteenth century, interest in the development of new types of apples with specific flavors, colors, and cooking or storage qualities had resulted in over 8,000 identifiable varieties by 1900. Present-day Americans do not enjoy the variety depicted in *Basket of Apples* as over seventy-five percent of the commercial crop now consists of a single type, the Delicious.

Apple crops in the nineteenth century were damaged or misshapen. They displayed the effects of insect and bacterial pests. Although the first spray, Paris Green, an arsenic derivative, was introduced as a retardant for the coddling moth in the late 1870s, by 1900 three or four applications a year were considered more than adequate. Many orchards used no sprays at all. Thus in Prentice's time, apples brought to market often bore the marks of various blights, readily visible in his painting. Great strides in creating different insecticides were made in the twentieth century. Today, a single crop of apples is subjected to twenty or thirty applications which can include a wide combination of synthetic chemicals. Blemished fruit such as those in *Basket of Apples* would not be salable in the 1980s, although, as has often been pointed out, tasteless ones with perfect red coloring are.

Prentice did not work in still life until he had been in the metropolitan New York area for some time. Born in rural Lewis county in the Adirondacks, he began his career as a decorative painter, designing parlor ceilings, as well as supplying portraits, that staple of nineteenth-century artists, and landscapes of Adirondack scenes. With a certain amount of ingenuity and talent, he fabricated his own brushes and palettes and constructed his own frames.

In the 1880s, wanting to advance his artistic abilities and status, he moved to Brooklyn. There, the artistic community included several successful still-life painters, the most notable of whom were William Mason Brown and Joseph Decker. Prentice's earliest dated still life was painted in 1892, around ten years after he settled in Brooklyn.

What gives a distinctive cast to Prentice's work is his intensely hard-edged imagery. The same linear qualities can be seen in the colorful skin of an apple, the texture of the grass and the soft wood veneers of the basket. Although the motif of an overturned basket of fruit was a well-established subject among American still life painters throughout the latter half of the nineteenth century, Prentice imparts, through his technique, something of the simplicity and practicality of life on a subsistence farm in upstate New York. The humility of Prentice's still lifes must have formed a vivid contrast to the urban parlors in which they hung.

Such nineteenth-century paintings also stand in marked contrast to the work of Walter Murch, whose paintings are a product of a society that had been radically transformed dur-

44

ing the intervening six decades. These years mark the proliferation of industrial processes and the expansion of the urban environment.

Murch came to New York from Canada in 1927 to study art with Kenneth Hayes Miller at the Art Students League. On a whim, he took a position as an assistant designer at a stained-glass workshop, and remained in the United States until his death in 1967. Murch, the artist, is a solitary figure. His medium is oil and his technique descends from a long tradition of realistic painters. Nevertheless, he was deeply committed to the art of his own time. His work has been described variously as realist, surrealist, magic realist and romantic realist. He shared with his friend Joseph Cornell a deep regard for the poetry of objects, the keystone of surrealist doctrine. At the same time he was akin to the painters of the Abstract Expressionist generation, using paint as the carrier of poetry and drama.

*Chemical Industry* is one of several paintings commissioned from Murch by what is now the Citibank Corporation. During the 1950s, Citibank was known as a supporter of innovations in industry, and in this painting Murch alludes to the corporation's image of promoting the public good through technological progress. *Chemical Industry* is a deceptively simple painting. In Murch's interpretation of the theme, nature interferes with the business of agriculture by unleashing pests like the moth and beetles found in the painting. Technology is summoned to control them. The laboratory equipment in the foreground suggests the development of chemical compounds while the distant helicopter represents one method of pesticide distribution. There is also a nearly invisible, and surely genetically engineered, food product—a combination of the roundness of the apple, the texture and color of the potato, and the kernel-bearing tip of wheat—to the right of the elaborate apparatus which divides the canvas. Reading the composition from left to right suggests two developments. First, that science has engineered a new hybrid agricultural product, and second, that as a consequence a mutant species of beetle has been produced. But any seriousness of intention is subtly undercut by touches of surrealist humor, such as the cosmic immensity of the space and the dramatic light effects. The artist also creates visual

puns by pairing the moth and the helicopter, the beetle with its striped back and the similarly shaped, black-stoppered bottle, and the shaft of wheat and the long, narrow insect. In the painting's view of agriculture, as in the world view of the Citibank Corporation, humans are in control; they are engineering their own future, designing their own fate, and improving on the processes of nature.

Murch's father was a jeweler and his mother was a pianist. As a child, his imagination was nourished by the presence of delicate instruments, mysterious gadgets, and sonorous machines, which explains the frequent appearance of mechanical devices and gadgets in his work. His subjects include such unaesthetic objects as carburetors, phonographs, and lock mechanisms. By isolating them and veiling them in an obscuring mist, however, Murch separates these objects from ordinary reality and invests them with a strange mystery. His paintings, no matter their subject, evoke pathos. This is particularly true when the trappings of industry are applied to the production of food.

Hans Hofmann, like Walter Murch, straddled the world of representation and invention. Both began with a simple subject: a still life of fruit. But while Murch traveled into the area of an imagined reality, Hofmann gravitated toward abstraction. Despite these diverse paths, both artists reflect the growing independence from nature that resulted from the advances in science and technology. By 1950, planting, cultivation, fertilizing, spraying, and harvesting were all performed by machines and therefore it is not surprising that naturalism had disappeared from works of art. Both Murch and Hofmann reject modeling; their objects no longer have material substance; light does not emit from an identifiable source; traditional rules of perspective are ignored. Matter, space, and time are all transformed. Hofmann alters them for compositional purposes. Murch manipulates them to evoke a surreal atmosphere. In both cases the experience of the real world is denied. The objects depicted in these works of art bear little relation to those which can be touched, smelled, and tasted.

45

46

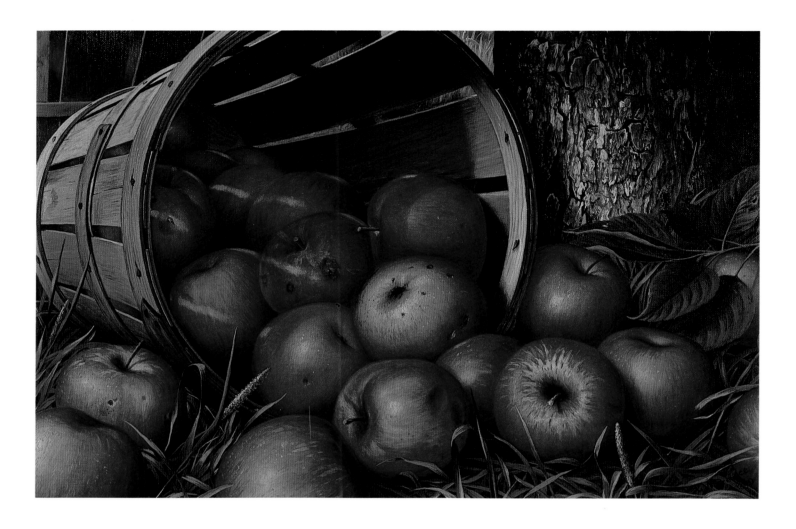

Levi Wells Prentice
(1851–1935)
*Apples in a Basket*
1890
Oil on canvas
23 7/8 x 30"
Courtesy Onondaga Historical Association,
Syracuse, New York

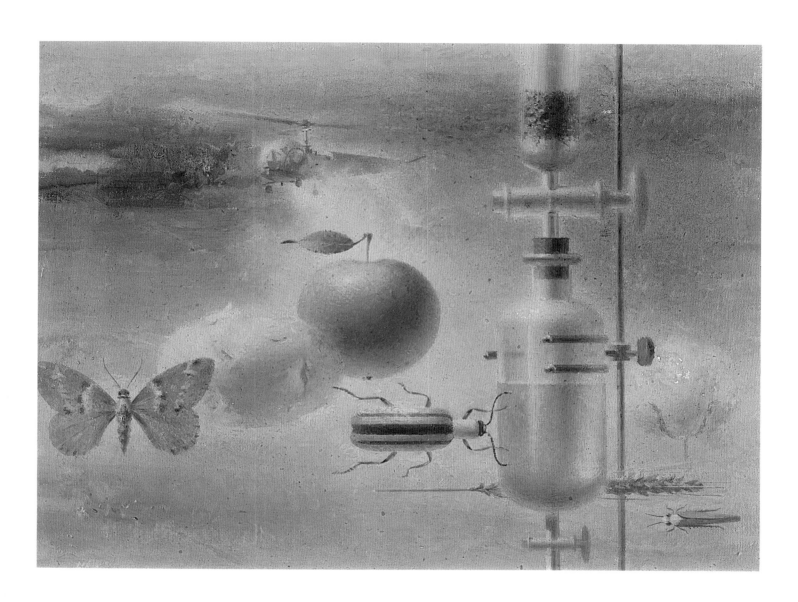

Walter Murch
(1907–1967)
*Chemical Industry*
1957
Oil on canvas
15 3/4 x 21 5/8"
Courtesy Citicorp Art Collection, New York

48

Alice Neel
(1900–1984)
*Cut Glass with Fruit*
1952
Oil on canvas
22 x 31"
Courtesy Robert Miller Gallery, New York

Hofmann was not only a great painter but a profoundly influential teacher as well. Born in Germany in 1880, he lived in Paris from 1904 until 1914, witness to the changes wrought during the age of heroic modernism. In Paris, he found the two main shaping influences of his art: Matisse and Cézanne. Hofmann admired Cézanne's structure and organization of space, and Matisse's color, brush stroke and enthusiasm. By fusing these two individual expressions, Hofmann created an art of tightly controlled exuberance. Unlike the work characteristic of the American Abstract Expressionists for whom he served as teacher, Hofmann's art is disciplined in its reference to visible reality.

Hofmann came to the United States in 1930, having been invited to teach at the University of California's Berkeley campus. In 1931 he joined the faculty of the Art Students League in New York City, and the following year he opened the Hans Hofmann School of Fine Art, teaching in New York during the academic year and in Provincetown in the summer. Teaching provided him with an opportunity to clarify and systematize his aesthetic theory, which he then passed on to his students. During the 1930s, when the dominant American painting style was social realism, Hofmann represented an alternative modern European sensibility. His abstract principles are apparent in *Fruit Bowl* of 1950, which reveals the impact of his initial contact with modernist painting through the abstractions derived from nature of Cézanne and Matisse.

Alice Neel represents an alternative way in which a painter's will is asserted upon the subjects represented. Best known as a portrait painter, her sharp insights into such diverse personalities as Virgil Thompson, Frank O'Hara, Andy Warhol, and Linda Nochlin have earned Neel a reputation as a "collector of souls." In her portraits she was able to capture the gesture, pose, and facial expression that disclosed the essential character of the subject. This sensitivity of perception is just as evident in her still-life paintings.

Neel was born in Merion, Pennsylvania, in 1900. She graduated from the Philadelphia School of Design for Women, now the Moore College of Art, in 1925, and moved to New York where she lived until her death in 1984. As a painter working for the WPA in the 1930s, Neel painted left-wing intellectuals and union organizers. She memorialized on canvas the individuals whose personal stories have become part of the social history of America. In later years, Neel's family and artist friends became her preferred subjects. These images from the 1950s and 1960s chart a history of the middle-class in America. In the 1960s, with the rise in interest in figurative art, Neel's paintings began to attract critical notice. Her retrospective exhibition in 1974 at the Whitney Museum of American Art signaled her belated acceptance as a major twentieth-century American painter.

Still-life paintings, seldom seen in Neel's *oeuvre*, convey a hidden narrative. *Cut Glass with Fruit* isolates the subject of the still life in a manner reminiscent of that in which the sitter is isolated in Neel's portraits. And, also as in her portraits, she uses space to evoke an emotional or psychological mood. In this painting, the emptiness of the room is emphasized both by the unoccupied chair pushed under the table and by the stark, relatively large areas of space. An ominous tone is struck by the glittering, sharp, cutting edges of the glass bowls seen in opposition to their functions as receptacles of organic flesh. This effect is reinforced by the contrast of the nearly empty bowl on the left to the full bowl on the right, and the shadow cast by one and not the other. The canvas here is an arena in which the inert objects project their contrasting characteristics. It is activated with the tension and veiled references usually reserved for portraits. The fruit in this painting is represented less as a food and more as a motif to serve the artist's personal psychological agenda.

American art has been deeply involved in the exploration of the relationship between man and nature, and Roy Lichtenstein's *Bananas and Grapefruit* carries that thematic exploration into the 1970s. His fruit represents America's utilitarian view of the perfecting of nature and the harnessing of her resources, the goal of American enterprise since the first settlers arrived.

In its flat artificiality, the image of engineered fruit in *Bananas and Grapefruit* suggests flat artificiality, a history of America's relations with the land and the complete subjugation of nature.

Lichtenstein is a Pop artist. Since 1961 he has found subjects for his art in the images of popular culture ranging

49

50

Hans Hofmann
(1880–1966)
*Fruit Bowl*
1950
Oil on canvas
29 7/8 x 38"
Courtesy Nebraska Art Association,
Sheldon Memorial Art Gallery,
University of Nebraska Lincoln, 1951.N-72

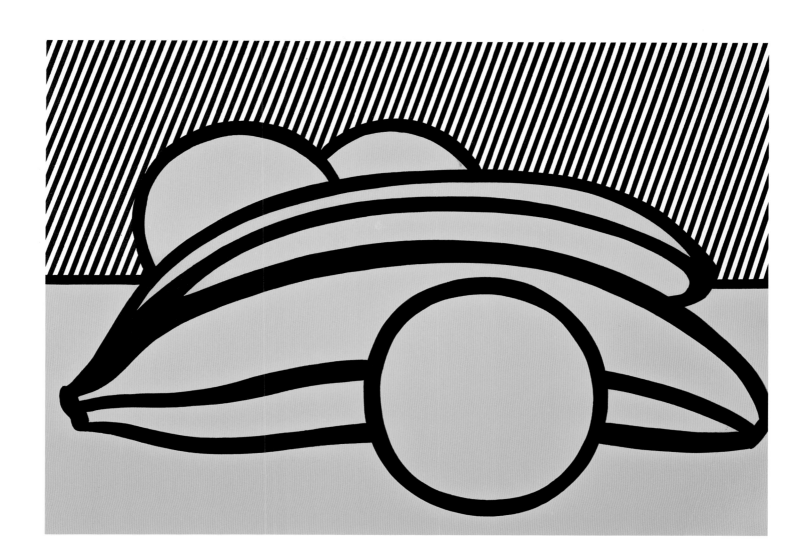

51

Roy Lichtenstein
(b. 1923)
*Bananas and Grapefruit*
1972
Oil and magna on canvas
28 x 40"
Courtesy, Mr. and Mrs. Ronald K. Greenberg
St. Louis, Missouri

52

Donald Sultan
(b. 1951)
*Black Lemon, August 24, 1984*
1984
Pastel on paper
50 x 48″
Courtesy Dunkin Donuts, Randolph, Massachusetts

from comic books to advertising to fine-art reproductions. Lichtenstein's art, always removed from nature, refers to contrived images of events, objects, or paintings.

*Bananas and Grapefruit* belongs to the venerable tradition of still-life painting but, in Lichtenstein's characteristic fashion, the image is an abstraction, with little in common with actual fruit. The reality of three-dimensional fullness has been discarded in favor of the flatness of post-Cubist painting and the pure, unmodulated yellow. *Bananas and Grapefruit* fits our ideal of excellent fruit, whose surface appeals to us in the same way that attractive packaging sells toothpaste, frozen dinners, and hair coloring. In *Bananas and Grapefruit* the American preference for plastic, non-natural materials; for surface, not content; for image, and not substance, is an underlying theme.

Unlike other still lifes, *Bananas and Grapefruit* concentrates on the artificial nature of fruit in today's markets. Fully harnessed and stamped with the technological imprint, this painting portrays fruit engineered into existence. It is nature remade in the image of civilization.

It is not uncommon for Donald Sultan to base his work on earlier models both in subject and in form, and the series of paintings of lemons that earned him such a distinguished reputation was inspired by a small painting by Manet. Despite these historic references, Sultan's works are neither nostalgic nor derivative; they belong uncontestably in the contemporary world.

Sultan himself has suggested that the modern look of his work is due to the absence of a still-life painting tradition in his country. He commented in an interview with Carolyn Christov-Bakargiev (*Flash Art*, May 1986), "It rapidly became apparent that I was the only still-life painter in America." Whether or not this statement is an exaggeration, Sultan perceived himself free to invent a new form of still-life painting. One area of innovation lay in the reclassification of his subject matter. His lemons are removed from the world of nature as well as from the media. They are stripped of the plumpness, freshness, and juiciness that identify them as organic and edible, and they have an overt dependence upon the industrial environment. As such, they are neither realistic nor Pop-like.

If the images are viewed as abstractions, the full and weighty silhouettes have a compelling grandeur. Their deep tones appear mysterious, and their velvety surfaces and soft edges provide a tactile appeal. But when these shapes are interpreted as lemons, they acquire sinister connotations. What is small in life is here swollen to gigantic proportions and pressed flat against the canvas. Sunny and inviting yellows have thickened to an impenetrable blackness and smooth surfaces have decayed into scabrous masses.

The same contrast between representation and pure painterly effects is apparent in Sultan's insistent devotion to the manual aspects of creation. Whether he is producing a print, a drawing, or a painting, Sultan's procedure is arduous and inventive. A laborious process of applying such non-art materials as tar, plaster, and spackle to masonite and linoleum aligns Sultan and his assistants with the techniques of the building trades industry. His prints are equally labor-intensive, requiring that the artist blow away the resin particles on the copper plate to create the desired image. Similarly, his charcoal and pastel drawings are heavily worked and demand great physical effort. All display skill in the manipulation of materials and devotion to manual effort which contrasts markedly from the impersonal technique utilized by the Pop artists. Sultan's lemon is transformed by the muscle and the willfulness of the artist working in conjunction with the materials and methods of the modern industrial environment. He has created a new, unnatural beauty. His lemons no longer represent the gifts of nature as they did in traditional still lifes. They belong, instead, to the effluence of the industrial environment. These new forms are both alluring and terrifying, just like the hybridized and engineered specimens of fruit that fill today's grocery shelves. Sultan's lemons are mutations, products of the power of modern industry.

53

# From Market to Merchandising

56

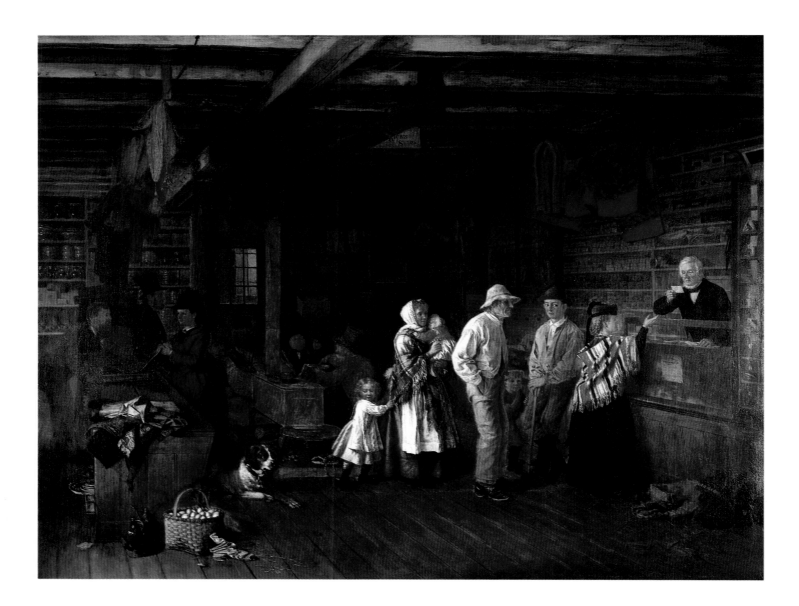

Thomas Waterman Wood
(1823–1903)
*The Village Post Office*
1873
Oil on canvas
36 x 47"
Courtesy New York State Historical Association, Cooperstown

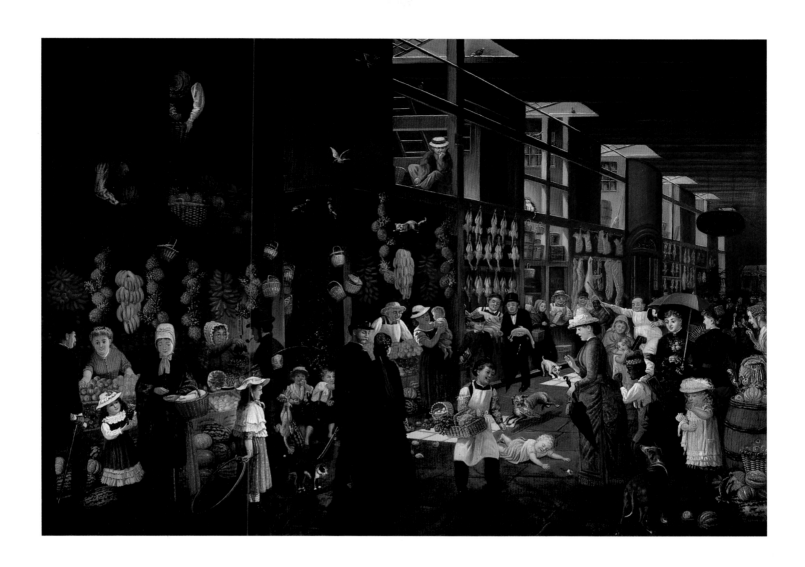

57

Charles Cole Markham
(1837–1907)
*Law Sakes Alive! What are you doing, Baby?*
1872
Oil on canvas
44 3/4 x 58 3/4"
Courtesy New-York Historical Society, New York;
Bryan Fund, 1985

The village store was a universal institution for most small nineteenth-century settlements. It was the center of trade, dispensing food, clothing, crockery, and mail, and the platform for social activity, where local gossip, national news, and political opinions were shared. It was a familiar, warm, and busy place, a venerable part of American life that was becoming obsolete because of the expanding possibilities of industrialized life. This was a time when the traditional morals and values of rural America were rapidly losing their economic vitality. Thomas Waterman Wood sought out surviving pockets of country life, particularly those in the central Vermont area surrounding his native Montpelier, that retained the flavor of a pre-industrial society.

Wood, trained as a cabinetmaker in his father's shop, embarked on a career in art with just rudimentary painting skills. He soon became a major figure in the contemporary art world. Elected to the National Academy of Design in 1871, he served as president between 1891 and 1899. He was also a founder of the New York Etching Club, and president of the American Watercolor Society from 1878 to 1890.

Like many genre painters, Wood was fascinated with the variety of human beings. *The Village Store* shows all ages and economic strata: the sleeping baby, the elderly postmaster, the scruffy checkers player from a farm family, the obsequious clerk, and the substantial, top-hatted townsman and smartly dressed woman of fashion.

Food does not play a large part in the depiction of the village store, believed to be the interior of the Ainsworth Store in Williamstown, Vermont. The very absence of it captures a characteristic of antebellum farm life. Most northern farms were self-sufficient. Only items not available to the relatively simple life and wants of the nineteenth-century farm family were purchased at the store. This would include coffee and tea, tobacco, a few spices and perhaps sugar, all arranged in boxes, jars, and drawers along the back wall.

Other typical items include the crockery, imported or machine-made textiles, and various tools scattered about the shelves.

During the nineteenth century, those foods which were not grown on one's own farm were likely to have been grown on that of a neighbor's. The purchaser of eggs was acquainted with the farmer who owned the chickens as well as with the merchant who sold them. In the left foreground of *The Village Store* is a small vignette of a basket of eggs and an earthenware cider jug, picturesque reminders of a barter economy.

A spouted, factory-made kerosene can is also visible in the painting, a material forecast of the newly emerging machine age. In a society quickly changing from a rural to an urban economy, stores such as this were familiar to many Americans from their childhood, but were no longer part of their adult lives. It is this nostalgic place, a symbol of old-fashioned rural life, that Wood chose to recreate.

Charles Cole Markham shifts the locale of his nineteenth-century market scene to an urban town setting. *Law Sakes Alive! What are you doing, Baby?* most likely records a family incident at the local public market in Brooklyn. His youngest daughter has tripped over a market basket and fallen directly across the path of a fleeing dog with a large, purloined steak in his mouth. An irate butcher is giving chase as a young bootblack raises his brush to throw at the dog. The rest of the market bustles under the routine of business with its usual mix of people.

Large open-air public markets were established in the United States as early as 1657. Soon after, structures were erected over them to offer protection from the elements. As cities expanded, markets were introduced to serve each neighborhood. Individual stalls were rented on a yearly basis to farmers and fishermen, who brought their own produce, and to butchers and grocers, who retailed specific goods. The markets were gathering places in which buyers from all social classes mingled with sellers of all races and religions.

58

They were early testing grounds for America's democratic ideal.

Markham offers a rare glimpse of a market interior in the 1870s. He captures its picturesque vitality and evidence of the major changes that were occurring at this time. The selection of foods that had remained constant for nearly two hundred years, consisting of seasonal produce from local farms, had suddenly multiplied into a cornucopia of delights. Both the quantity and the variety of foods available in these markets had increased due to the steady flow of imports by ship and by rail from Central and South America, the West Indies, and the Mediterranean. Suddenly an unprecedented supply of fresh produce, including tropical fruits that had virtually been unobtainable before, were available to everyone.

Although such mass-produced and packaged foods as Quaker Oats and Uneeda Biscuits were already in existence at the time of Markham's painting, most foods were still presented unwrapped, in their natural state. Meat, cheese, grapes, and the like, neither preweighed nor prewrapped, were selected and packaged individually by the proprietor upon customer request. The process of buying and selling was not only personal, it was also a daily occurrence in an era prior to domestic refrigeration.

Markham depicts stalls selling fresh vegetables—tomatoes, cabbage, asparagus, carrots—and a large mix of tropical fruits—bananas, pineapples, lemons, melons—as well as apples and peaches. There are several butcher shops specializing in beef, pork, and lamb or poultry and game birds. A cheese-seller surrounded by wooden tubs is cutting a wedge from a large wheel of cheese. There is also the sign for an oyster saloon, a popular type of American eatery before pollution destroyed most of the oyster beds around Manhattan and Long Island. The only hint of packaging and preserved food are the cans lining the rear shelves of the fruit store on the left.

Markham was an active member of the Brooklyn art community for his entire career. Born in Vermont, he came to New York City in 1852 to work for a manufacturing firm. When the American Exchange Bank failed in 1857 and he lost his job, he began to earn a living by painting photographs with oils, and he later served as an illustrator in the Civil War. After the war, he exhibited regularly at the Brooklyn Art Association, and sporadically at the National Academy of Design. He was a founder of the Brooklyn Art Club.

The impact of old-world European customs on urban market places is vividly portrayed by Elisha Kent Kane Wetherill, Joseph Wolins, and Frank di Gioia. All create sympathetic portraits of life on the Lower East Side of Manhattan. During the early years of the twentieth century, this area became densely populated by newly arrived immigrants who quickly established small-scale, family-run enterprises which perpetuated European habits of merchandising.

Elisha Kent Kane Wetherill graduated from the University of Pennsylvania in 1895 and began further studies at the Pennsylvania Academy. Here, he adopted an artistic interest in urban life, a tradition at the academy that had been begun by Thomas Eakins. Wetherill went on to study in Paris in the studios of Laurens and Whistler and eventually settled in New York City, where he created a number of works depicting life in the row houses of the Lower East Side. This may well be the setting for *Sidewalk Market*. In its small scale, careful tonalities, free brushwork and horizontal composition, it is very similar to the small shopfront sketches painted by Whistler in the 1890s.

Despite Wetherill's primary concern with artistic harmonies, one can still make out details of the marketplace. Bananas hang at the door, while a variety of bottles are in the window. Tables on the sidewalk hold an assortment of produce. There are people at both edges of the painting, suggesting the active street life of most urban centers. The display and

59

60

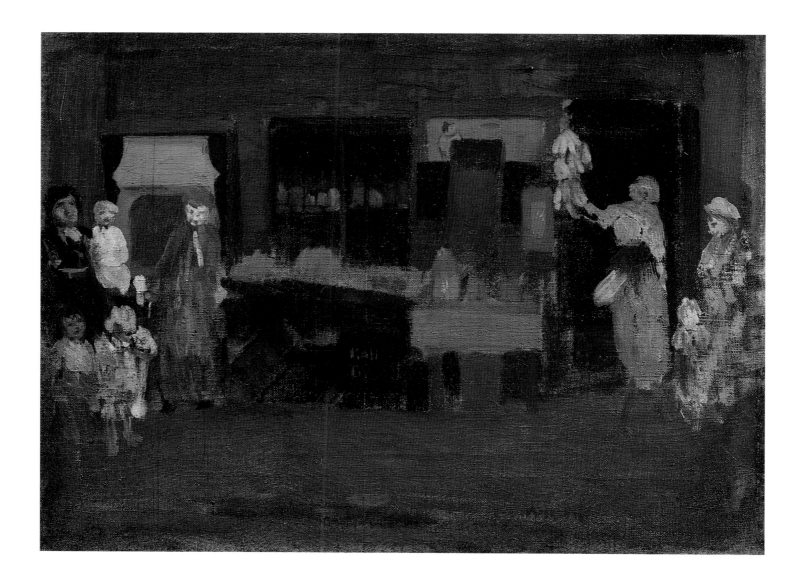

E.K.K. Wetherill
(1874–1929)
*Sidewalk Market*
1900
oil on canvas
9 x 12 "
Courtesy Richard York Gallery, New York

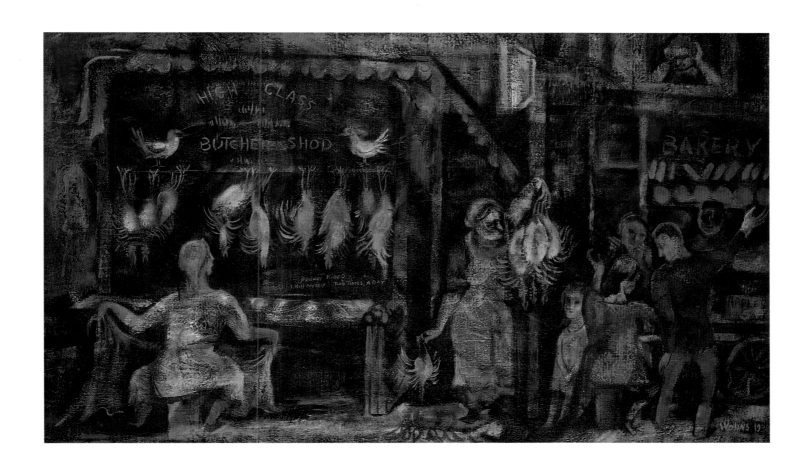

61

Joseph Wolins
(b. 1915)
*High Class Butcher Shop*
1938
oil on canvas
24 x 40 "
Courtesy Michael Rosenfeld Gallery,
New York

purchase of food was a part of this daily life, and permitted a continuous neighborly interchange between consumer and merchant.

Joseph Wolins's *High Class Butcher Shop*, completed in 1938, portrays the typical outdoor butcher shops of that day. Wolins attended the National Academy of Design, receiving instruction from Gifford Beal and Leon Kroll, and undertook a tour of Europe studying the work of the Italian masters Piero della Francesca and Andrea Mantegna and exploring the broad range of modern European painting. An imaginative artist, Wolins balances the stylized treatment of figures with flat, dynamic, abstract form. His keen eye for details and compassion for ordinary people involved in daily activity have enabled him to capture the facts and the spirit of the family-run shops of the immigrants on the streets of lower Manhattan.

This is a family effort and as the day begins, the daughter prepares to cover the outside display area as her mother brings out the poultry. The hand-lettered sign tells us this is a "high class butcher shop," a point the proprietor further emphasizes by adding the fact that the chickens are "freshly killed—I kill them myself two times a day." A similar routine is enacted at the bakery next door, as that family lays out its goods.

The particular merchandise that is proffered in these street markets, the language spoken by the merchants and their customers, and the decorum of these exchanges all define the particular ethnic group that makes up a neighborhood. Frank di Gioia recreates one of these city pockets. He was born in Italy in 1900 and emigrated to the United States as a young boy, growing up in an area so densely populated with other Italian immigrants that it came to be known as Little Italy. This neighborhood is the subject of his 1940–1941 painting, *Fish Market*. Its style reflects the influence of his teachers, Walt Kuhn and John Sloan, both of whom also

created epigrammatic summaries of the people they observed.

*Fish Market* recalls the animated existence of those who participated in New York City's wharf activity. Di Gioia paints a rich mosaic of individuals, packed between the bins and the display tables, the scales and the sinks whose facial expressions and explicit gestures reveal their role as either bargainer or merchant. A dynamic design of form and color conveys the intensity with which the all-important purchase of food was conducted during these Depression years.

Several narratives are presented simultaneously amidst the bustling fish market. To the lower right, a wholesaler makes his deal on a selection while immediately behind an older woman singles out an appropriate fish for her evening meal. In the background, workers carry in trays of the day's catch as two groups of customers continue to make their choices in the right foreground: a fussy wife, with her husband, who carefully scrutinizes the scale; and a mother who, with her child, is giving serious attention to the transaction.

The purchasing of food in this market setting depends on direct transactions between the vendor and the buyer. Gradually, the intimate nature of these exchanges has been replaced in the twentieth century by large and less personal enterprises. Most food purchases today take place in a store that is owned, stocked, and run by a central headquarters far from the store's location. Further, those purchases are governed by media advertising instead of conversation, and mass-production instead of family effort.

*Sloan's Supermarket* by Richard Estes depicts an increasingly familiar sight for urban dwellers. The supermarket has replaced the small neighborhood market and the neighborly experience of shopping. The activity of purchasing food in a supermarket can be conducted very efficiently without any verbal exchange. The shopper fills a cart with choices of foods that are stored in easy-to-reach displays. Printed advertising provides most of the information about the food items being selected. At the end of the journey through the

62

aisles, the shopper passes through a checkout line where the premarked prices are tabulated.

By concentrating on the exterior of the supermarket, Estes focuses on the role of the supermarket within the larger social context of contemporary urban and suburban living. The painting reflects the impersonality that now prevails in the many circumstances that once provided an opportunity for personal exchange: transportation, architecture, and the marketing of food.

On a formal level, layers of space are organized by the repetitive use of the color yellow, beginning with the traffic marker at the lower edge of the painting and continuing with the taxicab, the labels on the Scotch bottles in the advertisement on the city bus, and the ceramic wall of Sloan's Supermarket itself. This planar arrangement of space is enriched by the backward and forward thrust of the fire escape.

Estes's work is an example of photo-realism, also called super-realism and new realism, which came into prominence in the late 1960s. This movement is characterized by new techniques of painting which allowed the artists to accumulate unprecedented quantities of visual data and to present these in a neutral manner. Although the particular methods varied from artist to artist, most relied on the camera to translate the complexity of the three-dimensional world onto a two-dimensional surface. The factual nature of their products appears uncontestable.

63

64

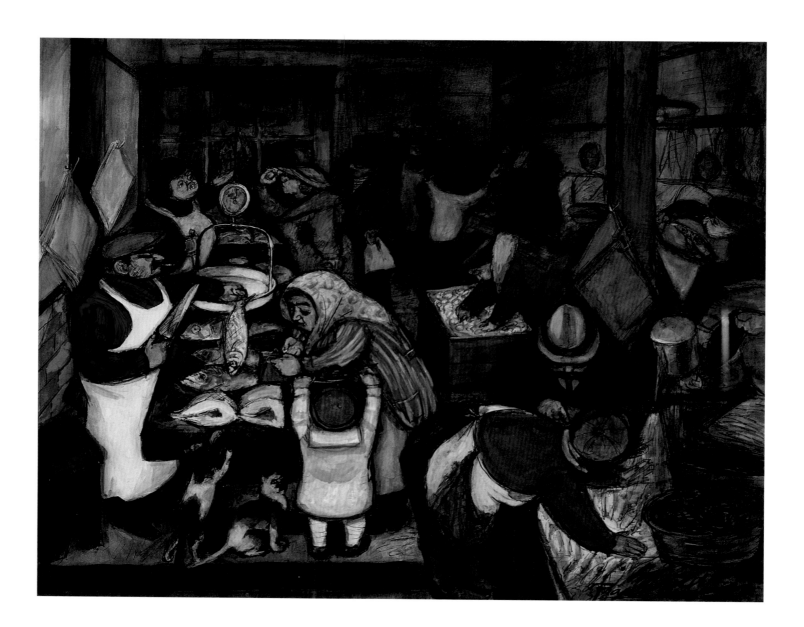

Frank di Gioia
(b. 1900)
*Fish Market*
1940–41
Gouache on paper
27 1/4 x 31 1/4"
Courtesy University of Arizona
Museum of Art, Tuscon
Gift of C. Leonard Pfeiffer

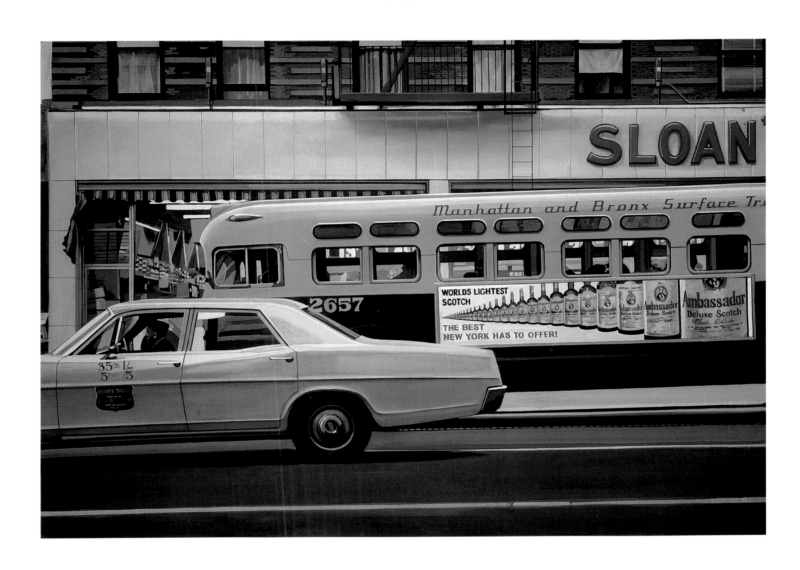

65

Richard Estes
(b. 1936)
*Sloan's Supermarket*
1968
Oil on canvas
24 x 33 3/4"
Courtesy Citibank Art Collection, New York

# Confections

It is said that the physical sensation of sweetness is connected to the pleasure zone in the brain. As such, it explains the universal association of sweets and rewards. Since the late seventeenth century, sweets have been reserved both for the culmination of a meal, desired and savored after the more nourishing foods have been consumed, and to mark a special occasion.

American cooks have always been proud of their cakes. *American Cookery*, the first national cookbook, published in 1796, demonstrates the celebratory and special nature of cake, including such recipes as those for Independence Cake, Election Cake, and Federal Cake. The importance of cake was also asserted by Catherine Beecher and Harriet Beecher Stowe, who wrote that American women made much better cake than bread. Perhaps because of their humble and universal nature in the American diet, pies rarely appear in nineteenth-century paintings; cakes, on the other hand, abound.

Of the various meals in nineteenth-century America, dinner was the most sumptuous and that which was most likely to include guests. When one looks for artistic inspiration in the various courses, soup does not have much visual appeal, and the main courses of gravied roasts, hefty joints or whole baked fish might be lacking in "delicacy." Thus, the large majority of table-top still lifes in the nineteenth century depict the dessert courses, usually cakes or fruit. In *Cake and Champagne*, 1865, by John Francis, the cake is accompanied by several different types of cookies, another sweet with great appeal to Americans. "Cookie" is an American adaptation of the Dutch word for "little cake."

Champagne was introduced to the Anglo-American palette by Charles II when he returned from continental exile in 1660. It did not become effervescent until several decades later, traditionally at the hands of the blind cellar-master, Dom Perignon. In the mid-nineteenth century champagne was still a sweet wine and thus popular with desserts. Designed to whet the appetite, dessert still lifes such as Francis's, promise rich rewards at meal's end. Then, as now, cake was a special treat, and champagne was an expensive and glamorous accompaniment.

Francis was well known, even celebrated, during his lifetime. As was the fate of his fellow nineteenth-century still-life painters, however, his reputation and work slipped into total obscurity after his death. A discovery and reappraisal of his art began only in the mid-twentieth century.

Born in Philadelphia, Francis was the son of French immigrants, but he evidently had little inclination for city life. What permanent homes he had were in the small towns in eastern Pennsylvania. It is not known if he received any training but, following the lead of many artists in the first half of the nineteenth century, he became an itinerant portrait and still-life painter. He established set compositions, and, probably, set prices that were repeated with small variations over much of his career. Selling to a disparate group of people on the road, he had little need to be concerned over so many near-copies that challenged any concept of originality.

Francis's smallest works consist of several pieces of fruit on a table. His most elaborate include all manner of fruit with cake, nuts, cheese, and crackers scattered over a linen-covered table top. Punctuated about are white or blue porcelain pitchers, dark green wine or champagne bottles, a cake stand and both tall and short wine glasses. There is no attempt at a *trompe l'oeil* effect, but a rather colorful, picturesque grouping emerges displaying the kinds of exotic delicacies that proper Victorians considered suitable for the last courses of a classic, formal dinner.

The table settings are not complete, as the kinds of food he portrays seldom appeared all at once, and the one or two knives or spoons are placed for artistic design rather than for use. At large nineteenth-century dinners, the main course was followed by salad. Then there might be a cheese course, followed by a sweet, then a fruit course and finally a selection of nuts, all accompanied by appropriate wines. At less grandiose occasions, the main course might be followed by one or two of the final courses. Thus, Francis's largest compositions, which incorporate elements from all these possibilities, were appropriately suggestive for both large and small dinners.

Sweets have always been considered luxuries. Because they are an inessential food, their denial is an effective symbol of economic deprivation. It is in this capacity that sweets appear in *Desire* by Mervin Jules. The universal desire for sugar establishes empathy between the viewer and the subject, a young woman who yearns for the taste of a confection displayed in a bakery window. Her glance conveys a longing that exceeds the moment; it suggests the multiple

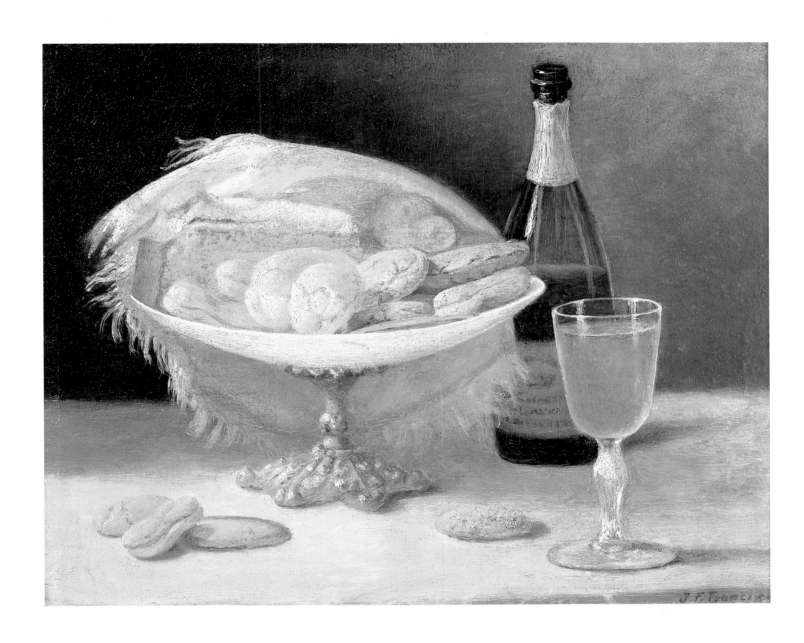

69

John Francis
(1808–1886)
*Cake and Champagne*
1865
Oil on canvas
11 1/2 x 14"
Courtesy Gerold Wunderlich & Co.,
New York

70

Mervin Jules
(b. 1912)
*Desire*
c. 1940
Oil on board
8 x 9 1/2"
Courtesy University of Arizona
Museum of Art, Tucson
Gift of C. Leonard Pfeiffer

yearnings in her life. She is a victim of the Depression, and her unfulfilled wishes represent the plight of many individuals in the 1930s.

Jules, a student of Thomas Hart Benton's at the Art Students League in New York, exhibited frequently at the ACA Gallery, an establishment founded by Herman Baron in 1931 that represented primarily artists who created socially conscious art. Jules concentrated on portraying the disillusioned and the disenfranchised, all victims of the Great Depression. In his painting, he interprets the lives and activities of anonymous people. By portraying specific episodes, he comments on the human condition in general. Jules believed that simple people convey great truths about the hopes, dreams, illusions, and disappointments of humanity as a whole. *Desire* provides an example of the effectiveness of this work. The viewer is moved to offer the cake, open the bakery door, and think about the people in need.

During the twentieth century the availability of sugar shifts from deprivation to glut. This change bears little relationship to its nutritive function. Since it provides an important source of energy, it once was an adaptive, instinctive craving. It became maladaptive only after the techniques for growing sugar cane and beet sugar were improved, making sugar available in unprecedented quantities. In the contemporary American diet, sugar is not merely consumed at dessert time; it is found in cereals, sauces, canned vegetables, drinks, and snacks. As a result, sugar today is responsible for many of the health problems of the nation.

Early in the 1960s, Wayne Thiebaud began to paint the items found in the haunts of individuals living in typical contemporary urban environments. These objects and foodstuffs were of interest not merely for their ability to expose the character of the era, but also for their formal qualities. Paying particular attention to geometry, Thiebaud painted objects which had simple, regular shapes such as the triangular pie slice and the circular or elliptical (depending on the perspective) plate. Although still lifes of dessert items are part of a long historic tradition, those of bakery cakes, gumball machines, and cafeteria foods are not. The novelty of the subject matter freed Thiebaud from the influence of art history and allowed him to record representative artifacts of contemporary American life and social custom. In his words, "I try to find things which I feel have been over-

looked, maybe a lollipop tree has not seemed like a thing worth painting because of its banal reference . . . more likely, it has previously been automatically rejected because it is not common enough."

*Pie Counter* of 1963 is a characteristic choice of subject for Thiebaud, not only for its allusions to a specific food type, but also because the counter of pies represents a found composition whose arrangement was dictated by its social function. Thiebaud describes his fascination with food displays: "I'm interested in foods generally which have been fooled with ritualistically, displays contrived and arranged in certain ways to tempt us, or to seduce us, or to religiously transcend us."

In *Pie Counter*, the pies and cakes are neatly laid out in a vision of abundant redundancy, suggesting that the origin of the food is in a factory and not in the kitchen, and that it was made by a professional baker, not an amateur. The effect of infinite repetition is enhanced by the painter's studied attention to the uniform consistency of each slice and by the casual cropping of the confectionery counter. Thiebaud's high vantage point is in part a faithful recreation of the customer's relation to the pie counter, but it also creates an uninterrupted vista more common to landscape scenes than to still-life paintings. The deep diagonal extension of space is wittily echoed by the edges of the confections on the plates. Also in the manner of modernist painting since Cézanne, Thiebaud has successfully integrated an activated surface of paint with a believable illusion of space.

Thiebaud's paintings are dialogues with the art of the past. In *Pie Counter*, as in all of his works, the implied comparisons allow a fresh approach to mundane fare—in this case the popularity of frivolous foods. Their repetition conveys the predictable nature of the contemporary eating experience.

Claes Oldenburg concentrates on the qualities of an individual slice of pie. He arrived at the Pop-art style by way of the experimental theater encouraged by, among others, John Cage. These experiments gave birth to a new art form, christened "Happening" by its inventor, Allan Kaprow, in 1959. Happenings were staged slices of life that could be either choreographed or chaotic assortments of simultaneous but unrelated activities performed by one or many participants. Oldenburg wrote and directed Happenings, for which he created his own props, environments, and costumes.

71

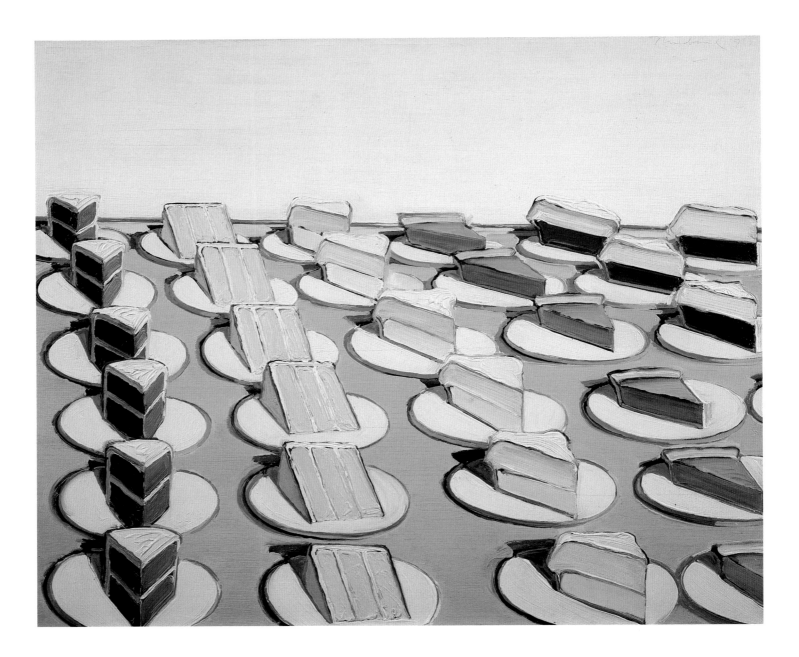

72

Wayne Thiebaud
(b. 1920)
*Pie Counter*
1963
Oil on canvas
30 x 36″
Courtesy Whitney Museum of American Art, New York;
Purchase, with funds from the
Larry Aldrich Foundation Fund 64.11

73

Claes Oldenburg
(b. 1929)
*Lemon Meringue Pie*
1961
Painted plaster
5 x 11 1/2 x 13 1/2″
Courtesy Helen Elizabeth Hill Trust

Oldenburg's first use of common objects and food as subjects can be traced to *The Store*, a work he created for the Martha Jackson Gallery's 1961 exhibition entitled "Environments, Selections, Space." *The Store* was an environment filled with the artist's plaster recreations of consumer goods found in the neighborhood stores. Brightly colored and expressionistically painted cakes, candy, dresses, slips, tennis shoes, and fragments of current advertisements were displayed in chaotic splendor. After the show closed, *The Store* could be seen in the artist's studio at 107 East Second Street. There Oldenburg acted as proprietor, selling the art in front and retiring to a back workroom to replenish his stock. Oldenburg's first large-scale soft sculptures appear in a third version, at the Green Gallery in 1962. All three versions convey the artist's amused acceptance of the confused vitality of urban life in mid-twentieth century America.

Although Oldenburg discarded the human figure as the vehicle for his art early in his career, *Lemon Meringue Pie*, like the traditional still life, evokes the presence of human participants—in this case, the consumer of the pie. A gourmand rather than a gourmet, this person desires all the extremes that a dessert can offer: sweetness, smoothness, bright color, and a very large helping. The garish surface and the curving, imperfect form indicate that, unlike its actual counterpart, this slice of pie is not mass-produced. A humorous metamorphosis has taken place between the cream pies and the plaster pies, of soft material into hard, edible into non-edible, and the inviting into the distasteful. Part of the surprise lies in discovering how similar actual pie-making is to plaster pie-making, and, of course, how like child's play is Oldenburg's art. As a work of art *Lemon Meringue Pie* is invested with an exuberance that is reflected in the handling of the paint and the undulating surfaces. As a thematic depiction it is a satire on popular food tastes.

Oldenburg often chose objects verging on obsolescence because they could draw on the memories of his audience with special nostalgia and affection. Food, especially the "junk food" to which America was rapidly becoming addicted, was a favorite subject because it conjures up a vision of a diner counter, with its formica surface and the cold glow of overhead lights. This slice of pie is a portrait of a particular moment in American life.

Robert Watts was a member of Fluxus, which was an international idea and event-oriented group of artists active in

the 1950s. Their philosophical precedents can be traced to Marcel Duchamp and John Cage, whose aesthetics of chance and belief in an egoless art was a great influence on the movement. In the 1960s, Watts applied these qualities to his Pop art pieces. At this time he selected banal examples of American food as subjects for his sculpture. He took part in the "Supermarket Show" of Pop art at the Castelli Gallery in 1964, where he exhibited plaster casts of loaves of white bread arranged on a wooden supermarket display shelf, and aluminum-cast cartons of eggs.

Watts characteristically remained detached from his subjects and believed that this detachment was more significant than the choice of object. For instance, *Chocolate Creme Pie* of 1963, like Oldenburg's *Lemon Meringue Pie* and Thiebaud's *Pie Counter*, is taken out of its anonymous existence and placed within the context of art. This unexpected transformation from a soft, edible object with a temporary existence into a hard and permanent art object invests it with new significance. Because its surface is neither sensuous nor expressive, this pie slice echoes the character of mass-production. Watts intentionally excludes art historical reference, aesthetic analysis, and visual interest. He maintains that his interest in food originates "in the TV dinner idea," suggesting that his cast-aluminum sculptures were based on a fascination with packaging, for food cast in aluminum is related to food encased in aluminum foil.

Because Watts's objectivity discourages easy interpretation, it is left to the viewer to ponder if this work is a criticism of popular taste or a comment on the manner of preserving the freshness of today's food.

Mark Kostabi reflects the intensification of the ruthlessness of business practices and the acceleration of marketing activities that have taken place during the twenty-five years that separate *Mallowmark* from Claes Oldenburg's *Lemon Meringue Pie*. This theme is reflected in one of his most famous works of art which takes the form of an immediately recognizable advertisement for a credit card. The words "American Expressionism" are written across its surface. The addition of the last six letters unites two uneasy partners—big business and art.

The confluence applies best to Kostabi's own art activities. He is as devoted to how a painting is promoted, priced, displayed, critiqued, and sold as to the qualities of the painting itself. The least expected of these activities is allo-

74

75

Robert Watts
(1929–1989)
*Chocolate Creme Pie*
1964
Aluminum
2 1/2 x 5 x 5"
Courtesy Jane Voorhees Zimmerli Art Museum,
Rutgers, The State University of New Jersey,
Gift of Bernard and Florence Galkin

76

Pat Lasch
(b. 1944)
*Black Cake*
1981
Cast bronze
6 x 6 x 6″
Courtesy Marilyn Pearl Gallery, New York

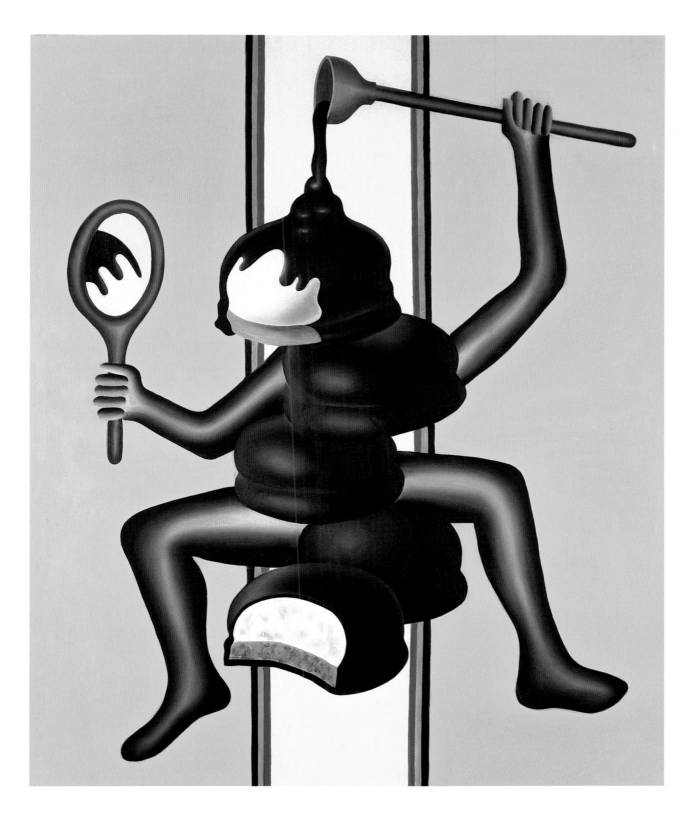

Mark Kostabi
(b. 1960)
*Mallomark (For Martina Batan)*
1987
Oil on canvas
90 x 68"
Courtesy Greca International Corporation New York

cated to others. *Mallomark*, for instance, may not have been painted by Kostabi, although it bears his signature. His employment of six assistants is justified by the slick surfaces of his paintings and the extraordinary demand for his work. (He purports to have been included in 450 East Village exhibitions alone.) Kostabi's working techniques reflect those of an American Express-like organization. With behavior typical of a CEO, he hires assistants to conceive ideas for his paintings. Those ideas which are approved are transformed into working drawings by a different assistant, and a third executes the paintings. Freelance writers are responsible for the witty titles which have come to be referred to as "Kostabisms" (such as the addition of the letter 'K' which makes the cookie, Mallomar, refer to the artist's first name). The roles Kostabi seems least likely to allocate to others are the marketing and promotion of his inventory, some fifteen hundred canvases in 1988. He says he has considered adopting "et" as his middle name, Mark-et Kostabi.

At the age of 28, Kostabi has inspired an equal measure of outrage and praise. His detractors accuse him of being a shameless opportunist, an avaricious maniac, a cynical shyster. Kostabi makes no attempt to deny these accusations; he sights as his major influences Andrew Carnegie and King Midas. But others have credited him with creating a compelling, if distressing, document of a society choked by the products of its own inventiveness, efficiency, and abundance. Beyond exploiting the methodology of the business world, Kostabi's paintings reflect its dehumanizing effects. They depict faceless humanoids who conduct their affairs through a multifarious conduit of touch-tone telephones, walkman radios, computers, televisions, digital watches, electrical outlets, and toilet plungers. This is a cartoon version of a mind-stunting, soul-numbing workplace. As Kostabi himself recognizes, "There may be humor in the work, but it's no joke."

*Mallomark* functions precisely in the zone between a smile and a cringe. The addition of insect legs to this familiar cookie is a reminder that it did not take an artist to transform it into a monster; many nutritionists would suggest it has been a monstrosity all along.

Mallomars are a symbol of the deceit that pervades the marketplace, qualities that Kostabi is accused of applying to the field of art. But Kostabi suggests that the brash young cynic that he has been accused of being is just an artful persona. The real Mark Kostabi raises questions and urges the viewer to confront unsettling issues regarding contemporary society.

Pat Lasch explores the symbolism of the cake and its role in the ritual of special occasions. Her work reminds the viewer that the birthday celebrant blows out one candle for each year expended, and a bride and groom enter their marital state by making the first cut into the wedding cake holding the knife together. In each case, the cake is large, intended to be eaten as a group activity, and all who partake participate in the honored occasion. The cake's lavish decoration suggests the special nature of the event and enhances the festive mood. Cakes are not only edible treats, they are the very embodiment of a blessed state of being.

In a shocking transformation, Lasch creates artificial black cakes, freak cakes, demented cakes, seemingly contrived by purveyors of evil to wreak death and disaster upon the recipients. Black cakes are tools of witchcraft, black magic, voodoo. They bode evil. Despite their filigree and roses, they have a fearsome presence. In Lasch's work, not only is this food corrupt, but all the joyous occasions with which cakes are associated are tainted as well. She has issued a bitter indictment of society.

Lasch's grandmother was married in a black wedding dress. The symbolism implicit in this color reversal was adopted by her granddaughter. In Lasch's sculptures, elements of celebration are transformed into occasions for mourning, innocence becomes laden with evil and purity deteriorates into corruption.

Lasch's father was a highly skilled pastry baker. His elaborate cake-decorating techniques were taught to his daughter, who reenacts his kitchen methods in her studio. What he created in sugar, she fashions in acrylic paint applied to wood and paper forms. The baker's festive multi-tiered white and pink creations are blackened by his artist daughter. They become, like a black wedding dress, an unsettling reminder of the bitter aspects of life's sweetest occasions.

Lasch is Catholic. Each art-cake, set on its pedestal, assumes the ritualistic formality of her religion. Her cakes are presented as iconic forms elevated beyond the status of the everyday world to be used in some unnamed sacrament.

# Packed for Travel

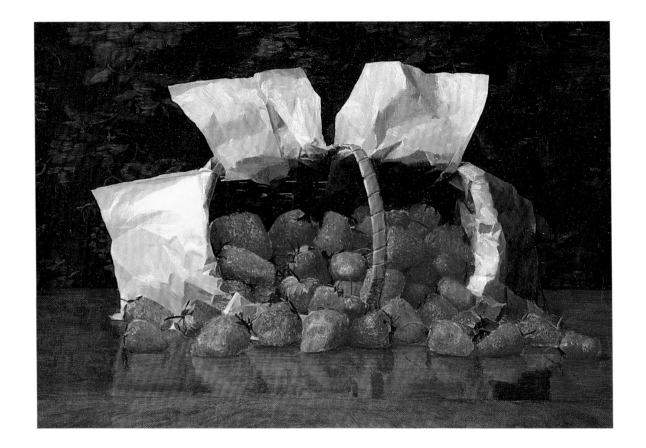

80

William McCloskey
(1859–1941)
*Strawberries*
1889
Oil on canvas
12 x 16"
Courtesy Daniel J. Terra Collection,
Terra Museum American Art, Chicago

Andy Warhol
(1928–1988)
*Heinz 57 Tomato Ketchup*
*Del Monte Freestone Peach Halves*
1964
silkscreen on wood
15 x 12 x 9 1/2"
Courtesy The Edith C. Blum Art Institute,
Bard College

After the middle of the nineteenth century, advances in technology brought new and exotic foodstuffs into the American home. Packaging and transportation of food improved so rapidly that expensive gastronomic rarities of the first half of the century became common fare by the end. Railroads transported lobsters to inland cities, while steamships carried pineapples, lemons, oranges, coconuts, and bananas north from Florida. At the same time, the life of perishable foods was greatly extended through the introduction of refrigeration in the railroad car.

Food had to be protected during the long journey from its place of origin to the marketplace. Canning, paper bags, and cardboard containers were all developed after the Civil War as an offshoot of the expansion of the railroads. Since that time, food has appeared in stores boxed, vacuum-packed, cellophaned, or sealed in sterilized containers. Thus hidden from the reach of the senses, distributors have been forced to rely on package design to provide information about the contents and appeal to the consumer. The functional design of packing material soon became transformed into the aesthetic and psychological design of packaging. Packaged goods carry brand names and a personality which is contrived for them by advertisers and market analysts. Some products become stars, foods known nationally by their surface appearance.

William John McCloskey provides an example of the manner in which packing developed in the nineteenth century. Strawberries were sold in pint and quart baskets lined with paper. The advertiser's use of packaging is not yet in evidence in this painting. Although he includes the paper liner, McCloskey uses a more decorative, handmade basket than the factory-made versions such as those that appear in the paintings of Levi Wells Prentice. Even with so few artifacts,

McCloskey creates the impression that these strawberries are an imported luxury. They are placed on a highly polished mahogany tabletop with gilt and dark green wall covering in the background. The functional paper liner forms an important artistic service by setting off and surrounding the strawberries with strong contrasts in texture, color, and form.

Strawberries were extremely popular on the New York market. In 1847 one train alone delivered over 80,000 baskets. By 1855, it was said that more strawberries were sold in New York City than anywhere else in the world. Railroads had extended the season from one month to four, bringing the first crops from South Carolina and Georgia. McCloskey's container is a commercial reminder of this transportation network, and a generational successor to the white and gilt-edged porcelain bowls in Francis's paintings, and the Parian basket of strawberries in Roesen's composition.

Born in Philadelphia, McCloskey studied with Christian Schussele and Thomas Eakins at the Pennsylvania Academy in the 1870s. He was married in Denver in 1883, and the following year settled in Los Angeles. On the west coast, McCloskey worked primarily as a portraitist, but he and his wife, Alberta Binford, a fellow artist and student of William Merritt Chase, led a very peripatetic life. They spent time in San Francisco and Salt Lake City as well as in England and France. On the east coast, McCloskey exhibited still lifes, becoming most highly acclaimed for his simple, but striking, arrangements of oranges and lemons, some still with the tissue-paper wrappings, packed for shipment.

Andy Warhol's matter-of-fact portrayals of commercial products became the rallying cry of a generation of artists, renegades who shared his penchant for selecting subject matter once deemed unworthy of fine art. They questioned the necessity of craftsmanship, the relevance of established standards of beauty, and the ideal of individuality.

This revolution, however, was not confined to the artists' studios. The techniques employed by the Pop artists mirrored those used in the marketing and manufacturing of non-art objects. Warhol, in creating the painting of a Campbell's Soup can, for instance, paralleled the methods that had come to characterize food production. He "manufactured" multiple images in a "factory" setting in which "workers" contributed the labor. Impersonal assembly-line techniques and machine methods supplanted craftsmanship; rapidity and uniformity became the measure of accomplishment; and profit became the explicit goal of the activity.

Warhol, with his art of repetition, monotony, and exasperating objectivity, became a critic of contemporary American life, itself mechanical, monotonous, and repetitive. He recognized that packaging is what distinguishes one consumer product from another, one celebrity from the next, or one human being from another. Stardom and celebrity are the real subjects of Warhol's portraits of movie stars, famous people, and the F.B.I.'s "most wanted men," of the images of Coca-Cola, Del Monte Peaches, Heinz Ketchup and Campbell's Soup, of the car crashes, and the electric chairs. All of these items share a ubiquitous familiarity. Warhol recreates the surface, analogous to the packaging of consumer goods. Because the surface is so thin, it emphasizes rather than conceals the emptiness beneath.

In 1964 Warhol exhibited plywood boxes silkscreened with the actual packaging designs of consumer products. These boxes of Brillo, Del Monte Peach Halves and Heinz Tomato Ketchup were stacked as they would be in supermarket aisles and storerooms. Interpretations of Warhol's intentions ranged from a celebration of the commonplace to social criticism of the highest order. Warhol, in characteristic fashion, insisted, "Just look at the surface of my paintings and films and me and there I am. There's nothing behind it." (Patrick S. Smith, *Andy Warhol's Art and Films*, UMI Research Press, Ann Arbor, Michigan, 1986, 129.) The nothingness behind his surface relates to his statement, "Nothing is perfect," in which he deliberately turns one of the clichés of human endeavor inside-out. He did not mean to say that everything is flawed, but instead that nothingness is a perfect state. The boxes of Heinz Tomato Ketchup and the Del Monte Freestone Peach Halves attempt this perfect state: Warhol presents the empty boxes as evidence of what is not there.

Warhol's famous paintings of Campbell's Soup cans provide the style, subject, and format of *Not Warhol (Campbell's Soup)* by Michael Bidlo, whose career as an artist rests on the process of meticulously replicating the work of other artists. The artists he chooses to mimic are revolutionary figures who have initiated new and historic art styles. In each case, Bidlo is mute and impassive, reproducing paintings that have already been included in the annals of art history. The meaning that emerges from this act of mimicry depends on the work of art reproduced. When Bidlo duplicated a painting by Jackson Pollock, he satirized the elevated status of the mark made by the master's hand. When Julian Schnabel's work was Bidlo's focus, he raised questions about taste, trends, and market values. Bidlo's recreation of Man Ray's work provoked questions about the differentiation of art from non-art objects.

In reworking Warhol, Bidlo is wisecracking the joker. He is copying an artist who appropriated machine methods of production for the purpose of suppressing expressive devices. Bidlo replicated Warhol's replication of the Campbell's Soup can, removing the last element of originality from this work of art and commenting on the predictable banality of a diet that consists of mass-produced foods.

But recreating the appearance of the original work reintroduces the issue of craftsmanship, an element alien to Warhol's work. Bidlo's skill in mimicking the original work of art is its measure of value. The viewer scrutinizes the surface, searching for any differences between it and the work of art being duplicated. The familiarity of the audience with his model is, therefore, essential to Bidlo's purpose. Because Warhol was an art-world celebrity and Campbell's Soup is a star among foods, Bidlo is riding on their media stature, and can flaunt both his plagiarist's intentions and his counterfeiting skills. Only he knows if his is an act of reverence or mockery.

84

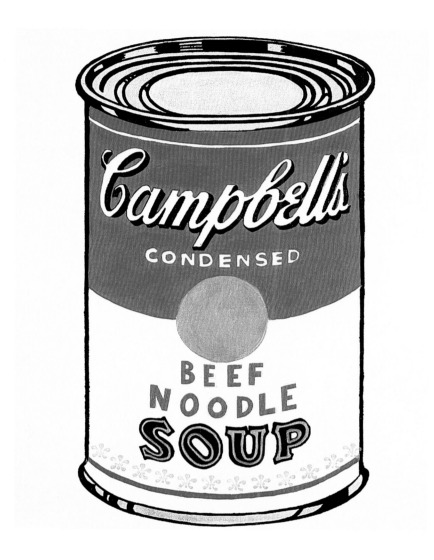

Michael Bidlo
(b. 1953)
Not Warhol
*(Campbell's Soup)*
1984–86
Silkscreen, acrylic and
metallic paint on canvas
20 x 16 x 1/2"
Courtesy the artist

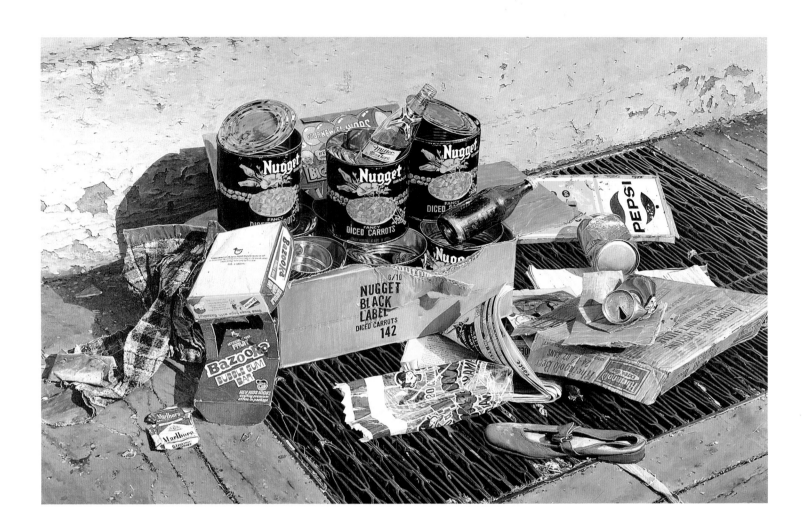

Idelle Weber
(b. 1932)
*Nugget - 1975, East 126th Street*
1975
Oil on linen
47 1/2 x 21"
Courtesy Martin and Rita Skyler

A similar ambiguity of intentions is evident in the work of Idelle Weber, who is known for her skill in recreating in paint the full complement of visual data that is recorded on a photograph. She works methodically and nonjudgmentally, avoiding interpretation and generalization. Like the super realists of the 1970s with whom she is associated, Weber aims at complete accuracy in her depiction. No detail is omitted.

The unprecedented factuality of her canvases makes the work seem as compelling and as verifiable as a scientific fact. For this reason, her depictions of urban debris are perceived as evidence of the habits of the people and the state of the environment at the time the work was created. Weber has recorded the end product of the contemporary food chain. Her subjects, instead of originating with the planting of the seed, the traditional initiation of the food cycle, begin in a processing and packaging plant. Their remains take the form of cellophane, Styrofoam, plastic, aluminum, and cardboard. Rinds, pits, husks, peels, bones, and other natural by-products have all been removed long before the food items have reached the marketplace. Her work provides disturbing evidence of the proliferation of packaging and the crisis of waste that has ensued. Although Weber insists that she perceives the refuse of civilization as an aesthetic resource, rich in textures, colors, shadows, and highlights, it is difficult not to become aware of the careless nature of material consumption and the magnitude of non-edible material that is produced along with our food.

The quantity of waste products has not diminished in the decades since Weber created N*ugget-1975, East 126th Street*, but certain items in it have been discontinued, and the packaging designs of others have changed. Weber's paintings have come to acquire a nostalgic aura. This painting of empty lots, gutters, and waste bins provides an inventory of the objects people once selected, used, and discarded—a record of a bygone era.

86

# *Lunch Break*

The paintings in this section chart lunchtime experiences as they evolved during the nineteenth and twentieth centuries in tandem with shifts in the nation's economy and its primary methods of production. The character of lunchtime in the workplace has shifted, from a rural to an urban setting, from a leisurely to a rushed tempo, from homemade to commercial food, and from a social to a solitary activity.

Although it is said to have been painted specifically on the Mount farm in Stony Brook, Long Island, William Sidney Mount's *Farmers Nooning* of 1841 captures a familiar moment in the cycle of early nineteenth-century farm life. After a morning scything hay under the late summer sun, the field-workers are taking a lunch break in the shade of an apple tree. One of them conscientiously sharpens his blade. Two others rest while watching a young boy playfully tickle the ear of a fellow worker, a Black man who dozes in the heat of the full sun on a mound of fresh hay. Lunch is over, but its remains are still evident. On the left, a wooden bucket, the original lunch pail, is partially covered by a cloth, the handles of two knives sticking above the rim. On a napkin is another knife, used for opening clams, and in what appears to be a small pewter porringer lies an open clam. To the right is an earthenware jug, the type used for holding many kinds of liquid. Here, it might contain water, hard cider, perhaps even whiskey. It is a simple fare: the food has originated on the land on which it is eaten and it has been prepared by the women of the household. The entire food cycle occurs in one location, among people who are well acquainted.

Artistically, the striking contrast between light and shade is an effect that Mount consciously sought by working out-of-doors. In the 1850s, while reminiscing about *Farmers Nooning*, he recorded that he was "one of the first (artists) that painted directly from nature." Mount reproduced on the canvas the blue sky and atmospheric stillness of late summer days on Long Island, hot but nevertheless pleasant.

The scene captured the imagination of Jonathan Sturges, a partner in a New York dry-goods store and one of the early patrons of American artists. He liked the painting so much after he bought it that he commissioned another farm scene from Mount "in the same line" the following year. *Ringing the Pig* was the result of that commission.

Sturges was not alone in his appreciation of *Farmers Nooning*. Two prints were widely distributed. The first, illustrated here, was made by Alfred Jones, published in 1843 for members of the Apollo Association, and later reissued by G. Appleton. Joseph M. Gimbrede made the second for the July, 1845, issue of *Godey's Lady's Book*.

The painting recordes a daily occurrence for farmers, an image of rural America that had acquired, even by mid-century, a nostalgic allure for city-dwellers. *Farmers Nooning* memorializes an era that was quickly passing.

Born and raised on Long Island in a family of which several members turned to the arts as a vocation, Mount was one of the first students at the new National Academy of Design. During his career he recorded the everyday habits and customs of his lifelong neighbors in the Long Island countryside, and through his work he, more than any other nineteenth-century artist, made the portrayal of ordinary farm life an acceptable subject in American painting.

Joseph Hirsch also found inspiration in the moments that filled the lives of average people. The contrast between the paintings of Mount and Hirsch provides evidence of the radical changes in rural and urban society that occurred during the century that separates their work. Whereas Mount observes a pastoral life in which the means of production has not yet been mechanized and the workplace remains on the homestead, Hirsch records the look of an industrialized economy as it mobilizes in a war effort. Factory production altered irrevocably the nature of lunchtime because the workplace became separated from the home.

In Hirsch's *Editorial* it is World War II, and two men break for lunch in a day filled with labor for the cause. One takes a bite into a mammoth sandwich, while the other reads from

the editorial page. The times are tough, decisions must be made, and everyone has an opinion. Hirsch captures the editorial-page reader's inquiring look.

As in all of Hirsch's work, the viewer automatically identifies with the "everyman" quality of the figures. They are recognized as personas of ourselves, representatives of the unrelieved drudgery of the worker's existence which proceeds at a plodding pace, day by day, within the context of political turmoil and a succession of international debacles.

The son of a Philadelphia doctor, Hirsch's early training was at the Pennsylvania Museum School of Industrial Art, from 1928 to 1931, followed by a two-month stint with George Luks in New York. Luks taught Hirsch to capture the vitality of life and the immediacy of moment, and thereafter his figure groups, depicting various segments of contemporary society, became convincing arrangements of daily activity, men who work and eat, sweat and care.

*Editorial* was completed in 1942 as the war effort was gearing up. It was followed by a series of other war-related subjects that Hirsch painted as a member of the Artists Division, documenting the activities of war personnel in the field. Among these, *Till We Meet Again* was the most widely reproduced war bond poster painting of World War II.

In his depictions of men involved in the war effort, whether at the front or in a support capacity, Hirsch's penetrating eye captures the larger context implied by simple action. One aspect of that context in *Editorial* is that lunch is no longer eaten in a family setting. Women were not at home to prepare meals: they were out working to support the war effort, filling the jobs vacated by men at the front. Instead of waiting with a hot meal at the sound of the noon chimes, the women often packed a hastily made sandwich such as the one the man with the goggles on his head is about to eat. The manner in which daytime meals were taken marked the transformation of the sociology of family life.

The industrialization of the workplace also altered the nature of the food eaten. This lifestyle required that lunch foods be packed easily and eaten on the run. The American cuisine changed to accommodate these circumstances, and new fast-food lunch counters were established to serve the needs of the workers. They are both represented in the painting *At Lunch* by Isabel Bishop. The women who a generation earlier prepared the noonday meal at home are presented here in their new capacity as "working girls." They are shown perched on stools at counters filled with the chatter and movement of a busy city lunch place. Bishop searched for a way to capture in paint the two quintessential American characteristics that she observed from her New York City studio—dynamism and the ever-present possibilities of change in American society. Bishop's working women are young, dynamic, and independent, and their freedom is communicated by their postures, gestures, and easy nonchalance. The atmospheric density and rich surface markings create a sensation of the tempo and transience of their lives.

*At Lunch* is a realistic portrayal of a society in flux. Bishop is one of very few American painters to accept young working women as the protagonists in her painted dramas. Seen beside Hirsch's *Editorial*, Bishop's image of urban women marks a great change in American social mores. Hirsch depicts two factory workers seated outside eating the lunch that we suspect their wives packed for them that morning. The relationship to traditional values of homemade food and the non-urban circumstances of their lunch establish a continuity between these men and Mount's agricultural workers pausing for a meal eaten in the field. In contrast, Bishop makes no reference to the past. Her subject is the women who are part of an industrialized work force crowded indoors, and, as far as we can tell, their lunching is no less fast-paced than their working. They appear to thrive in this exhilarating environment.

Until her death in 1987, Bishop traveled daily from her home in Riverdale, New York, to her studio at Union Square. Her fellow subway passengers and the spectacle of urban life in Union Square Park, visible to the artist from the window of her studio, provided her with a lifetime of subjects: people walking, reading a paper, drinking from a water fountain, waiting, and talking with companions.

89

90

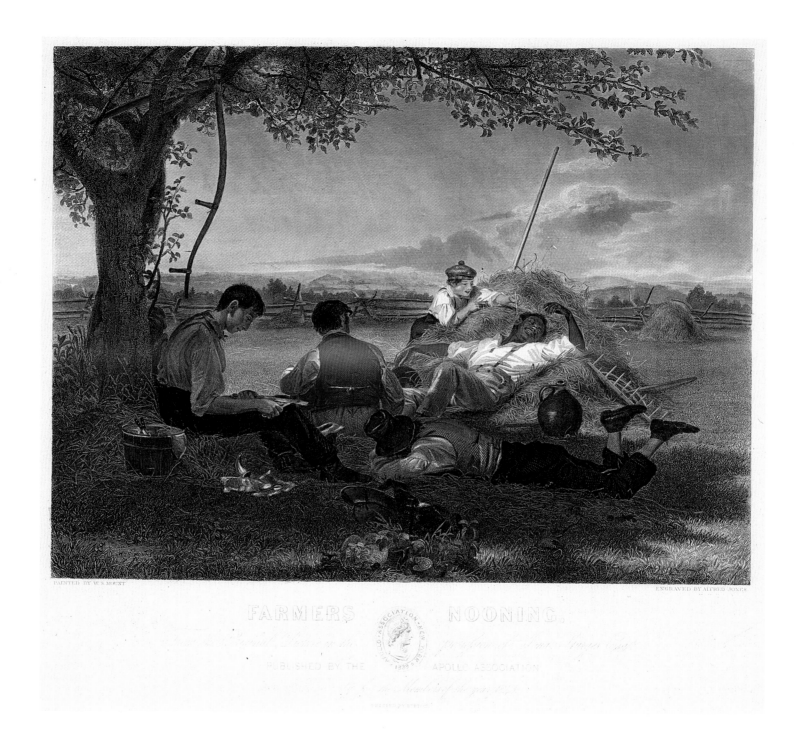

Alfred Jones
(1819–1900)
after William Sidney Mount
*Farmers Nooning*
1843
Engraving
23 x 26 1/4"
Courtesy The Museums at Stony Brook, Museums Purchase
Stony Brook, New York

Joseph Hirsch
(1910–1981)
*Editorial*
1942
Oil on canvas
18 x 26"
Courtesy University of Arizona
Museum of Art, Tucson;
Gift of C. Leonard Pfeiffer

Bishop came to New York from Cincinnati in 1918 hoping to become a commercial artist. Inspired by the vitality of New York City, she decided instead to paint the life around her. She enrolled at the Art Students League and studied painting with Kenneth Hayes Miller, for whom she held a lifelong admiration, and Guy Pene du Bois, who became a close friend. Miller taught his students to construct their pictures in accordance with principles of Renaissance art, and encouraged them to find their subjects, as he did, in contemporary American life. Bishop's art draws continually on her knowledge of past masters and in a remarkable degree creates a synthesis of classical form with a modern, moving image.

*Lunch*, George Tooker's 1964 image of lunchtime in the workplace is as static as Bishop's is dynamic. His troubling portrayal of the psychologically stunting aspects of technology contrasts with her representation of the newly won opportunities and freedoms enjoyed by middle-class Americans. A magic realist, Tooker's placement of realistically drawn subjects in ominous settings registers the toll exacted by an industrial society on individuals. His people have traded their humanity for material success. They are comfortably fed, clothed, and sheltered, but at a cost to their spiritual lives.

The setting for *Lunch* is a fast-food restaurant, similar in design to an urban Chock Full O' Nuts coffee shop. The patrons of the restaurant sit at narrow counters whose looped configurations offer maximum convenience for the waitress and minimum comfort for the patron. In this eerie interior, flooded with yellow fluorescent glow, everyone receives the same sandwich and coffee for lunch. Emphasizing the mechanized ritual of a lunch break, all the diners raise their hands and bite into their sandwiches; there is no eye contact. The conformity of their lives is expressed not simply in their similar attire and eating habits, but also in their evenly spaced seating at the counters. Every stool is occupied and, because the artist has cropped the composition, they continue interminably. Just as Andy Warhol intimated the conformity paralyzing American life in his *100 Cans of Campbell's Soup*, Tooker uses repetition for a similar effect. The strict grid of vertical wall panels and horizontal counter tops lock these diners into rigid positions. These alienated workers shown enacting the mechanized routine of eating lunch are reminders of the concessions many of us have made in order to fulfill the American dream; as our productivity increases, our individuality is diminished.

All of the artists in this section represent the return to genre painting that has taken place at intervals over the course of American art history. Although the impulse to return to the immediate environment often originates in a nostalgic need for connections with home, land, and nation, it has in actuality often revealed an unsettling social reality. Genre artists in America have commonly observed, and therefore depicted, a cheerless, alienated world.

Steven Stokley belongs to this tradition. In *Lunch Hour* he presents anonymous people conducting the routine affairs of their simple lives. The intimacy of the artist's perception is mirrored in the scale and style of his presentation: simple forms made all the more clear by the use of exaggerated perspective, clean, flat colors, cool light, and a shadowless environment. Stokley polishes, sweeps, and tidies the scene of a midday meal prepared in a mobile restaurant, purchased on the street, and eaten on the sidewalk.

Perhaps this setting and the speed with which meals are eaten explains the American predilection for foods that are both soft and capable of being eaten without utensils. Hand-held foods make it possible for the car, the sidewalk, and the park bench to serve as surrogate dining areas. Foods that have not traditionally fallen into this category are often redesigned to conform. Ice cream is frozen around a stick or placed in a cone. Fried chicken is cut into nugget- size portions. Sandwiches, pizza, tacos, hamburgers, hot dogs, indi-

vidualized and prepackaged portions of pie, soup, pudding, and the like have all become popular fare.

Although the litter, graffiti, noise, and clutter of the contemporary metropolis have been edited out, Stokley has created a poignant image of urban life. The lunch truck, the modern version of the pushcart, is a restaurant on wheels. It is the symbol of the eat-and-run mentality which belongs to the solitary existence of many urbanites. The presence of people assembled around the vendor intensifies the lifeless silence that pervades the scene. This is a gathering place, but it does not function in the communal manner of a town square. Mealtime and social time are here divorced from each other.

Stokley engages the viewer by reversing the perspective. The image, instead of receding, is thrust beyond the implied picture frame into the viewer's space. This dynamic spatial arrangement is intensified by the placement of the truck, which lies flat against the canvas and the wall on which the artwork is hung. It functions as a springboard from which all else projects.

The image consists of plywood and masonite cutouts, each presenting individual pictorial elements. Stokley assembles sketches made on different occasions and in different locations to form a relief that extends six inches from the wall. Illusionistic space and physical space interact simultaneously, creating the dynamic of a lunch which is cheap, simple, quick, and solitary.

93

94

Isabel Bishop
(1902–1987)
*At Lunch*
1954
Oil on gesso panel
20 1/2 x 13 1/2"
Courtesy Midtown Galleries, Inc.,
New York

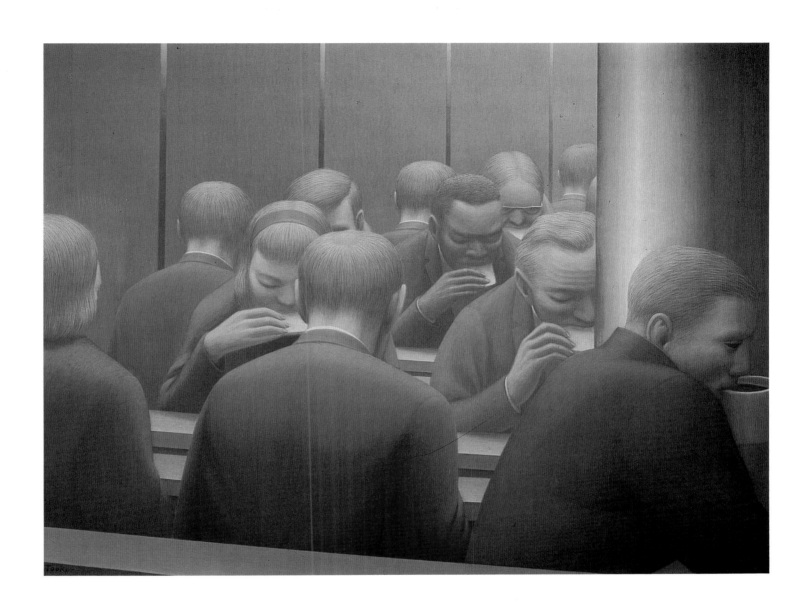

95

George Tooker
(b. 1920)
*Lunch*
1964
Egg tempera on gesso panel
20 x 26"
Courtesy, Collection of Philip and Suzanne Schiller,
American Social Commentary Art, 1930–1970
Highland Park, Illinois

96

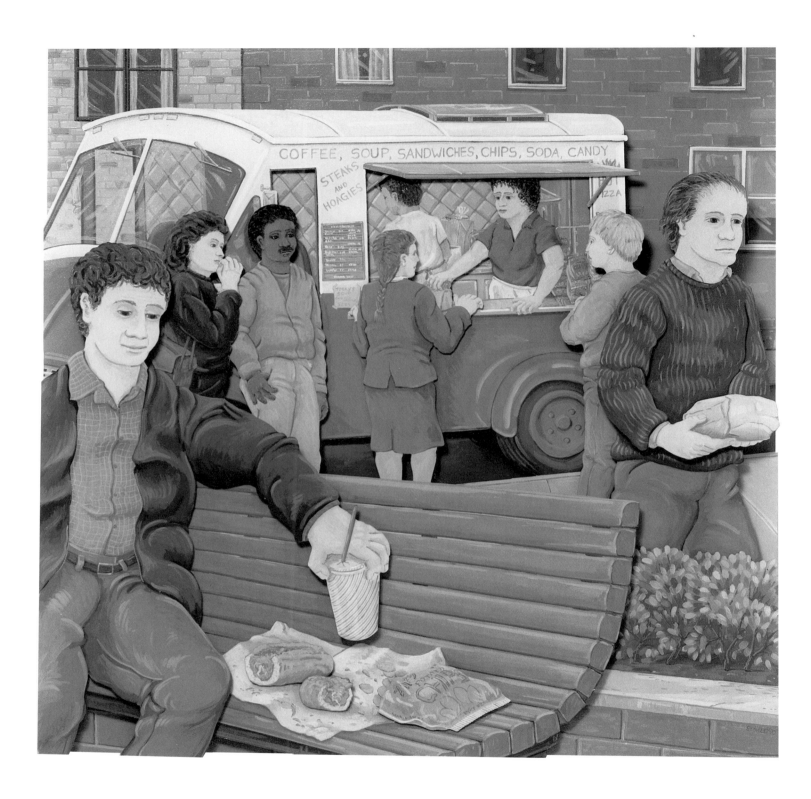

Steven Stokley
(b. 1956)
*Lunch Hour II*
1990
Acrylic on wood
36 x 36″
Courtesy the Artist

# Men and Meat:
## Hunter, Butcher, Carver

In today's world, as in the dawning of time, men have played the role of great feast-givers and meat-providers. Today's husbands who preside over the outdoor suburban barbecue grill or who carve the holiday roast are performing as the chiefs of old. The close association of meat and virility has remained unchanged since the evolution of the male as hunter.

Europe has had a long tradition of the hunt as a recreational privilege of the rich and powerful. In the Middle Ages, kings and wealthy nobles created vast private preserves for their own pleasure. The Norman kings of England went so far as to restrict for themselves alone the right to kill deer, and any transgressors were subjected to harsh punishments. Later, landowners adopted a similar prerogative for their own lands.

In the United States, however, both public and private land was open to all in the nineteenth century. By the 1850s, when British publications appeared that explained the techniques, rewards, and manners of good sportsmen, urban-bound American males adopted the British view of hunting as a sport. Ever-increasing numbers of Americans discovered the wilderness and sportsmen often led the way.

Arthur F. Tait was placed by circumstance and inclination to take artistic advantage of this new American trend. He was born in a suburb of Liverpool, England, the youngest son of a successful merchant. When unlucky circumstances suddenly forced his father's business into bankruptcy, Tait was sent to live on the farm of relatives. Raised in the country, he developed a lifelong passion for the outdoors and an interest in animals that did not preclude hunting and fishing. As a youth, Tait was apprenticed to Thomas Agnew, the well-known art dealer, where the natural abilities of the young artist were encouraged.

In the competitive field of British painting, however, Tait's artistic success was uneven, and in 1850 he sought a new

life and career, joining a cousin who planned to start a fireworks display business in the United States. Within a year of landing in New York, Tait discovered the Adirondacks, a 9,000–square-mile wilderness just becoming accessible by railroad. Opportunities of this nature were unavailable in the restricted game preserves of Europe, and Tait followed his natural penchant for the outdoors and his interest in hunting and fishing. His cousin's business failed to materialize and, as a well-trained draftsman with a polished painting technique, Tait quickly joined the artistic circles of New York. There, he specialized in painting hunting scenes and game.

As the concept of sportsman was just forming in the United States, Tait's paintings appeared in a rapidly growing market. His work sold quickly, aided in no small way by the popularization of his name by Currier and Ives. Between 1851 and 1865, the lithography firm reproduced forty-two images of Tait's work in inexpensive prints, including *Going Out: Deer Hunting* of 1862.

This composition depicts two hunters in a canoe on a magnificent Adirondack lake. One of them may be Paul Smith, one of Tait's favorite guides. No women are evident, nor is there any sign of civilization. Only the men and the deer inhabit the untouched wilderness. These settings, in reality or in art, appealed to the atavistic yearnings of the urban male. The image supports the tradition of man providing meat, conquering the wild beast in a display of skill and strength while foregoing the comforts of civilization. Such paintings recalled man's conventional role and became popular symbols in the Victorian home.

The corruption of this Victorian ideal is represented in Alton Pickens's *Saturn and Family*, a print in which the symbolic meaning of the act of dispensing meat is reversed. Instead of indicating the role of the male as protector and sustainer of the family, it bespeaks the horror of the father's ritual sacrifice of his sons. The brutal nature of this act is intensified by its incorporation in the context of a family dinner.

In this image, a contemporary event (American participation in the Korean War) and an ancient myth are united in a forceful indictment of human nature. The title, *Saturn and*

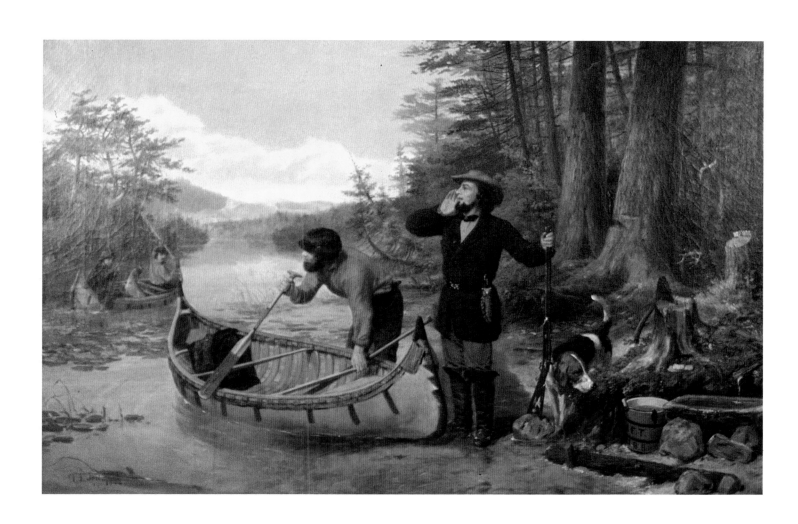

99

Arthur F. Tait
(1819–1905)
*Going Out: Deer Hunting*
1862
Oil on canvas
20 x 30″
Courtesy Adirondack Museum,
Blue Mountain Lake, New York

100

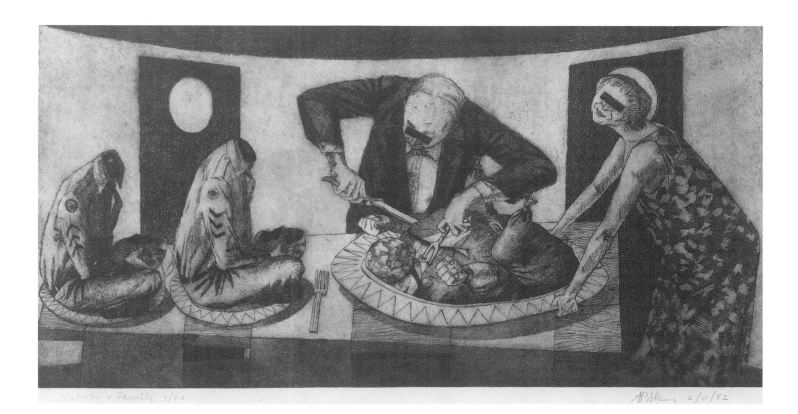

Alton Pickens
( b. 1917)
*Saturn and Family*
1953
Aquatint and etching
22 5/8 x 28 5/8"
Courtesy Museum of Modern Art, New York.
Abby Aldrich Rockefeller Fund, 447.53

*Family,* refers to the Greek myth which describes how Zeus attained his position as the most powerful of the Olympian gods. According to the story, Cronus, or Saturn, as the Romans called him, had received a prophecy warning him that one of his children would depose him and take leadership among the gods. To avert this, Saturn swallowed each of his children as they were born to his wife, Rhea. Zeus escaped, as Rhea wrapped a stone in swaddling cloth and Cronus, deceived into believing that it was his son, swallowed the stone. Zeus was hidden on the island of Crete until he reached manhood, at which time he returned to his father's realm, forced his father to disgorge his siblings and led them in a revolt against Cronus. Winning the war, Zeus fulfilled the prophecy.

In the tradition of Goya's *Caprichos* and *Disasters of War,* and certainly related to Goya's own *Saturn Devouring His Children, Saturn and Family* exposes society's cruelty. Like Goya, Pickens chose for his subjects the social and political fictions that man constructs for himself. The specific myth that Pickens debunks here is that of the American president as the father of his country who presides over the family at mealtime by carrying out the traditional male role as carver of the roast. In this case, the roast is a soldier, sent off to be killed in wars fought in foreign lands. Pickens suggests that this practice is analogous to Saturn's destruction of his children.

Most roasts are presented at the table without their heads. The decapitation makes the slaughter of the animal seem less gruesome. As depicted in *Saturn and Family,* however, the macabre nature of the feast is heightened because the headless roast is actually a soldier who has been cruelly sacrificed by his father.

In this updated version of the myth, Saturn is President Eisenhower, who, with the assistance of his wife, energetically carves the platters of "meat" set before him. The compliant postures of the young soldiers who patiently wait their turn on similar carving platters, and the cheery nonchalance of the first lady heighten the impact of this perverted portrayal of carving and serving a family meal.

Pickens, who was born in Seattle, acknowledged an early teacher of literature as his first art teacher, indicating the importance of narrative to his art. In 1947, Pickens published an essay entitled "There are no Artists in Hiroshima," revealing his deep commitment to significant issues of contemporary life. It is this concern for humanity which underlies his satire.

Abraham Rattner is best described as an American Expressionist. His theme is humanity, and his subjects are taken from the Bible, real life, and his imagination. Rattner's ambition is that his art, deeply felt and personal, makes "a statement so old, so everyday—of the things of the backyard, the ordinary well-known commonly experienced thing—nothing particular about it except my own experience of it, but not an ordinary thing after that—no, now it is more alive than before, existing more freshly discovered—intense as it is now inclusive of my own personal meaning." Instead of emphasizing the vicious aspects of the correlation between virility and meat, in *The Meat Cutter* he depicts the power, strength, and pride of the male who has entered a profession that promulgates this connection.

Rattner was born in Poughkeepsie, New York, in 1895. His parents were Russian Jewish immigrants, and although he grew up in poverty, his family's deep consciousness of Jewish intellectual life provided him with a love of learning and the hope of success in America. Rattner studied at the Pennsylvania Academy of Fine Arts until the First World War interrupted his work. He spent the years between the wars in close contact with avant-garde painting. Futurism, Expressionism, Fauvism, Cubism, Picasso, and Matisse were all important influences on his art.

Many of Rattner's paintings which post-date World War II are Biblical in theme. Other pictures, while not overtly religious in content, contain a Biblical power. *The Meat Cutter* is one of these works. The artist forces a confrontation between the image and the viewer by collapsing the space between them, reducing the palette to the three primary colors, plus black and white, and simplifying the composition. The figure is then monumentalized by the strong blue sky, which provokes a comparison between

101

102

Abraham Rattner
(1895–1978)
*The Meat Cutter*
1964
Oil on canvas
36 1/4 x 28 3/4"
Courtesy Kennedy Galleries, Inc., New York

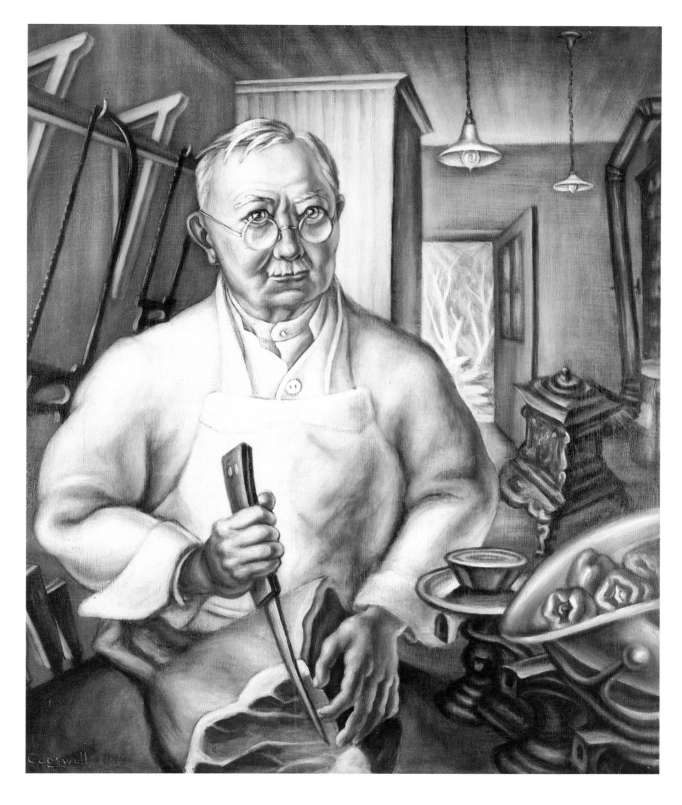

103

Dorothy Cogswell
(b. 1909)
*Country Butcher*
1943
Oil on masonite
33 1/2 x 28″
Courtesy Michael Rosenfeld Gallery,
New York

Rattner's *Meat Cutter* and a representation of an out-of-doors altar and a ritualistic blood sacrifice. The butcher becomes the presiding male, the high priest, the shaman, the individual invested with power and authority. He is depicted in the role traditionally reserved for men as the provider of meat. Through these references to the past, Rattner makes a "thing of the backyard" mythological.

Dorothy Cogswell's *Country Butcher* is a portrait of a meat cutter standing with his carving knife poised over a side of beef. A somewhat surreal and unsettling portrayal, the butcher, in the tradition of hunter and killer of animals, holds his knife in the manner of a dagger as he plunges it into the meat. Above him are the tools of his trade, his saws for breaking bones, and his weighing scale, now holding some colorful red and green peppers. Outside, the harsh white light suggests the bitter cold of winter, but the door is wide open and the pot-bellied stove shows no fire.

The first woman to receive an MFA from Yale, where she also received her BFA, Cogswell began teaching in the art department of Mt. Holyoke College in 1939. From 1964 to 1974 she was chairperson of the department. Cogswell's semi-abstract work is often tinged with melancholy; the mood is somber and the subjects are shown in cool isolation.

Butchers are also the theme of Sue Coe's painting, *There Is No Escape.* But instead of Rattner's compliance and Cogswell's emotional distance, hers is an art of protest. Coe's anger fuels her creative impulse. Her subjects are supplied by the atrocities that are reported in the news media—rape, political struggle, subway violence, racial persecution. She pleads her case in word and image, not in terms of cool logic or hard fact, but through searing scenes of violence. Her outrage is uncompromising, engendered, ironically, by

104

the same extremism that is used against those whose cause she pleads. Coe summons the harsh glare of the inquisitor's light, the steep angles of calamity, the black shadows of evil, the angular shapes of a scream, the shrill tension of a siren.

All of these elements are evident in her most recent series, *Porkopolis, Animals and Industry,* an ongoing examination of the meat industry in which Coe addresses farm conditions, processing plants, meat-packing procedures, and slaughter houses. She has visited them all so that the stylization of her work, instead of being an abstraction, is an intensification of the reality she has observed. She identifies with the victims, the animals whose flesh is savored on the dinner table.

Sue Coe grew up in post-World War II England, where she became acutely aware of the rigidity of class structure. As a member of the working class, she identified with those who were repressed and exploited. To Coe, persecution is no less poignant when the victim is an animal. The carcasses hanging on meat hooks have the appearance of corpses. The screaming animals who flee from the butchers seem undifferentiated from victims of lynchings. The hacking and bleeding of a pig are as gruesome as those of a human. Coe's work is an assault on complacency and a demand for self examination.

*Porkopolis* returns the emotional elements to the act of transforming animals into consumable portions of meat. The killing of the pig is no longer neutralized by the repetitive nature of the task and the systematic procedures prescribed by the Meat Packers Union. Coe has invested it with gleeful treachery on the part of the butchers, and terror on the part of the pigs. This is not work; it is cold-blooded murder. Coe has created a vivid and unsettling reminder of the brutality inherent in the act of eating meat.

Entitling her work *Porkopolis* suggests the culture of the ancient Greeks and the historic origin of today's rituals asso-

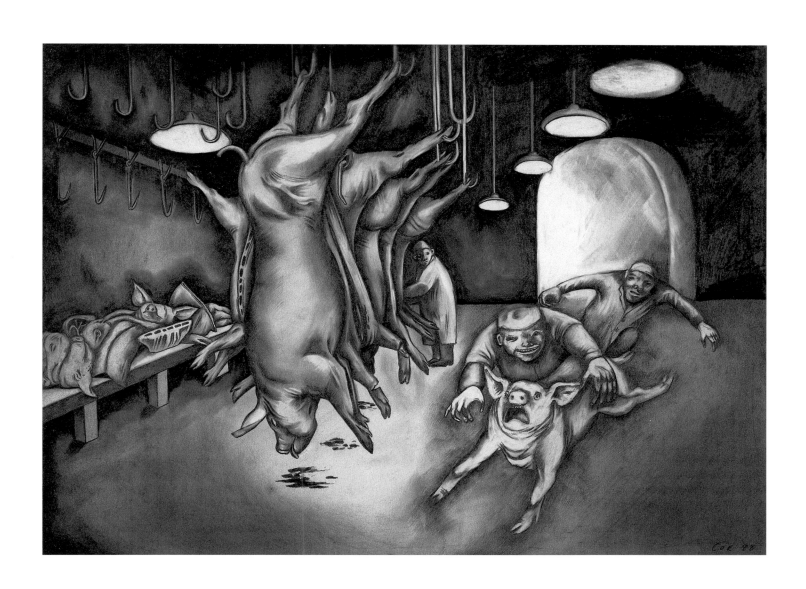

Sue Coe
(b. 1951)
*There Is No Escape*
1987
Watercolor & graphite on paper
22 x 30″
Courtesy Gil Michaels

106

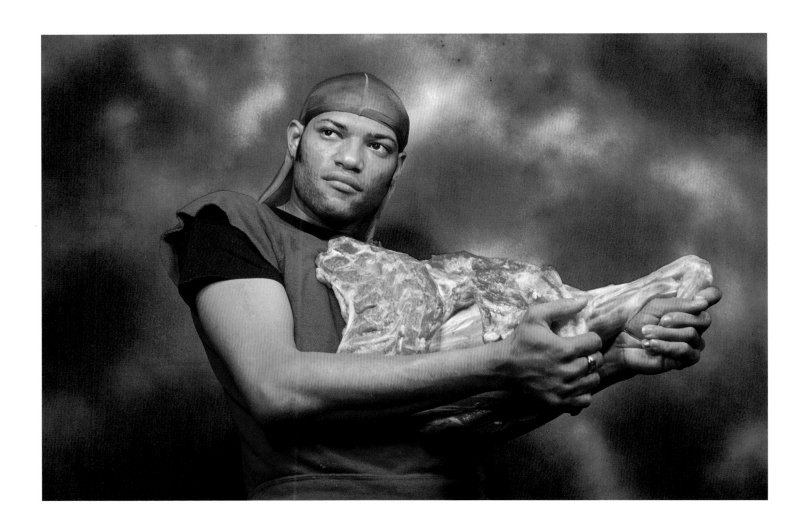

Andres Serrano
(b. 1950)
*Meat Weapon*
1984
Cibrachrome Print
35 x 45"
Courtesy Stux Gallery, New York

ciated with meat-eating. Homer reports that during a feast the beast always was killed by the male host or by one of his sons. It was roasted by males because beef was considered too noble a food to be entrusted to women. The modern meat industry harks back to this tradition.

Unlike Sue Coe, Andres Serrano does not imply the age-old association between the carcass of meat and the animal (animus) powers of man. He reenacts it. Serrano creates gorgeous photographs of distressing subjects. He fabricates scenes within his studio to suit specific emotional and thematic intentions. Models are selected, costumed, and posed. Props are identified and arranged before a mood-evoking backdrop. They stand poised before the camera lens like a theatrical tableau, the implied drama twice frozen in time—once in the posing and once on the photographic negative itself.

The theatricality of the final photograph is intensified by Serrano's use of focal clarity, saturated hues, and high-wattage light levels. All of these effects are employed to full advantage to give his insouciant subjects their maximum impact. Carcasses, beasts, hooded monks, cages, crosses, pedestals, bread, and meat all appear in irreverent circumstances, more shocking, perhaps, than a painting of the same subject, because the photograph is a record of an actual occurrence in the real world.

*Meat Weapon* is a portrayal of a man raising the front half of the carcass of an animal in a manner that one would lift a rifle or machine gun. Parallels are drawn between the man and the weapon as they are between the man and the meat: the ribs of the meat rest against those of the man, the front legs of the animal extend along the arms of the man, his hands hold the animal's hooves. The man's hairless body displays a well-developed musculature, the flesh barely dis-

guising a physical structure similar to that of the carcass he holds.

Serrano extends this series of double reversals by presenting the dead animal, a victim of a murder, as a weapon, or perpetrator of violence. Weapons, too, have a double function; they can be used to attack or to defend. Although animals don't use weapons, they too are capable of both kinds of aggression. In this way the parallels established between the body of the butchered animal and that of the man are extended to include their behavioral characteristics. By establishing this close relationship between humans and meat, Serrano presents our carnivorous tendencies in a moralistic context. Butchering and hunting have been condoned by society. One is a respectable profession. The other is a popular recreational activity. The sadistic aspects of both have been suppressed by cultural conditioning.

In sum, the artists in this section identify meat with the cluster of aggressive activities that has traditionally been the work and the pleasure of men.

*"A mighty porterhouse steak an inch and a half thick, hot and sputtering from the griddle; dusted with fragrant pepper; enriched with little melting bits of butter of the most unimpeachable freshness and genuineness; the precious juices of the meat trickling out and joining the gravy, archipelagoed with mushrooms; a township or two of tender, yellowish fat gracing an outlying district of this ample county of beefsteak; the long white bone which divides the sirloin from the tenderloin still in its place."* [1]

107

[1] "Rhapsody on Beef," by Mark Twain, *A Tramp Abroad*, 1894, Hart, Conn., page 572.

# Women in the Kitchen

110

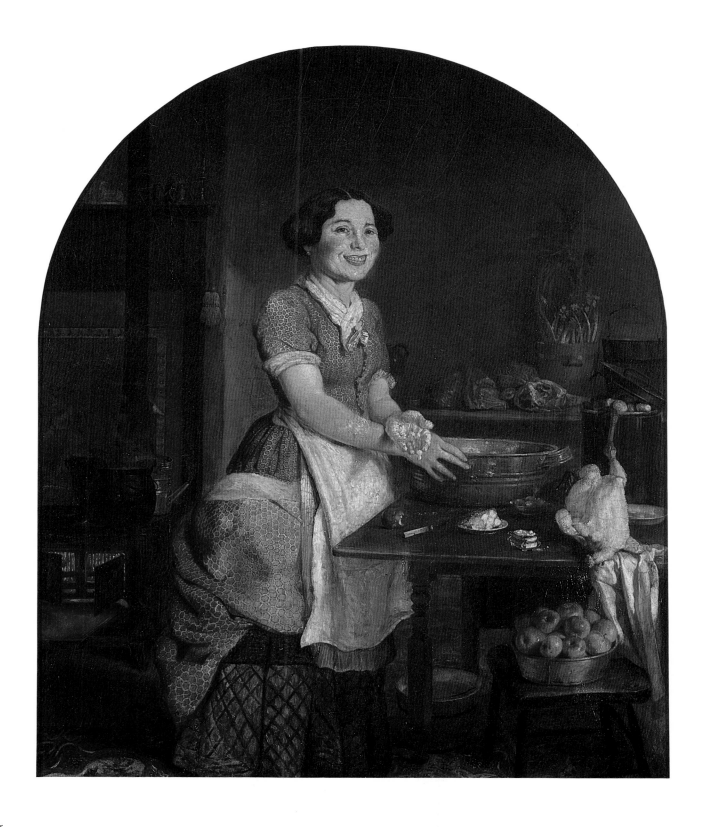

Lilly Martin Spencer
(1822–1902)
*Shake Hands?*
1855
Oil on canvas
30 1/8 x 25 1/8"
Courtesy Ohio Historical Society

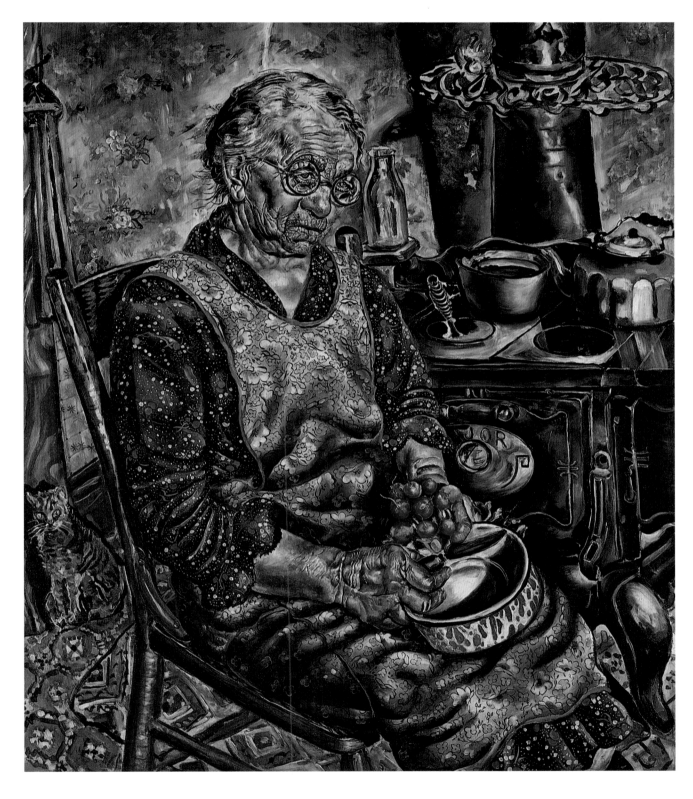

Ivan (Le Lorraine) Albright
(1897–1983)
*The Farmer's Kitchen*
c. 1933–34
Oil on canvas
36 x 30 1/8"
Courtesy National Museum
of American Art,
Smithsonian Institution,
Transfer from the U.S. Department of Labor

American artists who have portrayed the kitchen, whether in 1880 or 1980, consistently depict it as a female domain. What has changed are the attitudes regarding the persistence of assigning women the responsibility for meal preparation.

Catherine Beecher wrote indignantly in her cookbook, published in 1846, "In what respects are women subordinate? Wherein are they superior and equal in influence?" Her answer to the second question was, "In the kitchen." Supremacy in this realm did not strike Beecher as demeaning, for she maintained that cooking was an art. "Women's control of the kitchen gave her a weapon by means of which she could control everything else."

Throughout the nineteenth century, despite the introduction of processed foods that reduced the drudgery of cooking, American women continued to resist the invasion of industrially produced foods. They took great satisfaction in preparing a meal well, and did not consider cooking a task unworthy of their attention.

In *The American Women's Home*, Catherine Beecher and Harriet Beecher Stowe admonished their readers that the natural duty of women was to be "housekeepers and healthkeepers" for the family. They identified the woman of the house as the "chief minister of the family estate," while the man was the provider and outdoor laborer. To the Beechers, daughters and sisters of well-known clergymen, it was woman's sacred duty to run the house and oversee the children during their crucial early years. In this, the Beechers wrote, women were both "equal and superior" to men in influence.

Lilly Martin Spencer surpassed this goal of responsibility and equality in her own home. Not only did she manage the family household, which came to include thirteen children, she was also the main provider. Her success as an artist made her the most famous woman in her field in America in the 1850s and 1860s. Born in Exeter, England, she and her family immigrated to the United States in 1830. They eventually settled in Marietta, Ohio. Her father, an educator and utopian philosopher, encouraged his daughter's artistic inclinations, even moving to Cincinnati to give her greater opportunity. Aside from a brief contact with the portraitist and genre painter, James Henry Beard, Spencer insisted that she was essentially self-taught. In 1844 she married Benjamin Spencer, and after he attempted several professions, he turned to assisting his wife in her artistic career by acting as her business manager. In this partnership, they were both very successful. In 1848, the Spencers moved to New York City where she concentrated on domestic scenes, portraits of children and the odd study of family pets, particularly dogs.

Whereas the nineteenth-century writers may have proclaimed kitchen work to be the domain of the wife, Spencer probably had little time for domestic duties, and allocated these tasks to a servant. As a professional painter, she anticipated the changes that were to take place in the kitchen once women, in the middle of the twentieth century, entered the work force in great numbers.

*Shake Hands?*, painted in 1855, portrays a servant making bread in the Spencer family kitchen. Objects suggesting other kitchen duties are arranged in the foreground and background, while the female servant stands in the middle of the composition. The Beechers advised strict control of servants, whose contributions to the household depended on patience, training, and mutual respect. Some servants formed close bonds with their employers and were viewed as members of the family. *Shake Hands?* implies an emotional tie of this sort, or at least a familiar easiness between the artist and sitter. The woman extends a flour-covered hand with a forthrightness that reverses traditional nineteenth-century decorum for a servant. On her face is a wide, toothy grin. Such blatant humor is rare in paintings of this period, despite the fact that this work struck such a chord with the middle class that it was reproduced as a popular print. In fact, throughout the 1850s and 1860s, Spencer was paid royalties on a number of similar domestic scenes that were sold by firms such as Goupil, Vibert and Company.

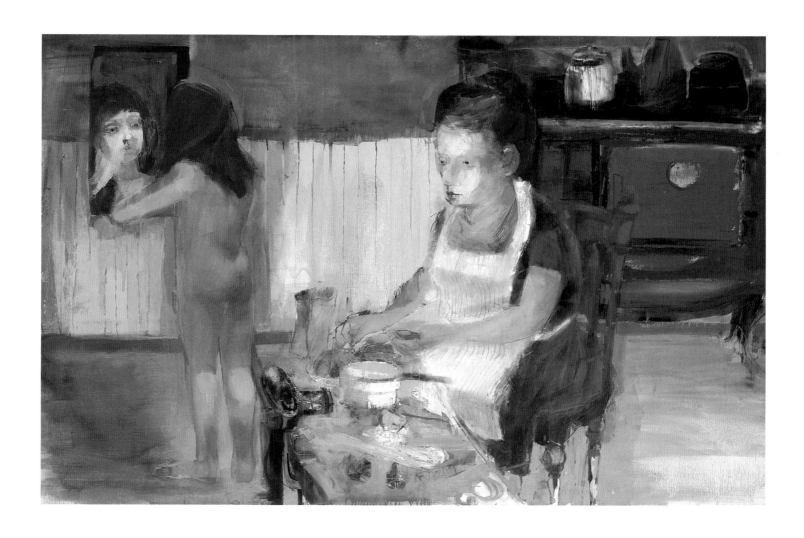

113

Ruth Gikow
(1915–1982)
*The Kitchen*
1960
Oil on canvas
40 x 60″
National Museum of American Art,
Smithsonian Institution,
Gift of S.C. Johnson & Son, Inc.

The opposite view of kitchen "enslavement" is presented in *The Farmer's Kitchen*, by Ivan Albright. It conveys the exhaustion of the body and soul of a farmer's wife. The aged woman appears to have been utterly debilitated by a dreary life spent in the kitchen preparing an endless succession of meals. Her misery contrasts dramatically with the spirited pride of Spencer's woman servant.

Although labeled a magic realist, Ivan (Le Lorraine) Albright, one of twin sons, both of whom followed artistic careers, remained outside the mainstream of American art. Because of his independent financial means which freed him from the need to sell his paintings, he was able to pursue his own course, spending years on a single work, and never compromising his subject matter.

Beginning his study of art at age eight under the direction of his father, Albright became a medical artist in World War I assigned to the base hospital in Nantes, France. While in Europe, he studied at the Ecole de Beaux Arts, and completed his training at the Art Institute of Chicago after the war. Despite all this training, Albright consistently paints in a style uniquely his own. Fascinated with the nether world, his primary subjects are detailed images of humanity in the process of decay and corruption.

In *The Farmer's Kitchen* a hard-working country woman is lost in thought as she automatically pursues her standard chores. She is an old woman now, and her sagging breasts and gnarled hands are evidence of a long life of labor. The detail is staggering: the pores on her bristly chin, the deeply furrowed brow, her dry gray hair, the resigned, sad eyes, all tell the same story. This is the woman whose many struggles and occasional triumphs have been enacted against the backdrop of the kitchen, and she is resigned to this fate. How many potatoes has she peeled? How many radishes cut and washed? This toil has caused more than the decay of the flesh; it has corrupted the spirit as well. Seen in a somber, bluish light, Albright's woman evidences the tolls exacted in the performance of the duties of her gender.

A very different experience is represented in Ruth Gikow's painting, *The Kitchen*. In it this wife, too, is bent on her task of preparing a meal, but the atmosphere in this kitchen is one of sweetness, nurturing, and family intimacy. The mother who presides over this humble setting has retained her dignity. She displays the rewards, not the humiliations, of performing her traditional female role. The domestic setting is her domain, not her prison.

The style of painting conforms to its subject. Gikow's brush is sensitive, gentle, and graceful. Her palette is delicate. The atmosphere is soft. This painting provides a sympathetic view of contented women.

Despite the fact that Pop art and minimalism commanded the attention of the critics and the art market in the 1960s, realist painting continued to be produced as well. Gikow is one of many artists whose allegiance to realism was formed in the midst of the Depression. She studied with two prominent realists in the 1930s, John Steuart Curry, the regionalist, and Raphael Soyer, one of the greatest painters of the Depression. Like Soyer, Gikow's earliest subjects were taken from the life around her on Manhattan's Lower East Side. Paintings such as *Orchard Street Gypsies*, 1939, *Tenement Fire*, 1939, and *Little Roosevelt Street* of 1946 indicate both her interest in the city's poor and her commitment to social realism.

Gikow's experience as an artist working under the WPA firmly convinced her of the importance of the artist's role in society. With many others of her generation, Gikow turned from easel paintings and private patronage to murals which were more accessible to the public and of greater service to society. In another attempt to make art more democratic, Gikow helped found the American Serigraph Society, the purpose of which was to produce quality art that could be sold to the public for nominal fees.

*The Kitchen* is nearly mural size and combines, provocatively, elements of genre painting and personal symbolism. According to the artist, the painting is a memorial to her mother. The setting is the cold-water flat on the Lower East Side in which Gikow grew up. Seated at a low table in the center, the mother prepares vegetables. To the left, her nude daughter, the artist, studies her reflection in a mirror. The scene is serene, less a portrayal of the cluttered business of

a working kitchen than a meditation on the world of memory and the mythic roles of woman. Gikow sensitively suggests the connection between a goddess of nature and the modern mother by surrounding her subject with her own child and the bounty of the earth. Complicating this theme is the female child's self-awareness that separates her from her mother and the definition of femininity that her mother represents. Through such means, Gikow raises opposite emotional states of being that characterize the relationship between women and their role as nurturers.

A contemporary interpretation of this theme is provided by Rhonda Zwillinger's *The Way to a Man's Heart*. Its diptych structure extends beyond the formal division of the canvas. The dichotomy applies equally to the subject matter and to the manner of presentation; characteristics of each are intensified by the pairing of contrasting elements. On the left panel, set against the expansive saturated hues of a glowing sun, looms a full-bodied Black woman. She towers above the viewer's sight level like a great fertility fetish, the power of her body matched only by the apparent strength of her resolve. The woman balances an enormous basket of produce on her head, identifying her with an unnamed, but distinctly non-European, culture.

In as resolute a manner, the kitchen setting on the right panel indicates a middle-class, suburban home. The cool colors and the frontal depiction establishes the banality of this scene. Zwillinger presents the stereotypical TV housewife, her diminutive body wrapped neatly in an apron which is as starched as her smile. She gazes admiringly at her husband, who appears to derive pleasure from watching his wife conduct her kitchen chores.

Zwillinger sets up this dialectic of the female experience and describes each in terms of its media source. Both panels refer to the history of modern media as the source of persistent social attitudes. The image of the large Black woman is a parody of the dramatic devices invented by Hollywood in the early days of cinema—low camera angle, artificial backdrop, exaggerated gesture, saturated colors, and so forth. The cardboard flatness of the image on the right is drawn from an equally processed source—the sitcoms and commercials which dominated television of the '50s. The out-of-date nature of Zwillinger's source material is common

among artists who are identified with the East Village art community. Much of their work is an irreverent acknowledgement of the television saturation of their youth.

The title, *The Way to a Man's Heart*, focuses attention on our attitudes regarding domestic bliss and the vital role food plays in romance, courtship, and marriage. Man's love is won, we are told, through the stomach. It is the responsibility of the female to offer food in order to procure a mate. Feeding is represented as an act of barter, earning love in exchange.

Zwillinger's painting parodies the clichéd imagery of her media sources in order to demonstrate the attitude-framing power of the marketplace and the entertainment industry. She then raises several critical questions which have emerged from the changing sex roles and undefined domestic structure of contemporary society:

—is household cooking a servile activity?     —how do kitchen functions define the dynamics between the sexes? —are the answers to these questions different in non-Western societies?

115

Zwillinger confronts the viewer with evidence of our past dreams and inherited myths regarding the female role as the preparer of meals, as well as of the continuation of this tradition to this day. She directs these issues to viewers who have witnessed the proliferation of convenience foods and food-preparing gadgets, the evolution of the feminist movement, the growing popularity of restaurant dining, the popularization of concerns regarding nutrition, and the disintegration of the American family. Throughout these dramatic social transformations the one essential element that remains constant is that women are still the primary meal-preparers.

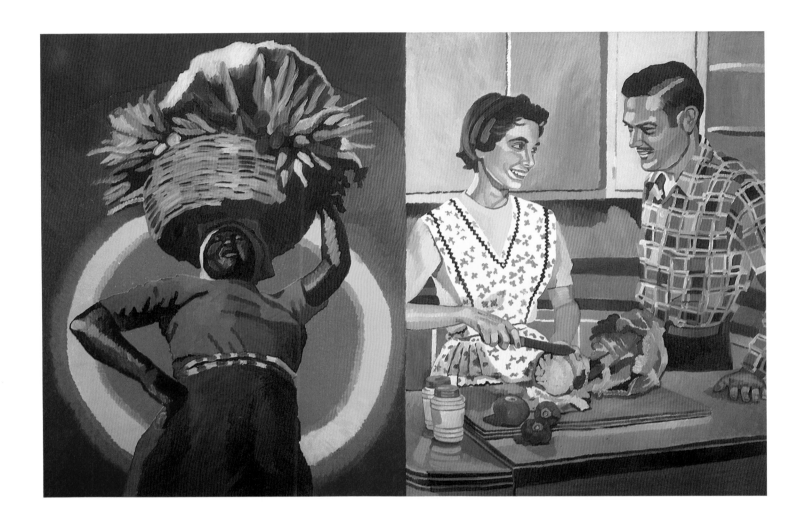

116

Rhonda Zwillinger
(b. 1950)
*The Way To A Man's Heart*
1985
Oil on canvas, Oil/acrylic on wood frame
72 x 103″
Courtesy the artist

# Fish out of Water

Perhaps due to their abundance, their succulence, and their nourishing qualities, fish were viewed by American artists of the nineteenth century as proof of the bounty of nature and the grace of God. Their depictions glorify them as a natural treasure, and stand in marked contrast to their most recent twentieth-century images. Of all the foods which have been subjected to the effects of an industrialized environment, it seems that fish most dramatically symbolize the disastrous state of our environment and the threat it poses to life. Recent artistic representations of fish express the concern regarding pesticides, residual chemicals and their degradations of the waters. These paintings chart the fear which has accompanied the growing awareness of environmental dangers. If the earliest images celebrate the wealth of aquatic life in America, the latest ones are distressing reminders of its imminent demise. They have given visual form to Rachel Carson's bleak warnings:

*"As man proceeds toward his announced goal of the conquest of nature, he has written a depressing record of destruction directed not only against the Earth he inhabits but against the life that shares it with him. The history of recent centuries has its black passages—now we are adding a new chapter and a new kind of havoc—the direct killing of birds, mammals, fishes, and indeed practically every form of wildlife by chemical insecticides indiscriminately sprayed on land."*

Rachel Carsen,
*Biology or Oblivion*

Samuel Marsden Brookes exemplifies the nineteenth-century point of view. The extreme verisimilitude of his canvases reflects his belief that reproducing the appearance of fish in the most exacting manner would provide a pleasurable visual experience and, perhaps, a spiritually uplifting one. Paeans to his realistic canvases were published in the local San Francisco newspapers, such as the one that ran:

*"By thy Great art*
*the salmon*
*from the canvas start*
*with rod, reel, line—"*

Brookes's penchant for exact detail led him to include from time to time painted drops of water not only on the fish but also on the frame.

The same realism which so delighted his fellow Californians can be seen in *Steelhead Salmon* of 1885. Brookes depicts two fish on the ground, the upper bodies held aloft by fishing twine tied to a branch, a proper trophy for a morning's outing. What held the audiences in awe was Brookes's minute depiction of the fish bodies, with their mucilaginous and refractive scales. Combined with the carefully delineated rod and reel and set off against the background of a California trout stream, all aspects of the fisherman's quest are realistically and recognizably depicted. Although the steelhead is considered a member of the trout family today, the nineteenth-century pundits labeled it a salmon. As long ago as the Romans, the salmon was valued as one of the best game fish. In the seventeenth century, Izaak Walton called it the king of freshwater fish; it has remained a prize catch through the nineteenth and twentieth centuries.

With few exceptions, the nineteenth-century artist viewed the fisherman as one in harmony with nature. The outcome of fishing was natural, the survival of the fittest. The challenge for the fisherman was to second-guess the fish and display enough skill with the rod to lure it onto the hook. From the days of the earliest European settlement, fishing had been both a necessity and a sport in North America. From the 1870s, however, interest surged in fishing as pure sport. This was particularly true among late Victorian businessmen, who spent their days enmeshed in a highly structured urban environment. Close on the heels of post-Civil War industrialization, "roughing it" in the wilds during leisure time became popular. Such a return was considered not a disruption but rather a communing with nature in a time-honored pattern. The great Adirondack camps are, perhaps, the most romantic of the attempts by urban dwellers to rediscover the wilderness, but the phenomenon was nationwide. Brookes attempted to capture the salient points of the craze in wilderness fishing. By doing so in such a realistic manner, he achieved the admiration and patronage of a local audience.

From the very beginning of his career, Brookes's close attention to detail was a characteristic of his art. Born in a small village near London, England, he immigrated with his family to Michigan in 1833. In Chicago in 1841, he paid two itinerant portraitists for lessons in miniature painting. This early, but slight, training may have been the source of his closely observed and finely detailed mature style.

What is unusual about Brookes is his preference for still life with game. Few artists made a specialty of it and even fewer were successful. In 1862, Brookes settled in San Francisco and created a grand kitchen still life composed of many different types of fish and fowl and a large variety of vegetables. When it was purchased by the influential Judge Edwin Bryant Crocker, Brookes gained instant recognition. He quickly established himself as an active leader in the San Francisco art community and became a founder of the San Francisco Artists' Union.

The subject of Milton Avery's *Primeval Fish* has been depicted as an abstract form whose simplified contours, flattened masses, and rigidity remove it from the realm of the edible despite its presentation on a serving platter. Its geometricized form indicates the artist's independence from observed reality and his self-proclaimed separation from the natural environment. Avery's willingness to divorce himself from the given world and invent his own reality is suggestive of the attitudes of producers and marketers of non-art goods as well. Nature was perceived as a territory which could be made to submit to human will. Avery's fish, like so much of the natural environment, was being restructured and forced to succumb to the dictates of civilization.

Born in 1893 in a small farming community in upstate New York, Avery was the son of a farmer. He was largely a self-taught artist but for one term in 1923 at the Connecticut League of Art Students. Two years later, when he joined the artists' colony in Gloucester and met fellow-artist Sally Michel, Avery found his own artistic path.

Avery's use of exuberant color combined with geometricized forms builds an emphatic pattern and a poetic lyricism that leaves his style with neither precedent nor direct follower. It is a unique style in which traditional subjects are conceived with a vision so fresh that they transcend their own meaning. In this case, Avery's willingness to collapse and rebuild the shapes of objects in the material environment and to color them with his own palette allows the work to suggest an expanded past. *Primeval Fish* embraces the origin of life which occurred in the sea, and reminds the viewer of the religious and mystical associations of its subject matter.

Hyman Bloom also uses the fish to express an expanded vision of life. But rather than harking back in time, his fish suggests an uncertain future. Bloom is a member of the Boston expressionist school of painters. This group, contemporary with the New York abstract expressionists and the Chicago "Monster" school, allied expressionism with figuration in an attempt to communicate the pathos and tragedy of modern life. Unlike their New York counterparts, the Boston painters drew their inspiration from the European expressionist traditions. For Bloom, the paintings of Soutine and Rouault were profoundly affecting and provided an important stimulus for his own expressionism.

Bloom was born in Lithuania in 1913. In 1920 his family came to America and settled in Boston's West End. From an early age, Bloom was a serious student of art, taking painting classes at the Boston Museum of Fine Arts and at the Fogg Museum at Harvard University. He received his first recognition outside Boston in the Museum of Modern Art's exhibition, "Americans 1942: Eighteen Artists from Nine States."

*Haddock* can be interpreted as a *momento mori*. The vehemence of the brushwork and color obliterate much of the

119

120

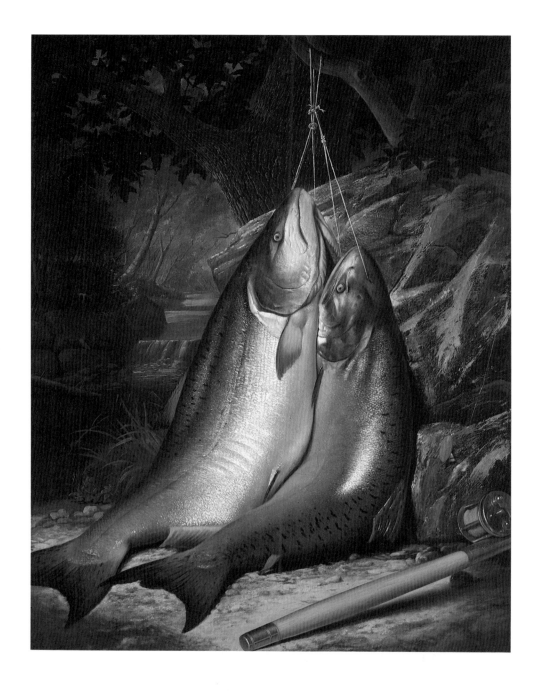

Samuel Marsden Brookes
(1816–1892)
*Steelhead Salmon*
1885
Oil on wood panel
29 1/2 x 30″
Courtesy Oakland Museum,
Kahn Collection

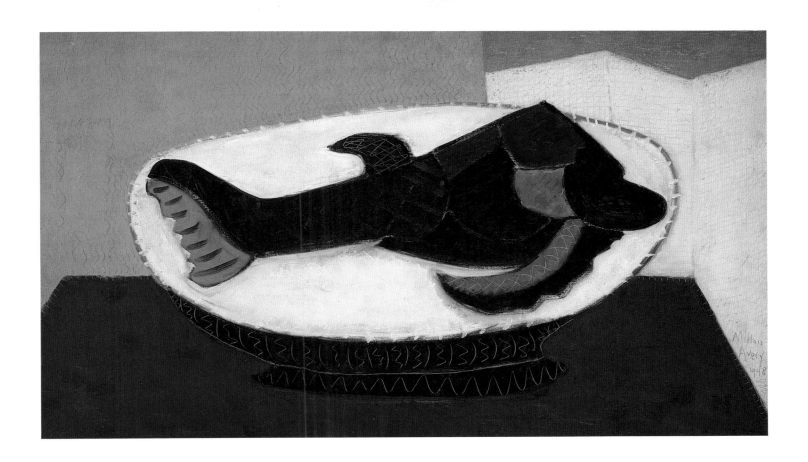

121

Milton Avery
(1893–1965)
*Primeval Fish*
1948
Oil on canvas
34 x 50″
Courtesy Milton Avery Trust

descriptive facts of the fish. Instead, intense reds and the pulsing surface translate the violence of the fish's removal from the world of nature to the world of man. The artist has transcended the subject so that the fish is not merely a realistic representation, but one which records the artist's subjective response to his world during the Cold War, when the memory of wartime violence combined with the threat of worldwide destruction. Like Bloom's paintings of cadavers, amputated limbs, and slaughtered animals, *Haddock* is primarily a vehicle for the expression of his fear and vulnerability, of man's brutality and his demonstrated ability to disrupt the natural order. Modern in conception, *Haddock* locates the subject in the artist's emotional state and not in the object portrayed.

Emotions cool in David Wojnarowicz's exploration of the subject of fish. *Tuna*, created in 1983, comments on the manner in which living fish become food in today's American households. This process rarely involves rod, bait, and tackle. Instead, it concerns consumers who, like the food they purchase, seem to have never existed in the natural world and would have trouble recognizing a tuna with its head, fins, and tail intact. David Wojnarowicz presents tunafish in its most familiar form—canned, labeled, and priced. At the same time, he suggests its most familiar context. Presented as the subject of an advertising poster, this work connotes the complexity of the modern tuna's normal environment—the supermarket.

The work echoes the bold and insistent message that store-owners plaster on their windows to lure customers with the promise of a bargain. At the same time, the piece conjures images of the bewildering array of choices that lies behind these windows—the coupons, specials, discounts, cans, boxes, bags—each bearing brand names and beseeching the consumer to choose it from amidst the abundance.

In this piece, a comic-like portrait of Superman has been superimposed on a supermarket poster advertising tunafish. Although it is tempting to contemplate the significance of this popular image of unnatural strength, this bigger-than-life hero on a brandless can of tuna, Wojnarowicz insists that he intends no political message. Instead, the behavioral patterns established during the artist's extensively documented childhood seem to explain his choice of theme and format. Wojnarowicz's biography is replete with stories of kidnapping, confinement, rape, dope, thievery, homelessness, and hunger. As a child, he was dependent on guile to survive the constant terrors of street life. His diverse activities as an artist all seem to derive from the tuning of his senses to an "alert" status. This constant vigilance has made Wojnarowicz remarkably aware of sights, sounds, and smells, and his many creative endeavors are the result of a lifetime of collecting street data. Wojnarowicz was a scavenger as a child, and has remained one as an adult.

In each of the media in which Wojnarowicz works, he presents images, direct and unmediated, just as they would appear randomly on the street. For example, as a writer, bits of overheard language are gathered and written down. A succession of harsh urban noises recorded on a pocket tape recorder comprises his music. Similarly, as an artist, Wojnarowicz recreates the visual environment crammed with competing messages. The surfaces on which he paints are collected from the environment—garbage-can lids, maps, or, in the case of *Tuna*, a supermarket poster. The paintings themselves are most often stenciled. In each medium Wojnarowicz has selected a technique that presents material in a non-judgemental, style-free manner. Instead of sensationalizing or neutralizing his material, the individual identity of each element is preserved. The viewer is presented with a reminder of the clutter of modern urban life.

123

Hyman Bloom
( b. 1913)
*Haddock*
1951
Oil on canvas
16 x 40"
Courtesy Terry Dintenfass Gallery,
New York

124

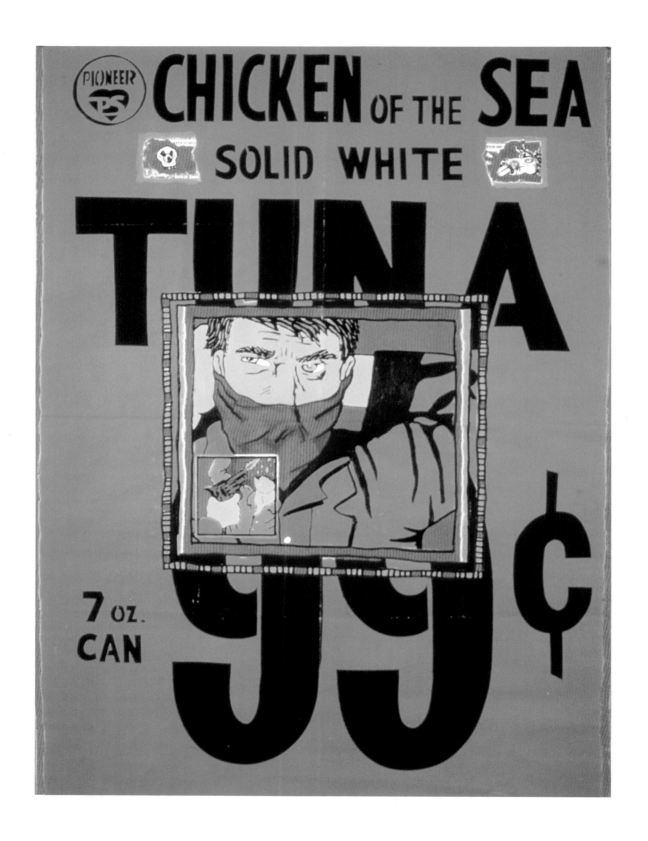

David Wojnarowicz
(b. 1954)
*Tuna*
1983
Acrylic & map on poster
30 x 20″
Courtesy Gracie Mansion Gallery, New York

The ability of art to awaken consciousness and instigate change is also exploited by Christy Rupp. Her work is unified by the depiction of the contest between nature and humanity, and in a work that addresses the plight of the fish in the oceans today, humanity loses irrevocably. The naturalistically rendered fish that comprise this series, *Acid Rain Brook Trout*, are all victims. Acid rain and PCBs are identified in the titles as their attackers. Some of the fish exhibit a ferocious visage, as if they have been transformed into monsters battling the onslaught of dredge, debris, and contaminants; others have developed perverse mutations, adaptations to the blighted waters of the world. The rest are dead.

Rupp believes the fish stories that are reported in the news. They proclaim that fish are imperiled and fish-eaters must be warned. The dangers they describe come from imprudent human behavior both onshore and off. Coastal hazards include oil and gas development, mineral mining, coal and oil transference. Ocean toxification comes from the dumping and incineration of sewage sludge, industrial wastes, dredged materials, and radioactive wastes.

Although Rupp's pieces make manifest some disturbing disruptions of the natural order, none of her images is frightening or gruesome in appearance. The intimate scale and pretty colors create a disarmingly toy-like appearance, and their witty, punning titles belie the urgent economic, political, sociological, and ecological controversies they address. The means are playful but the goal is didactic. Rupp has chosen gentle humor, not impassioned polemics, as the device to transform opinion.

125

126

Christy Rupp
(b. 1949)
*Acid Rain Brook Trout*
1984
Cardboard and spraypaint
5″ x 14″ x 2″
Courtesy P.P.O.W., New York

# Fowl Play

Game birds from the coastal beaches, salt- and fresh-water marshes, wooded highlands, and mountains were an important part of the American diet. From the days of the earliest colonists, hunting birds was both a sport and a necessity. The vast north-south flyways filled the skies with hundreds of thousands of birds on biannual migrations along the east coast. Relatively inexpensive, abundant, and very tasty, game birds were in great demand, particularly in the cities. By the 1850s, professional bird hunters, called market gunners, found a livelihood supplying eager urban buyers.

About the same time, the sporting aspect of bird hunting superseded necessity for many urban businessmen. They took spring and fall vacations to "camp" in the salt marshes and inland lakes and shoot all manner of wild fowl. Such hunting was perceived as a continuation of, or a return to, a time-honored tradition, and it became an accepted yearly rite for many men.

Images of hanging birds—trophies of the hunt—were accepted decorations on furniture and in paintings and prints on the walls of Victorian-era dining rooms. Game birds comprised one of the standard courses in large nineteenth-century dinners. This popularity led to inadvertent slaughter and a great reduction in the wildfowl population, including the extinction of several species. This was before Americans had the constant supply of beef brought about by the development of the Chicago stockyards and the rapid transportation by railroads.

Alexander Pope specialized in painting and sculpting all kinds of wild and domestic animals. Born in Dorchester, a pleasant town of villages, farms, and estates near Boston, his favorite occupation as a child was drawing and carving animals. Familiarity with wood came as his birthright; the Pope

family ran a lumber business. Pope was an avid sportsman, and his intimate knowledge of game birds and dogs grew from his passion for hunting.

In the late 1870s, against the advice of his family, Pope became a professional artist. His first efforts were wood carvings of game painted in close imitation of real birds. *Mallard Against Woven Basket* is one of a series of hanging-game still lifes he designed as wall plaques.

Pope expanded the techniques of *trompe l'oeil* painting by combining them with traditional decoy-making to create a hyper-realistic work. Not only is the duck carved and painted in a meticulously realistic manner, but it appears to be suspended on a real string, and its body extends over the side and the bottom rails of the frame. The level of artistry was appreciated by a wide public and two were purchased by Alexander III, the Czar of Russia.

Pope's first major commission was a series of illustrations for two portfolios, *Upland Game Birds and Water Fowl of the United States* (1878), and *Celebrated Dogs of America* (1882). In 1883, Pope turned to painting in oil. His work was well accepted locally and he became a successful artist. In an age which had developed breeding into a science, there was a large market for portraits of favored pets and farm animals, and Pope painted famous racehorses, championship cattle, and celebrated dogs. In fact, at the turn of the century he became known as the "Landseer of America," named after the sentimental English animal painter so admired by Queen Victoria. As Pope's love of wildlife grew, he turned against hunting. His final years were devoted to portraiture.

Harvey Dinnerstein has painted a proud man. The role that he performs is vital to his community and he performs his task according to the strictest standards of the law. Every Sabbath celebration and every holiday feast depends on him. He is a Kosher butcher, as the golden sign in Hebrew letters that hangs behind him indicates. His name is Noah

Wolf and he is an important member of the Jewish society. Providing food in this community conveys a religious aspect as well as a material one. Wolf wears a yamulke on his head and sits piously with his hands together, as if in prayer. He has assumed the responsibility of making food Kosher, according to the scriptures. In order for food to become sanctified, the butcher must serve the will of God.

This painting is in the tradition of early Flemish portraits in which sitters are shown accompanied by the tools of their trade: the jeweler's scale or the scholar's pen and paper. In this case, the dead hanging chicken epitomizes Noah Wolf's life—providing cleaned, plucked, and blessed chickens.

Painted by Dinnerstein in 1949 and purchased by the Pennsylvania Academy of Fine Arts a year later, this work is typical of the disciplined compositions and illustrative realism for which Dinnerstein is noted. A graduate of Temple University's Tyler Art School in Philadelphia, Dinnerstein was born in the Jewish neighborhood of Brooklyn where butcher shops like this were common. After graduating from Tyler, he returned to New York City to study at the Art Students League with Julien Levy, Yasuo Kuniyoshi, and later with Moses Soyer.

The chicken hanging over Noah Wolf's head defines the double role of this man—he is both of the flesh and above it. The dignity that Dinnerstein invests in his sitter demonstrates that Wolf does not perceive of himself as a common merchant. In his mind he is fulfilling a holy duty prescribed by God and essential to the Jewish community.

A distinctly profane version of the subject of poultry is created by Roy Lichtenstein. The painting is stubbornly devoid of iconographic clues. Despite the profusion of asso-

ciations relating turkey dinners with holidays, family gatherings, festivities, feasts, and formalities, this turkey sits on a red surface without any indication of its role there. It is a generic turkey—timeless, seasonless, locationless, and tasteless. Neither prospective diners nor table service accompany this roasted bird. It has no function and it has no home. It is, like all of Lichtenstein's subjects, an abstract sign for a bird not a real one.

This kind of neutralized image is common to the commercial design that abounds in the contemporary environment. Lichtenstein cropped it, intensified its colors and the shadows, and enlarged the Benday dots of the commercial printing process, making manifest the visual devices utilized by the media as well as the ludicrous nature of its subject matter. Lichtenstein's work typically represents heroes who are placed in highly romantic or dramatic situations. In this painting the heroes have been replaced by a humble, inert, and plastic turkey. The artist seems to be satirizing American popular culture as well as his own artistic representations of it.

Lichtenstein began to paint in a non-expressionist, non-gestural manner in the early 1960s. This dead-pan manner was first applied to such subjects as Donald Duck and Mickey Mouse. He treated them as vernacular signs which were capable of being transformed into the unique expression of an individual artist. *Turkey* belongs to this period.

129

130

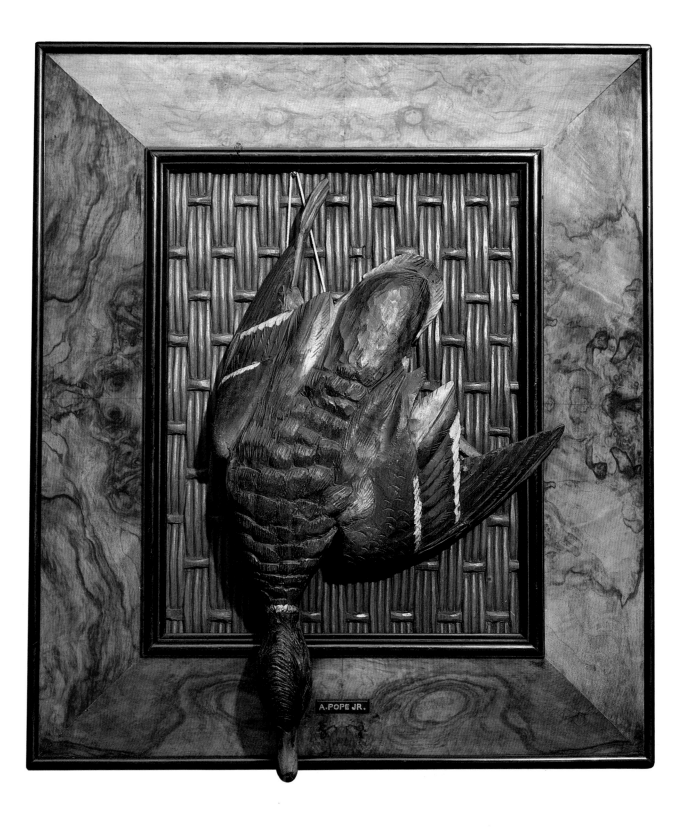

Alexander Pope
(1849–1924)
*Mallard Against Woven Basket*
c. 1879–1883
Painted wood
28 3/4″ x 23 3/4″
Courtesy Richard York Gallery, New York

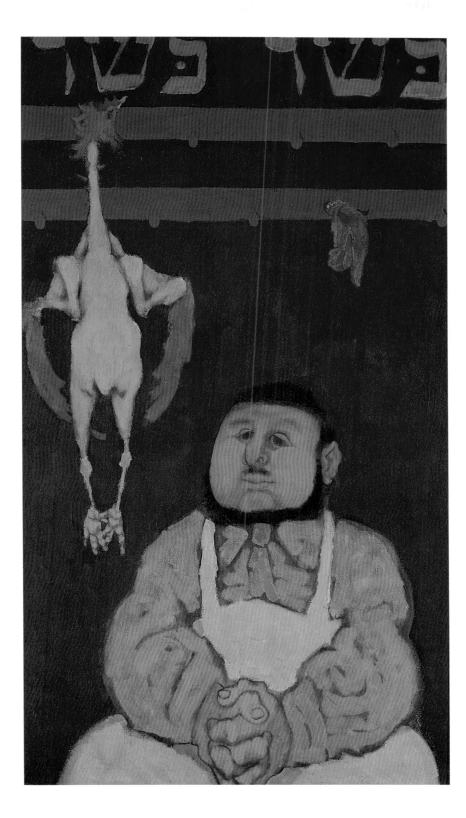

Harvey Dinnerstein
(b. 1928)
*Noah Wolf*
c. 1949
Oil on canvas
25 x 30″
Courtesy Pennsylvania Academy
of Fine Arts, Philadelphia

132

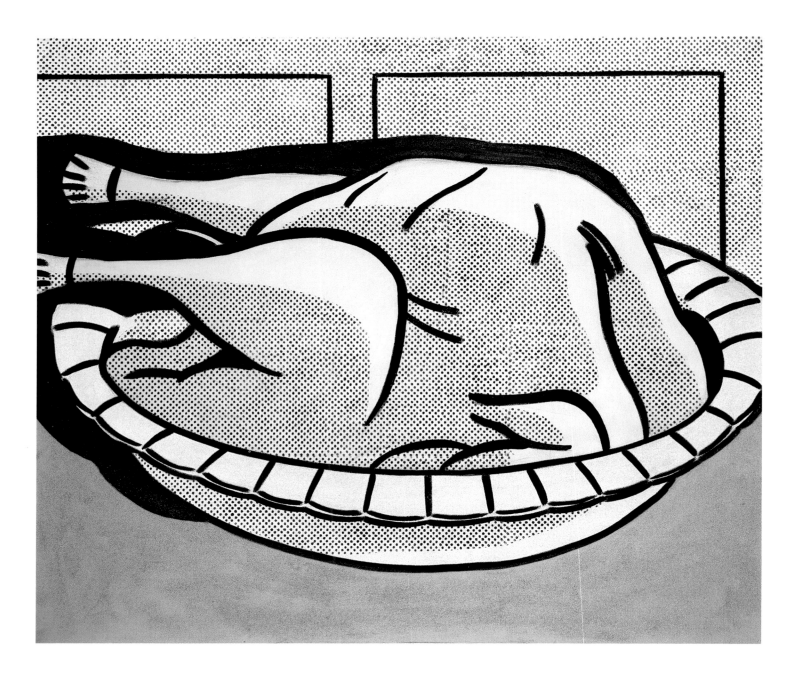

Roy Lichtenstein
(b. 1923)
*Turkey*
1961
Magna on canvas
26″ x 30″
Private Collection

# Apples and Eve

134

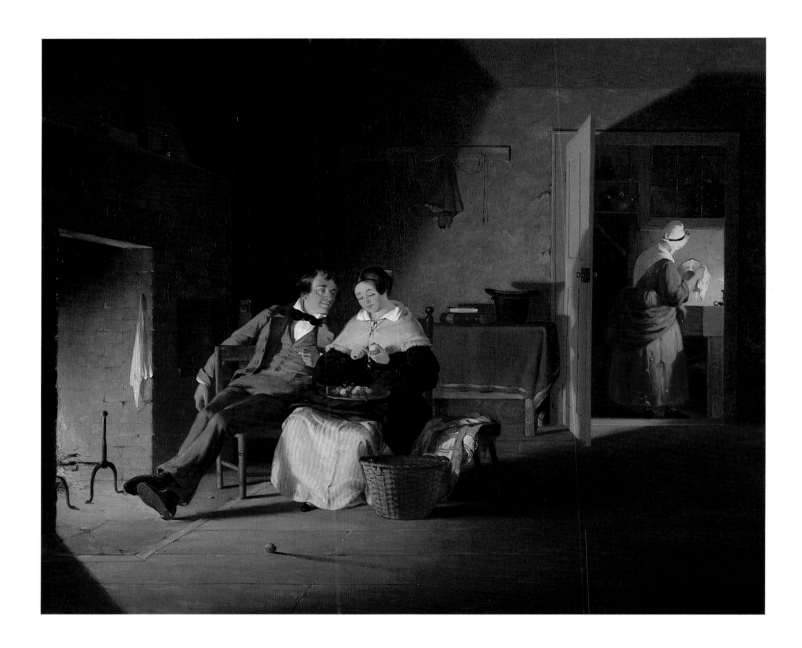

Francis William Edmonds
(1806–1863)
*Sparking*
1893
Oil on canvas
19 15/16 x 24″
Courtesy Sterling and
Francine Clark Art Institute
Williamstown, Massachusetts

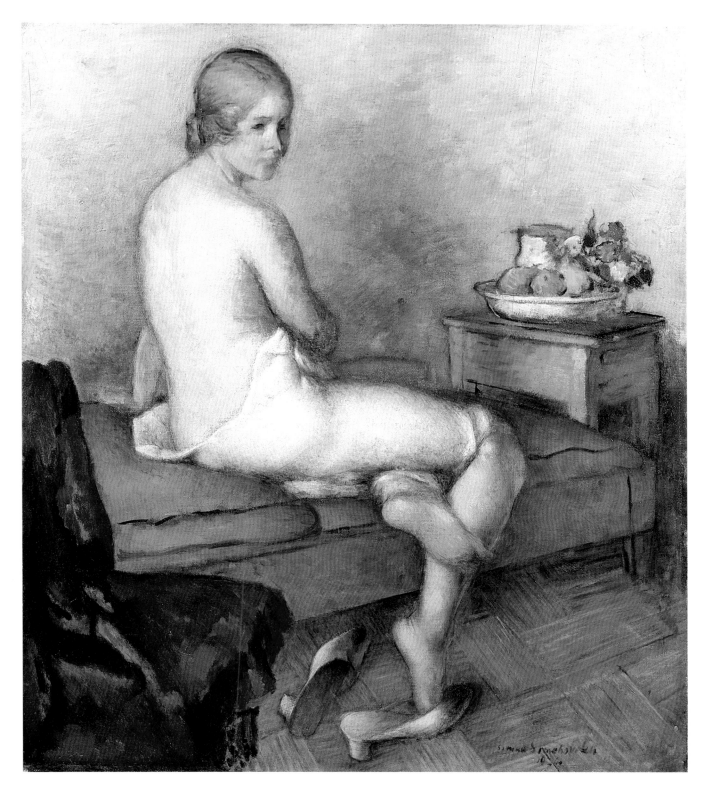

Simka Simkhovitch
(1893–1945)
*Aurienne or Nude with Still Life*
1930
Oil on canvas
28" x 23 3/4"
Courtesy Janet Marqusee Fine Arts

In the book, *Consuming Passions, The Anthropology of Eating,* George Armelagos and Peter Farb provide an explanation for the age-old association between food and sexuality:

"According to the Judeo-Christian tradition, eating the Fruit of Knowledge in the Garden of Eden was followed by sexual shame; first came food, then sex . . . More words from the lexicon from eating than from any other human activity have been used to describe sexual relations and organs. A woman is referred to as spicy, a dish, a hot tomato, a honey pot, a bit of mutton, a piece of cake, somebody who in fact looks good enough to eat. To lose one's virginity is to loose a cherry. Breasts are apples, melons, grapefruits, or fried eggs; testicles are nuts; the penis is a hot dog, a banana, or meat, the female organ is a bun . . . The close connection between eating and sex is not hard to explain, if it is assumed that early in the evolution of the human species males and females were brought together primarily by the two basic necessities for survival—food and procreation."

Although the apple has been used to connote wholesomeness and health, its association with eroticism and fertility is, perhaps, the most pervasive of all: the golden Apples of Hesperides were given to Hera as a wedding gift, the Apple of Discord was intended for the fairest woman of all, the apple tree bent its branches low so the Virgin Mary could eat the fruit, the tossed apple is a proposal of marriage in many cultures, and, invariably, the Tree of Knowledge is presumed to be an apple tree although it is not identified in the Bible.

Most of the works of art in this section refer back to the role of the apple in the medieval explication of the expulsion of Adam and Eve from the Garden of Eden. According to this doctrine, Eve was the guilty accomplice of the serpent-devil and the instrument of evil. Her seduction of Adam took place through the offering of an apple. In this way, fruit and woman became united in a coded symmetry that exists even in secular paintings of the female nude.

The perpetuation of the traditional relationship between food and sex is also a focus of these paintings. Around this baseline, however, society's attitudes toward sex swing from high to low. During this 150-year period here represented, sexual attitudes have not merely permutated, they have undergone a complete reversal. These paintings document those attitudes, from the coy exchange that accompanies nineteenth-century scenes of courtship to the blatant expression of sexual intentions in the works of the late twentieth century.

Overt sexuality is virtually nonexistent in nineteenth-century painting. However, the attraction between the sexes was touched on occasionally, sometimes in the guise of mythological stories, and other times in genre paintings. Of all the American artists of his time, Francis William Edmonds depicted more frequently the act of courtship within family life. John Lewis Krimmel and William Sidney Mount predate Edmonds in scenes of newlyweds or rival suitors, but the rituals of courtship offered him fertile ground for depicting the ways and mores of rural Americans. He does so with a mixture of humor and tenderness, always maintaining a proper decorum.

*Sparking* is one of Edmonds's earliest and strongest images of American courtship. The two would-be lovers bask in the warmth and light of the fireplace. In the background is the anonymous figure of an older woman, a proper chaperon who is not actually looking on, but certainly able to hear everything. Food is used as a symbol of the budding relationship. The young woman, with eyes averted and a slight blush to her cheeks, peels apples. This was a common pastime on American farms, but to reinforce the imagery of the apple, long identified as the fruit Eve offered Adam, a single apple is silhouetted on the floor before the couple. The young swain is admirably smitten, and in this view, the young Eve is suitably coy. While not a major focus of the painting, the use of the apple reinforces the idea of courtship by symbolizing Adam and Eve.

Edmonds was an unusual figure in the art world of his time. He was a successful banker and active in political affairs. He also enrolled in classes at the National Academy of Design,

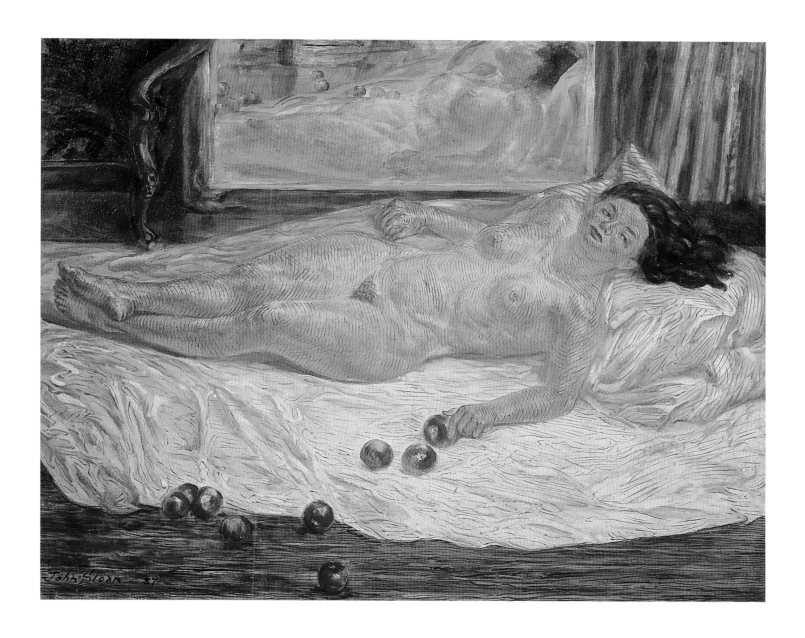

137

John Sloan
(1871–1951)
*Nude and Nine Apples*
1937
Tempera and oil on board
24″ x 30″
Courtesy Whitney Museum of American Art, New York
Gift of Gertrude Vanderbilt Whitney
by exchange 51.41

and his work was exhibited in New York City throughout much of his life. In the 1840s, he served as manager of the American Art-Union. In his dual vocations, as businessman and artist, Edmonds witnessed many sides of American life during the era of Jacksonian Democracy. He caught the essence of some of our national traditions, local foibles, and economic hardships.

Like Francis William Edmonds, Simka Simkhovitch utilizes many of the techniques intended to capture in painting the visual and the physical effects of the material world. The colors, textures, light, and shapes confirm the viewer's sensual experience. Simkhovitch has fully rendered the human figure and the settings in which they were placed; the artist's own personality is subverted. This naturalistic inclination was soon to disappear.

Simkhovitch was born near Kiev in 1893, the son of a middle-class family that managed a department store. Not interested in pursuing the family business, he attended art school in Odessa, and continued at the Royal Academy in St. Petersburg. In 1924 he immigrated to New York City where he began work as an illustrator for the Hollywood filmwriter Ernest Pascal. Pascal introduced Simkhovitch to gallery-owner Marie Sterner, and she exhibited his work in her 57th Street gallery.

*Aurienne or Nude with Still Life* is typical of the strong, yet sensitive, compositions for which Simkhovitch, sometimes called a modern Watteau because of the languorous feeling evident in much of his work, is best known. A portrait of his wife, Elsa Fornell, a New Englander of Swedish descent, it was completed in 1930, the year after their marriage. The composition, which at first glance appears informal, is carefully thought out. The colors of the apple, pear, and orange are chosen specifically to contrast with the umber of the chaise and the light lavender satin of the casually strewn, open-backed slippers. The low vase of light pink flowers at the right, nestled in with the fruit, draws our attention back to the subtle pink paleness of the nude woman's body.

To achieve the sculptural quality he desired, Simkhovitch concentrates on the planes of his sitter, the couch, and the table so that the bulk of the forms are emphasized, transcending the conventional approach and bringing a real freshness to the work. As he stated in a 1940 interview, art for him was bound up with the depiction of existent ideals and happenings, the sincerity of order, and joy in everyday living.

That joy is evidenced in the intimacy of feeling shown in this work, a subject that has a long history. Portrayed in the style of an Odalesque, somewhat reclining on a chaise longue with only a thin sheet to cover her soft ivory body, the subject brings to mind a host of other equally lovely nudes by a myriad artists from Ingres to Manet. In many of those compositions, as here, the succulence of the fruit is complemented by that of the model's body. Both delight the senses and speak of pleasures yet to come.

The subtlety of the rendering in Simkhovitch's painting, like the modesty of his model, is eliminated in the work of John Sloan. Not only does Sloan allow the activity of his brush stroke and the transformations of his style to intervene with the model and the completed work of art, he also removes any subtlety from the presentation of the nude. Unlike the figures in Edmonds's painting who are fully clothed, and the nude in Simkhovitch's who discreetly holds a cloth across her body, Sloan's figure is assertively naked. Devoid of any semblance of shame or shyness, she confronts the intense scrutiny of the artist as well as that of the viewer. Sensuality has been replaced with sexuality.

In 1892 Sloan landed a job in the art department of the Philadelphia *Inquirer* and enrolled in classes at the Pennsylvania Academy of Fine Arts. There he took night classes in drawing from Robert Henri. Henri encouraged Sloan to study the work of Manet, Hals, and Velasquez, and when Henri moved to New York City in 1904, Sloan followed.

There, Sloan became fascinated with urban America in all its diversity, and some of his most popular paintings from this period are anecdotal vignettes of Manhattan city life. His painting of a Greenwich Village backyard, complete

138

with garbage cans, gave the name the "ash can school" to the young group of artists surrounding Henri.

Searching for his subjects on the city's streets, Sloan relied on his reporter's instincts to make quick and keen observations, and his approach in these early scenes is fresh and energetic. As the twenties came to an end, however, so did Sloan's interest in city life, and by 1930 he had turned his attention to the old masters. Nudes and portraits then became his primary subject matter, and he completed more than thirty separate etchings, and numerous pencil sketches, and oil and tempera paintings on composition board. *Nude and Nine Apples*, executed in 1937, is one of them.

Reclining on a sheet that has been spread over a wooden floor, the nude poses comfortably. She is full-bodied, attractive, and sexual, but presented at a studied distance. Her image is reflected in the mirror placed behind her. To the left of the composition is part of a couch; to the right, a stack of the artist's paintings—the accoutrements of the artist's studio. Nine apples are strewn across the floor and sheet, one of them in the left hand of the model. She looks out with a vaguely sad and pensive look, sexual and yet aloof, perhaps with the forethought of events to come.

Stylistically, Sloan uses extensive linear surface modeling to give plasticity to his composition, broken reddish lines to sculpt the polychrome clay-like consistency of the figure. These linear strokes follow along the curves of her body, giving contour and form to the flesh colors, as well as a sense of movement to the sheet on which she reclines.

Sloan called this technique "linework," and he employs it to add significance to certain surfaces, increasing the impression of light and shade. The crosshatching was not appealing to a number of his critics who were more attracted to his earlier scenes of urban life. But Sloan kept to this linear style until the end of his artistic career, using the texturing to add to the tangibility of his forms.

Sloan's nude here is a vital woman. Through the rendering of the particularities of her body, face, and posture, he has created a living being. She is capable of provoking the viewer because of the full evocation of her personality.

In the thirty years between this work and the painting by Mel Ramos, the interest in capturing the nuances of personality had greatly diminished. Art became blatant—its colors intensified, its forms simplified. Intellectual and poetic content were omitted in favor of instantaneous impact, qualities it shared with the thirty-second advertisement. Ramos's nude, like the objects that surround her, appears to be created out of wax, cardboard, and foam core. Individuality, with its unique combination of flaws and attributes, has been replaced with the impossible perfection of stereotypical forms that are conceived of, and produced by, the media.

Ramos is representative of the Pop movement in California. He is a dead-pan painter of pin-up nudes lolling on, in, or beside contemporary, packaged food products. *Miss Fruit Salad*, 1965, is Ramos at his most outrageous, reasserting the connection between sex and commodity as it has been exploited again and again by the advertising industry. As is commonly known, sex sells, and Ramos is willing to expose the absurdity of the society that accepts soft porn in its capitalist program of consumption while remaining opposed to such sexual abandon in everyday social life.

Ramos began to paint these all-American sex goddesses provocatively posed with advertising imagery in 1964. Titles such as *Val Veeta* or *Lola Cola* reduce both girl and food product to a packaged commodity. The idealized sex-objects are as processed as the foodstuffs they sell. *Miss Fruit Salad* conjures up, by pose and make-up, a particular time—the early '60s. Her placement within a cup of fruit salad is both banal and undeniably sexy. The sweet, juicy bits of fruit and the bronzed, glowing flesh together excite the appetite of the viewer. *Miss Fruit Salad* self-consciously addresses desire and cliché. In a replay of the ancient story, Eve entices Adam once again to taste the forbidden fruit of paradise.

In the past thirty years advertising has become more refined and more insistent, but during these years, too, the culture has become more visually sophisticated and more aware of the false promises set forth by seductive juxtapositions. It is

139

140

Mel Ramos
(b. 1935)
*Miss Fruit Salad*
1965
Oil on canvas
60 x 50 1/2"
Courtesy Frederick R. Weisman
Art Foundation, Los Angeles

Buster Cleveland
(b. 1943)
*Juicy Fruit*
1986
Mixed media collage
19 1/2″ x 19 1/2″
Courtesy Gracie Mansion Gallery, New York

significant to our appreciation of Ramos's spoofs on advertising to recall that Herbert Marcuse was extremely influential in the 1960s. Marcuse saw the evils of the increasingly consumer-oriented society and condemned the homogenization of civilization. Advertising was and is still the driving force behind capitalist consumption. Ramos, in his absurd reading of an ad-man's vision, knocks all the subtlety out of the seduction and exposes advertising's tricks for what they are.

Buster Cleveland exaggerates the layering of associations found in Ramos's work. Cleveland's rather serious social purpose is executed with high-spirited humor. He is a jester whose jokes reveal truths about contemporary culture. Cleveland explains in an interview: "It's important to make people smile. I consider myself an anarchist, but not a bomb throwing anarchist. I prefer to make people laugh."

*Juicy Fruit* is an example of the manner in which Cleveland translates his "artgangsterism" into actual art objects. His assemblages and collages are created out of poured plastic in which mass-produced objects from contemporary Pop culture are imbedded. Frames are painted gold and silver, and encrusted with pearls, baubles, charms, and pennies, creating the look of a Barbie Doll dreamhouse or a casino ballroom.

The tone is ideally suited to the theme of this piece, which exposes the sexual innuendoes that abound in advertising of even the most innocuous commodities, in this case, Juicy Fruit gum. Fruit has long been identified with sexual temptations because of its plumpness, ripeness, juiciness, sweetness, all qualities shared by the pin-up nude in the calendar that is affixed to the middle of the assemblage. Cleveland evokes its naughtiest connotations and sets the viewer's mind traveling into the metaphoric realm where even "ten five-stick packages" and "Wrigley's" and "fascinating" and "Lucky Strike" all seem to acquire sexual references. These found and recomposed bits of reality, which at first appear arbitrary, are united by the artist's punning humor. Apparent

meanings are reversed and multiplied and directed into unexpected interpretations.

These pieces are all presented in the form of television screens or storefronts. Once the viewer peers in, the earnest goal of the Dada jester is fulfilled: "To make people aware of the bullshit."

Buster Cleveland has established a position in a very particular juncture on art's family tree. He traces his ancestors back to Zurich and Berlin, where artists fleeing World War I congregated and founded the Dada movement. He explained in 1981, "I grew up and I wanted to be a beatnik, but I was too young, and I was too old to be a hippie, so I became a Dadaist." The Dada movement was established as a rebellion against other art forms. Cleveland retains its anarchistic nature, creating objects and devising escapades which assert opposition to traditional artistic values.

Peering within is also the mode of visual perception appropriate in viewing a work of art by Ed McGowin. His sculptures are enclosures in the form of underscaled architecture. The spaces within contain tableaux or sound tracks of a story or a song that is usually written by McGowin himself. Interiors are as provocative as the exteriors are uningratiating. The scenes within are carefully contrived to evoke surprise, humor, enlightenment, or frustration. These emotional responses are calculated to comment on timely social issues. In the past, McGowin has addressed aging, labor, alcoholism, gun control, divorce, and pornography. *Girl with Apple* explores the mythic role of the apple.

The superimposition of the female head, and the translucent apple that fills McGowin's canvas evokes a dreamy atmosphere: is this figure "the apple of someone's eye?" The ambiguous image is sharply contrasted by the cast-metal frame on which twelve embracing couples are explicitly described and regularly arranged. Once again, the mystery of McGowin's interior is exaggerated by the solid material presence of the frame. The stillness, singularity, and flatness of the painting contrasts with the activity, multiplicity, and three-dimensionality of the sculpted frame.

142

The two areas also contrast in terms of scale (a single large form vs. multiple small forms), color (full scale within and monochrome without), texture (atmospheric vs. reflective), and medium (paint vs. metal).

These contradictions may also parallel the substance of the apple itself and explain its traditional association with female allure: smooth and beguiling, the skin encloses a sweet and succulent interior. It, in turn, contains seeds, the source of its progeny. Although apples share these characteristics with many other fruits, they are distinctive in several ways; they are more red, more shiny, more popular. Simply put, apples are more tempting, and therefore likely candidates for symbolic functions.

Besides the apple, another sweet and enticing food that serves as a metaphor for sexuality is candy. It is used by Al Hansen, who, like Buster Cleveland, is known as one of the pioneers of the Fluxus movement.

*Eyes Momma* is a classic Fluxus work. It manifests the difference between Fluxus and Pop art despite the fact that the appropriation of commercial products is common to both schools. Hansen does not adopt Pop art's straightforward, marketplace appearance. Instead, he playfully manipulates and transforms his subject. *In Eyes Momma*, Hansen invents a host of visual and sound associations, making a burlesque of the devices employed by the advertising industry. The work is a comic exaggeration of the techniques employed by Madison Avenue to seduce the consumer into making a purchase.

Hansen's *Eyes Momma* has been shrunk in parts and swollen in others to evoke the ample curves of a great fertility goddess. The candy bar assumes a magical presence. It is simultaneously sexually and orally enticing, leaving the viewer with a predicament: is unwrapping the candy like undressing the doll?

Nowhere in this work does Hansen write the complete word HERSHEY. Instead, bits and pieces of the word float, like stars in the Milky Way (or perhaps in a Mars Bar). They sparkle in silver against the chocolate-brown night sky— broadcasting their seductive message to the viewer, who is beckoned to partake in a double-dose of forbidden pleasures—candy and sex.

Like so many effective advertisements, the two delights are intermingled, inextricably linked as sensual and tempting. The message is bold and captivating, recreated in the form of a visual poem that not only suggests the two kinds of irresistible indulgences, but their emotional aspects as well. Such gutteral exclamations as *Y*, an expression of immediate and unmitigated glee; *R*, an announcement of one's intentions to succumb to temptation; and *SH*, an admonition to be quiet while partaking in the forbidden act; OOH LALA—MMM! MMM! MMM!—HEY! Hansen reminds us of the nature of this pleasure by further splitting the letters of HERSHEY to form the words HER, SHE, and HE. These are joined not only with the word YES, but the triple repetition of this word, as if the victim has not only succumbed, but is most eager to proceed.

143

Hansen, thereby, uses visual and sound associations to evoke a desire for the most unnecessary of foods—candy, and the most necessary of acts—sex.

144

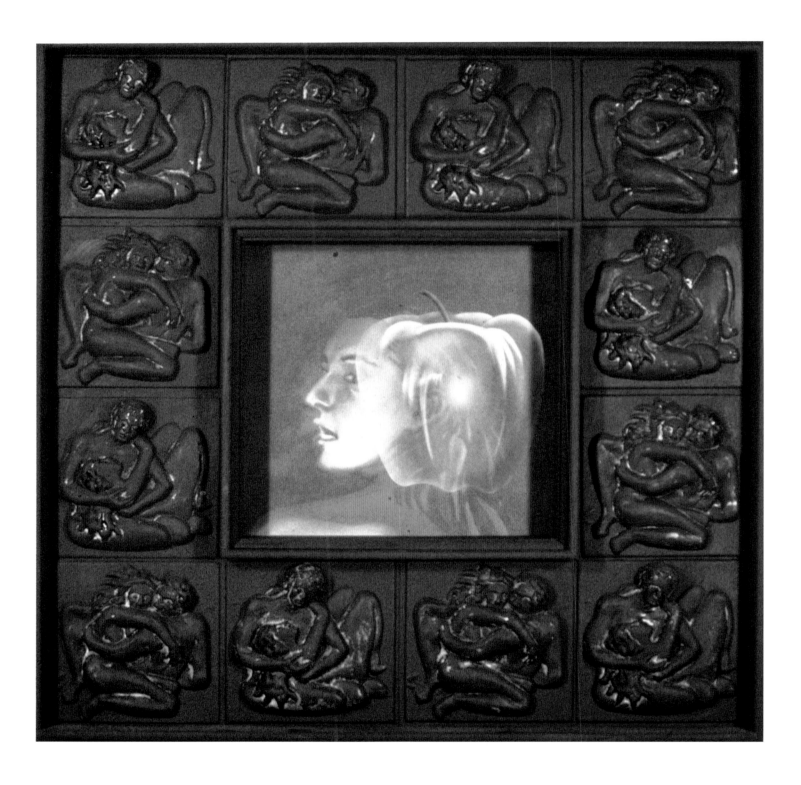

Ed McGowin
(b. 1938)
*Girl with Apple*
1987
Acrylic on board, cast styreen & wood frame
35″ x 35″
Courtesy Gracie Mansion Gallery, New York

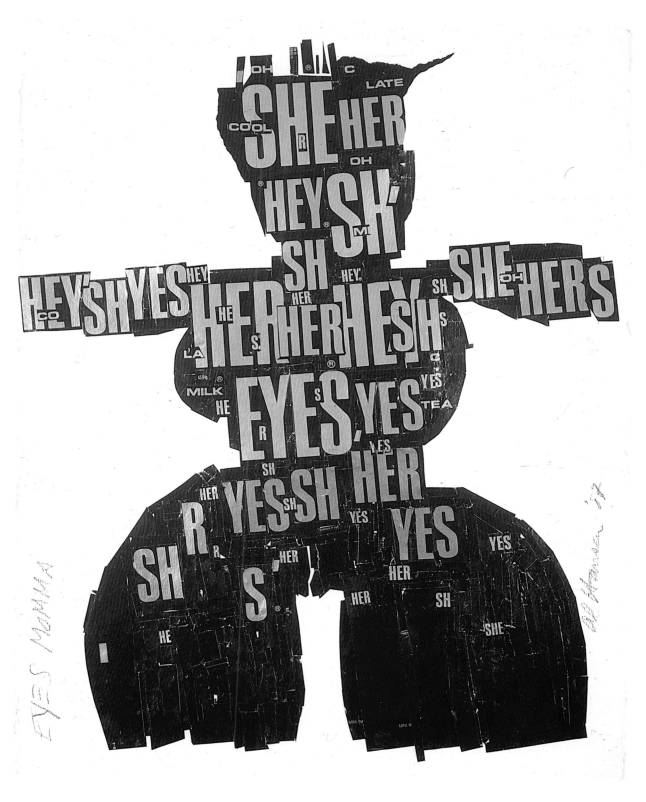

145

Al Hansen
(b. 1946)
*Eyes Momma*
1987
Hershey Bar wrappers and mixed media
31 x 21 3/4
Courtesy Gracie Mansion Gallery, New York

# Mixed Drinks

148

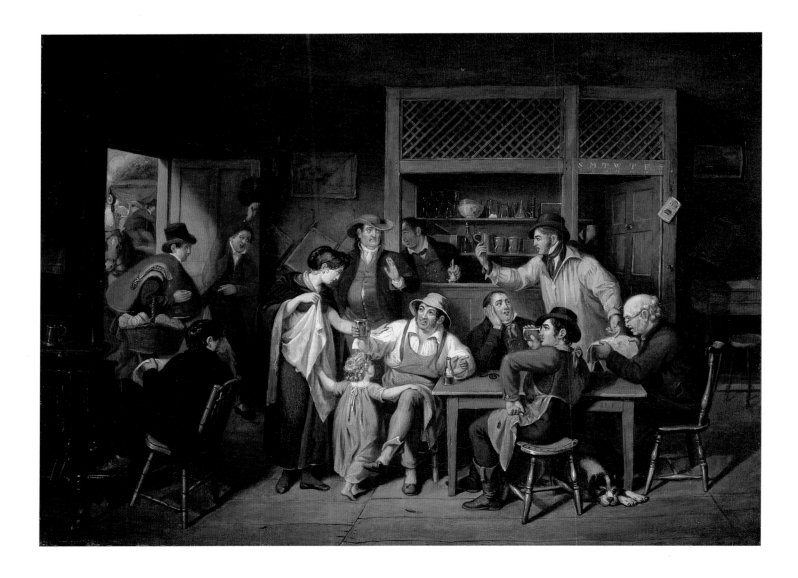

John Lewis Krimmel
(1789–1821)
*The Village Tavern*
1813–14
Oil on canvas
16 7/8 x 22 1/2"
Courtesy Toledo Museum of Art,
Toledo, Ohio;
Gift of Florence Scott Libbey

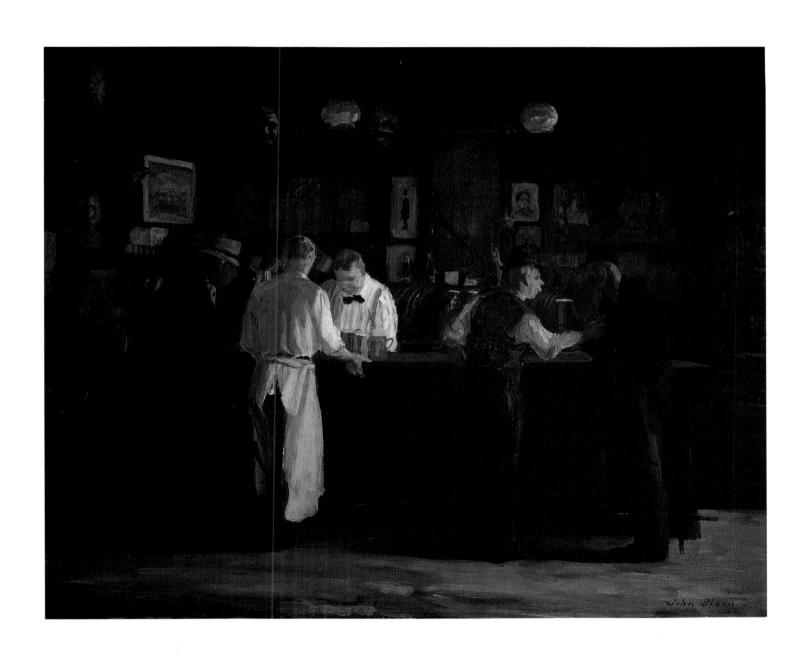

149

John Sloan
(1871–1951)
*McSorley's Bar*
1912
Oil on canvas
26 x 32″
Courtesy Detroit Institute of Arts,
Founders Society Purchase

In 600 BC a Scythian sage summed up the nature of alcohol consumption: "The first draught serves for health, the second for pleasure, the third for shame, and the fourth for madness." Alcohol can be consumed for the pleasure of its taste or for its effect upon the psyche. It can either preserve or ruin one's health. As a psychological stimulant, it can provide comfort to the depressed, confidence to the bashful, and courage to the fearful. The artists here whose works depict the subject of alcohol have represented those habits of consumption that were common within the cultural settings in which they lived.

Alcohol came to North America with the first settlers. The Pilgrims included beer as one of their necessities on board the *Mayflower,* and they began production soon after landing. The adaptability of apple trees to the northeastern United States resulted in abundant harvests and a great deal of hard cider.

It has been reported that for most early Americans, young and old, male and female, the day began with a tumbler of rum or whiskey. Breakfast was accompanied by spirits and then in mid-morning offices, shops, and factories closed so that employees could repair to the tavern for their "'leven o'clock bitters," a custom that was repeated in the mid-afternoon. Rum, whiskey, and brandy were served at lunch and dinner. Prayers and a nightcap were the habit before bedtime.

Distilled liquors acquired an important role in the economy. The mainstay of the profitable triangular trade was the New England production of rum. The South was equally engrossed in the production of different whiskeys, particularly bourbon, first made in Kentucky from corn, rye, and malted barley.

When John Lewis Krimmel painted *The Village Tavern* in 1813, drinking alcohol was still acceptable to a large majority of Americans. *The Village Tavern* is set in the Pennsylvania countryside and depicts a local clientele of farmers and workmen. Most of the activities that made the American

tavern the focus of community life are carefully included. Krimmel represents the tavern's two main functions—providing a place to dispense information and to drink—around the table in the center of the painting. On the right, a white-haired man is reading a newspaper. One of his listeners gestures to an elderly man in Quaker dress who gently demurs with a raised hand. The news may well concern the ongoing War of 1812, to which the pacific Quakers were opposed. On the left is a workman, still wearing his apron, who declines to leave with his wife and child as he has yet to finish his drink. In the background is the tavern-keeper, interrupted during the mixing of a drink by the arrival of the stage, just visible outside. Several newspapers are hanging on the wall behind him. A young man carries the mail satchel and packages through the open door. In the left corner sits a lounger, warming his feet and drink on the stove while watching all the activity.

Krimmel captures all that the tavern meant to early nineteenth-century Americans. It doubled as a stage stop and a post office. It provided a place of meeting for townspeople and travelers and was often a focus of political debate. It has even been said that the American revolution started in the taverns. Not least, the tavern was a center of conviviality and refreshment. The disapprobation and disreputable character of barrooms that later struck the American social conscience are barely discernible here. *The Village Tavern* is a straightforward depiction of an important American institution.

Krimmel, a native of Ebingen, Germany, was the first artist in America to devote his career to genre painting. After some artistic training in Württemberg and London, he joined his brother in Philadelphia in 1809. An early work, *The Village Tavern* reflects the influence of European art.

John Sloan was as assertively American in his style of painting as Krimmel was European. A political artist and the most actively involved of all the urban realists, he joined the Socialist Party in 1909, ran for New York State Senate twice, and was editor of the *The Masses* from 1912–1916. In 1918, he became president of the Society of Independent Artists, a position he held throughout his life.

Influenced by the teaching of Robert Henri, Sloan concentrated on direct observation of daily life, turning his back on the conservative and conventional art of his day. He was fascinated by the activity he found going on at street corners and in backyards, restaurants, outdoor amusement parks, and saloons. Of the many bars he visited, McSorley's was a favorite and his diary entries, particularly for 1912, show that he made frequent visits there. Located in Sloan's Manhattan neighborhood, at 15 East 7th Street, and originally called The Old House At Home, McSorley's Old Ale House was opened by John McSorley in 1854. Off-limits to women, it attracted a varied clientele of poets, artists, bankers, brokers, and bricklayers. Sloan made numerous drawings and at least five paintings of McSorley's, showing the assorted characters who frequented the bar, McSorley's cats, and many of the objects which gave the place its special atmosphere.

This version of McSorleys shows the bar at ten after eleven in the morning, according to the clock on the wall, a slow time for the usually crowded establishment. Only four patrons are in the bar: one sits solitarily to the left, smoking his pipe and drinking from a tankard of ale; another, near him, drinks alone at the bar; and down to the right two men converse as the red-haired bartender in his striped shirt and bow tie fills up beer mugs for the attending waiter. Sloan captures the easygoing familiarity of the scene and all of its accoutrements: the tankards hanging from the hooks, the horse-racing painting framed at the left, and the illustration of Abraham Lincoln in his stovepipe hat. This is the neighborhood meeting place and an important center for the male community, where alcohol and friendship reign supreme.

Henrik Glintenkamp, too, studied with Robert Henri, from whom he learned his most important lesson—to search for subject matter in the bustling activity of city life. *Cuban Workers' Club* documents one of Glintenkamp's excursions to the private clubs and saloons of New York City, where, for the cost of a five-cent beer, he could enter the atmosphere of a foreign culture. Glintenkamp, who knew Spanish well, was at ease in the environment. His painting, completed in 1937, captures the spirit of a club where Cuban workers gathered to share a meal or a drink and exchange ideas. The Spanish slogans on the wall echo the feelings of the day, "Que Haces Tu Para" ("What do you do to . . . ").

*Cuban Workers' Club* captures the spirit of the time as men and women gather to talk, drink, read the newspaper, and just observe. Only the viewers, like the blond-haired man in the middle, watch the activity with some distance, from the outside. The painting is of a predominantly male group, almost entirely Hispanic and Black. Of the three women, one occupies a prominent place at the center. The solitary blond figure to center left may be a self-portrait of Glintenkamp. The focus of the work, however, is on the woman and two men in the center. Elegantly dressed in a heavy wool coat and feathered hat, her nails polished a bright red to match her lips, the woman exudes strength and vitality. She is speaking as they listen.

The paintings by Krimmel, Sloan, and Glintenkamp confirm a conviviality that accompanies drinking. The occupants of these bars and clubs use alcohol as a social catalyst, creating a relaxed atmosphere, friendly banter, and an uninhibited exchange of thoughts. The relative absence of females attests to society's traditional proscription against the use of alcohol by respectable women. These settings visualize the relationship between the words "fraternal" and "fraternize."

The reverse effect of alcohol is recorded by George Tooker, who portrays a man seated in a window, a bottle of wine held firmly in his hand. He gazes out while a woman, covering her naked body with a sheet, peers out from behind a curtain. The wine seems to have isolated this drinker. Not only is he separated from the outside world, his back is turned to his partner. He prefers the company of the bottle. The mood, unlike the festive spirit in the other paintings, is mellow. Tooker demonstrates that alcohol can also be a vehicle for retreating from the world.

George Tooker is a magic realist; he works on the edge of realism and surrealism to create eerie evocations of contemporary life. Tooker paints with egg-yolk tempera, the slow, methodical technique of Italian Renaissance art. This requires that an artist work out his composition completely before beginning his work; accidents of process, therefore, do not play a role in the realization of the subject. Tooker's

151

152

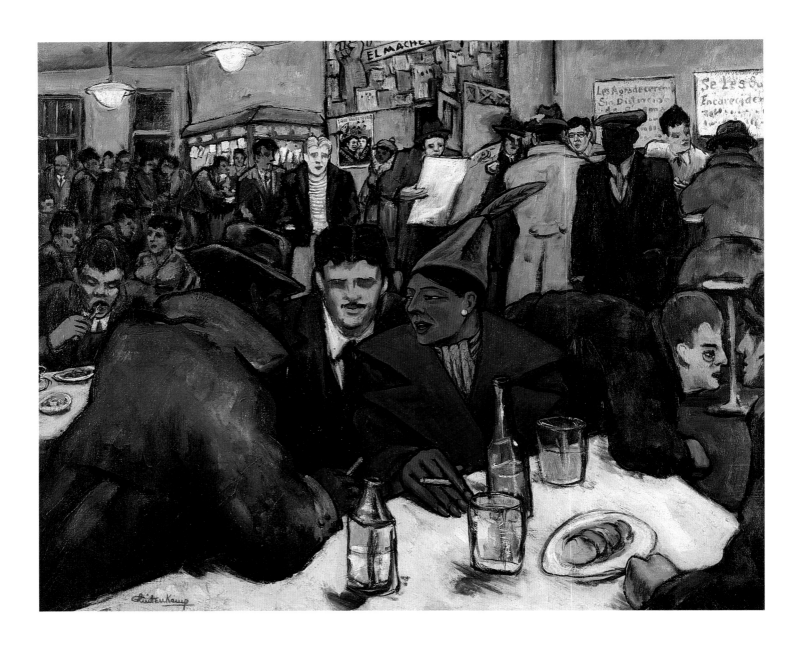

Hendrik Glintenkamp
(1887–1946)
*Cuban Workers' Club*
1937
Oil on canvas
26 1/4 x 32 1/4"
Courtesy The Chrysler Museum,
Norfolk, Virginia

153

George Tooker
(b. 1920)
*Window*
1987
Egg tempera on board
23 1/2 x 17 1/4"
Courtesy Marisa del Re Gallery,
New York

154

INDULGE OR DENY?

Brad Melamed
(b. 1948)
*Bacchanal*
1984
Acrylic on canvas
24 x 16"
Courtesy Doug Milford

considerable skill in this difficult medium invests his work with a luminosity and solidity of form comparable to that found in Renaissance painting.

The composition of this work, in which the frame of the painting simultaneously functions as the frame of the window, is also a device with a long history. While it is traditionally used to enhance the illusion of looking through the canvas into a painted setting, Tooker reverses the direction of the voyeur's gaze. In an uncanny twist, these two painted beings study our world, while remaining aloof from our scrutiny of them. The young man whose forearm rests on the *trompe l'oeil* ledge of the window moves forward into the viewer's space. Tooker's inclusion of this half-finished bottle of wine is significant. It is an indication of passing time in contrast to all the other elements within the composition, such as the solid, architectonic figures which appear frozen in a moment spun out through eternity. In the same way, the interlocking shapes of the constricted composition hold time in suspension.

The bottle of wine is also an indicator of mood. Alcohol is generally associated with celebration, but here the wine evokes a sense of meditative stillness. Instead of ushering the drinker into a social environment, it has isolated him. Because he and the label-less bottle are generalized types, they become symbols of the alienation of contemporary life.

Brad Melamed applies a distinctly contemporary point of view to the subject of alcohol. He refers to drinking as a temptation that should be resisted for fear of its consequences. It is a category of human decision-making to be added to the accumulation of choices regarding material goods, careers, residences, and entertainment that the American economy assures its citizens, as a legal right, each and every day.

For the individual, making a choice provides the opportunity to demonstrate the nature of one's will, character, and personality. But choice is not only a privilege, it can also become a burden. In a free society promises and possibilities abound. This bewildering array of options is the subject of Melamed's paintings. Images in his works are combined with questions in which the viewer is interrogated and must make a decision:

"Would You Rather Prove Your Individuality
or Sense Your Universality?"
"Would You Rather Live a Lie or Feel
Inconsequential?"
"Would You Rather Live a Lie or Feel Like
a Homosexual?"

Some of the dichotomies posed by Melamed's work go beyond these psychological dilemmas. They measure changing circumstances that have evolved in society as a whole. For instance, "Free Love/Safe Sex" is a pairing of phrases that summarizes two eras in American history. They are a reminder that the hedonism of the 1960s contrasts sharply to the restraint of the 1980s and '90s. Similarly, the title of this work, *Bacchanal*, applies the contrast in attitudes to another category of human behavior—drinking. Along one side of the canvas appear the words "Indulge or Deny?".

155

*Bacchanal* confirms the fact that people have lost faith in the no-fault society. Actions that were once considered sources of pleasure are now complicated by their association with dreaded and widely publicized consequences; gratification is threatened by anticipated fear or guilt. Sunbathing is known to be dangerous, for example, cigarettes carry warnings, and romance is inhibited by fear of AIDS.

*Bacchanal* relates the choice between short-run pleasure and long-term regret to the subject of drinking. It is a motto for an era in which intemperance is neither tolerated nor desired.

# Dying to Eat

Several of the artists in this section address the irony that eating is both a life-preserving activity and a murderous act: preparing food for sustenance necessitates killing some other living being. In the work of these artists, food becomes an effective metaphor for mindless and socially sanctioned violence. The other artists here demonstrate that both excessive as well as insufficient eating can be the cause of death.

Albert King's painting *Wine, Whiskey and Death* conjures the deadly consequences of alcohol by its depiction of the most common symbol of death, the skull. Other frequently used symbols include a recently snuffed candle or a vase of wilted flowers. These themes were established in the Dutch still-life tradition and were called "vanitas" because of their reference to the Biblical proverb, "Vanity of vanities, all is vanity." The vanitas was revived in nineteenth-century art, and while not a common theme for American artists, it appears from time to time, mostly in still-life form.

Several canvases with skulls painted by William Michael Harnett, a leading still-life artist of the later nineteenth century, may have inspired King. *Wine, Whiskey and Death* is a frontal image, with the objects lined up along a table top that is parallel to the picture plane. The skull, with its misshapen eye socket, leers at the viewer. It is symmetrically balanced by a champagne bottle with an empty glass and a wine decanter with an empty tumbler. The arrangement is a direct parallel between death and alcohol. Alcoholism was a persistent concern in American society from the colonial era, and it was in the mid-nineteenth century that a serious temperance campaign began to flourish, gradually growing until prohibition was declared a national law.

King, largely a self-taught artist who was born and raised in Pittsburgh, worked as a portrait painter for most of his career. He has been characterized as an artist that continued the nineteenth-century style well into the twentieth.

George Grosz came to New York City from his native Germany in 1932, having been invited to join the faculty of the Art Students League. He is best known for his brutally satiric drawings of the greed, corruption, and vulgarities found in all societies but certainly prevalent in post-World War I Germany. In America, Grosz depicted the follies and corruption of the social system, but the harshness of his satires was diminished by his enjoyment of his new country. By 1937, he had turned his sharp, critical eye away from society, preferring to experiment with nudes, landscapes, and still lifes in the traditional medium of oil paint. The declaration of World War II, however, renewed his criticism of society and his anti-war sentiments. In response to the prolonged violence of the war, he produced a series of paintings which, in their savage portrayal of the inhumanity of man, confronts the viewer with the unimaginable horrors of war.

*Movable Feast* relates human flesh to eating and suggests cannibalism. Grosz's table is filled with perverse fare; human eyes, noses, faces, and inner organs peek out from among the platters heaped with cakes, fruits, salads, and luncheon meats. Food becomes animated with leering eyes and smiling mouths, a literalization of "eating each other alive" and "consuming each other." Similar in method to Dali's self-induced paranoiac vision, Grosz uses his surrealist "paranoiac critical method" to envision a gruesome array of human parts on a well-laid table.

The chef who smiles in self-satisfaction reveals the degree to which inhumane behavior has become institutionalized and sanctioned in society. With a Dadaist's humor, Grosz portrays a social order in which individuals selfishly compete against one another. This society is based on the principle that someone must be sacrificed in order for someone else to triumph. Grosz portrays the "dog eats dog" mentality by depicting a "man eats man" banquet, prepared with great skill and served with fanfare by a chef who appears celestial, standing in front of towering cumulus clouds. Food, because its preparation involves an act of killing, is used here as a metaphor for all forms of aggressive social behavior—economic, militaristic, and political.

Instead of using the subtle intellectuality of metaphor, Robert Indiana has adopted the declarative form of communica-

tion that is associated with billboard aesthetics, storefront signage, merchandise packaging, and media promotion. The appearance and the strategies of these commercial practices characterize his paintings; they are bold, bright, concise, and explicit, capable of being read along a highway while traveling seventy miles an hour. Indiana has retrieved advertising's word-image declarative from the competitive marketplace. His text is consistent with the jargon that already abounds in the cluttered and fast-paced contemporary environment.

Indiana's painted words are either isolated on the canvas or located within geometric shapes similar to the road signs that line our highways. In 1961 he described himself as "an American painter of signs charting the course," although he does not define the specific nature of that course. Indiana is apparently addressing a broad theme, applying the tactics of consumerism to the ultimate metaphysical question: the relationship between life and death.

*The Green Diamond Eat The Red Diamond Die* diptych employs the elemental and seemingly irrefutable logic bantered by the media. Indiana has stated that the grand American myth is "the idea that Americans have more to eat than anyone else." This myth is summed up in the three-letter word "eat." It suggests that within this society not being able to participate in its material abundance is tantamount to death. Indiana portrays the life/death dichotomy from the consumer's point of view, a very prevalent philosophical stance in the 1960s. He is commenting on the satisfaction of human needs, even philosophical ones, through the commercial sector.

In Indiana's iconography, the highway is the setting for the unfolding of the American dream. It is the equivalent of the sea passage of the immigrants to the new world, the westward rails of the pioneers, and the physical embodiment of the restlessness of the American character. More concretely, the highway is the site of overscaled, neon advertisements. *The Green Diamond Eat The Red Diamond Die* refers to those signs which are placed in front of diners or roadside restaurants, luring travelers inside. In this setting there is neither the time nor the inclination to welcome potential diners; there is only a cryptic phrase that announces the function of the business establishment.

The power of the message is conveyed through word and image. Clear, unadorned, and direct, the words float on an uninterrupted field. *The Green Diamond Eat The Red Diamond Die* adopts the language of American advertising vernacular, but it is simultaneously a meditation on life and death. It represents the ultimate encounter with fate in terms of an ironic philosophical truism. There is an autobiographical poignancy here as well. Indiana reports that after his father died his mother supported her children by cooking meals in a roadside diner. Furthermore, her last word to her son before she died was "eat."

After studying at Syracuse University and the Art Institute of Chicago, Robert Indiana moved to Coenties Slip on the East River in lower Manhattan in 1954. This was probably the most significant event in his artistic development. On the slip, Indiana joined Ellsworth Kelly, Agnes Martin, Jack Youngerman, and James Rosenquist, artists who shared not a style but a rejection of the gestural abstraction that was then so important.

Whereas Robert Indiana rejects a particular style of artistic expression, Bruce Nauman rejects the necessity of working within the confines of any style or any particular medium. He is among the artists of his generation who defy specialization in art. He participated in the zealous attack on borders, boundaries, and definitions that characterized the 1960s and '70s. Art, he maintains, is a form of investigation, and artists are at liberty to direct their attention to all phenomena and utilize all available means.

Nauman's systematic exploration led him to create art from fiberglass, rubber, photographs, and neon. Over the years he has made books, films, videos, holograms, audio tapes, and installations using these devices to examine sounds (clapping, breathing, stomping, violin-playing), the body (leaning, squatting, bending, stepping), the material environment (tearing, folding, hanging), and mental states (claustrophobia, boredom, humor).

Nauman is also involved with many kinds of languages, all presented in the form of puns: images as transformations of

159

160

Albert King
(1859–1934)
*Wine, Whiskey and Death*
Oil on canvas
18 x 22″
Courtesy Kennedy Galleries, Inc.,
New York

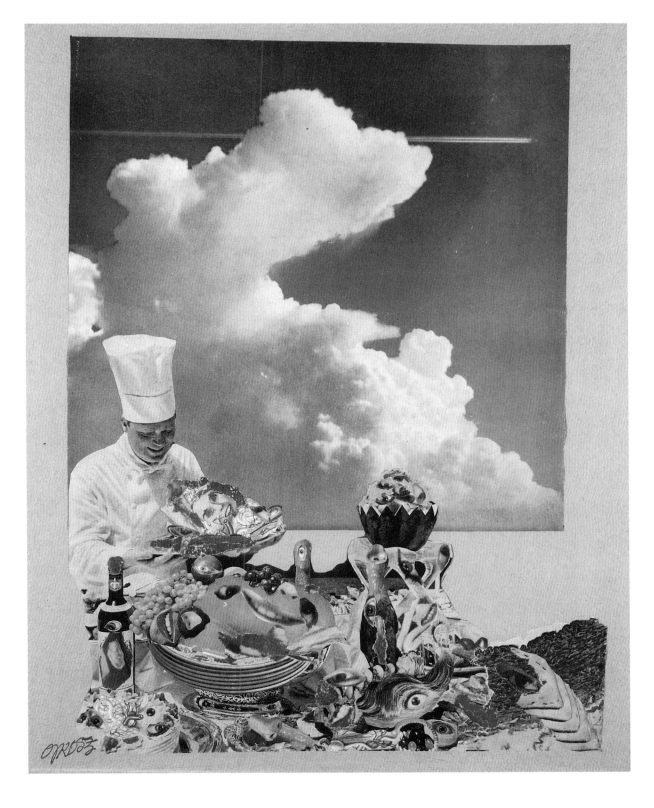

George Grosz
(1893–1959)
*Movable Feast*
c. 1958
Collage on paper
18 3/4 x 14 7/8 ″
Courtesy of Heckscher Museum,
Huntington, New York,
Museum Purchase: Heckscher Trust Fund

the ordinary which unsettle our expectations, words as riddles in the form of surrogate information, and behavior, which provokes thought but yields no answers.

For instance, *Eat/Death* succeeds in demonstrating the inherent ambiguity of language and its potential for art-making. Nauman identifies the word EAT situated symmetrically within the word DEATH. The two concepts are fused, and the viewer is invited to explore their relationship. The piece calls to mind the innumerable ways in which death can be eaten. The viewer is reminded of the news stories detailing the dire consequences of consuming pesticide residue, dyes, preservatives, chemical additives, hormone-treated meat, mercury-laced fish, artificial sweeteners, and dairy substitutes. Eating may be necessary to sustain life, but it can as easily poison the system.

The relationship between food and death goes beyond the issue of what is eaten; there is also the consideration of how much. Undereating results in malnutrition and starvation. Overeating taxes the heart, kidneys, and other vital organs. Both can be fatal.

Eating too quickly can be another cause of death. *Eat/Death* is a reminder of the tempo and style of contemporary eating habits. The words are quick, short, unembellished. Popular eating patterns proceed in a similar mode: fast-food, drive-in and drive-out, instant service, quick turnover, gulp. Nauman demonstrates that eating and dying are bound together in an ironic blend of danger and pleasure.

Nauman's defiance of traditional means of artistic expression is reversed by Brenda Zlamany, who has resurrected and mastered the traditional, academic technique of painting, complete with under- and overpainting and glazing. She applies this technique to traditional, academic subject matter; in this instance she has selected food, a topic with a long-established history within the genre. But Zlamany defies the charm and intimacy we have come to expect from still-life paintings. Her paintings are not just still, they are dead.

Zlamany's intense scrutiny and meticulous rendering of dead animals reveals a fascination with the subject matter that smacks of the macabre. The head of an animal, with its mouth open, eyes blank, appears as a pitiful victim of some unconscionable deed. The carcass is dead through an act of methodical butchery. It lies divorced from time, place, and circumstance, isolated in space like a perverse icon. The work is expressive of a society in which violence plays a vital role in its leisure and entertainment activities, but is denied in its habits of eating. Meat, for instance, is presented in tidy portions on Styrofoam trays in order to nullify thoughts of killing, death, and blood. Zlamany returns an awareness of murder to the act of eating.

Acquiring carcasses as subjects for her paintings requires collaboration with workers in the food industry—butchers, cowboys, ranchers, trappers, fishmongers, dairy farmers, organic poultry farmers, and exotic bird growers. This process has familiarized Zlamany with the diverse public attitudes about the relationship between the eating of meat and the meat industry's attitudes regarding the slaughter.

She explains in a letter dated March 15, 1990: "The lamb's head was not even regarded as food but as garbage, which made it all the harder to purchase from a reputable slaughterhouse. The chicken used for another painting was retrieved from the weekly pile of casualties outside an inhumane egg 'factory.' Those encounters with the food industry were tense, but the cowboys and ranchers I met while staying in Wyoming had a natural sympathy with my project and left game on my doorstep at night. Another enthusiastic group were the wholesale butchers of the Brooklyn waterfront, who insisted on participating in the aesthetic selection of the perfect carcass.

"Popular attitudes toward unskinned animals have made it difficult for me to find subjects in New York City. For example, according to a butcher at Balducci's, the store can no longer display whole rabbits in the window because animal-rights activists fear that passing school children would associate the 'bunnies' with food and become more callous toward animals."

Zlamany has related food and death from the point of view of the consumer and the consumed, the one who eats and the one who is eaten. Moral issues have been suggested regarding "good" food and "bad" food and whether preserving the self necessitates sacrificing the other.

162

Bruce Nauman
(b. 1941)
*Eat/Death*
1972
3 color lithograph
42 1/2 x 31 1/8″
Courtesy Gemini G.E.L., Los Angeles

164

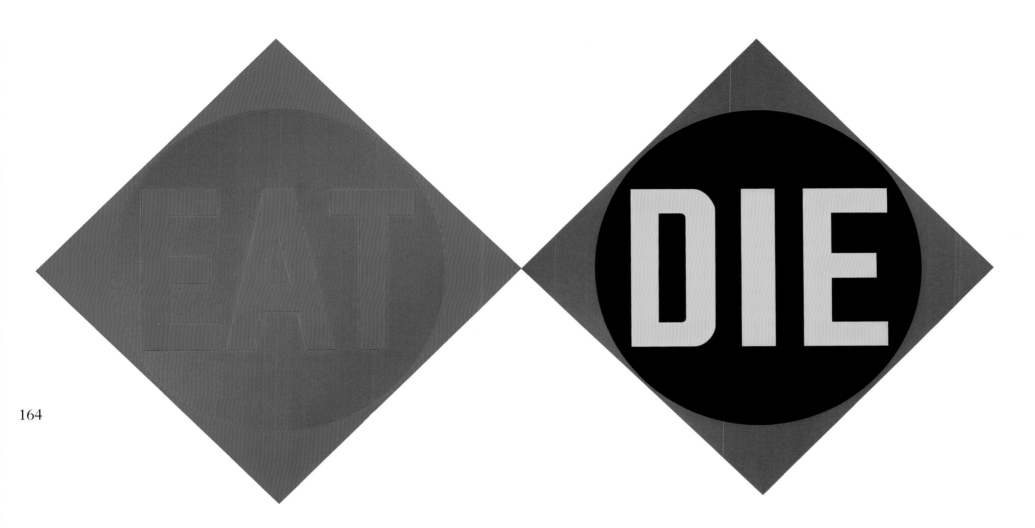

Robert Indiana
(b. 1928)
*The Green Diamond Eat The Red Diamond Die*
1962
Oil on canvas
85 × 85″ (on dia.) 60 × 60″ (sq.)
Courtesy Walker Art Center, Minneapolis,
Gift of the T. B. Walker Foundation, 1963

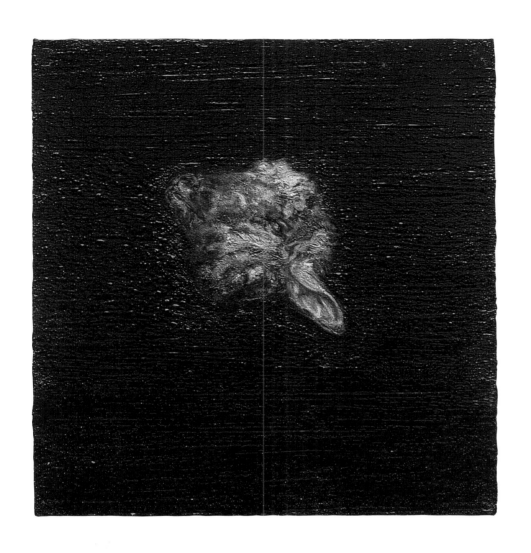

Brenda Zlamany
(b. 1959)
*Untitled (Lamb's Head)*
1989
Oil on canvas
30 x 28" unframed, to be framed
Courtesy the artist

# Scarcity and Abundance

168

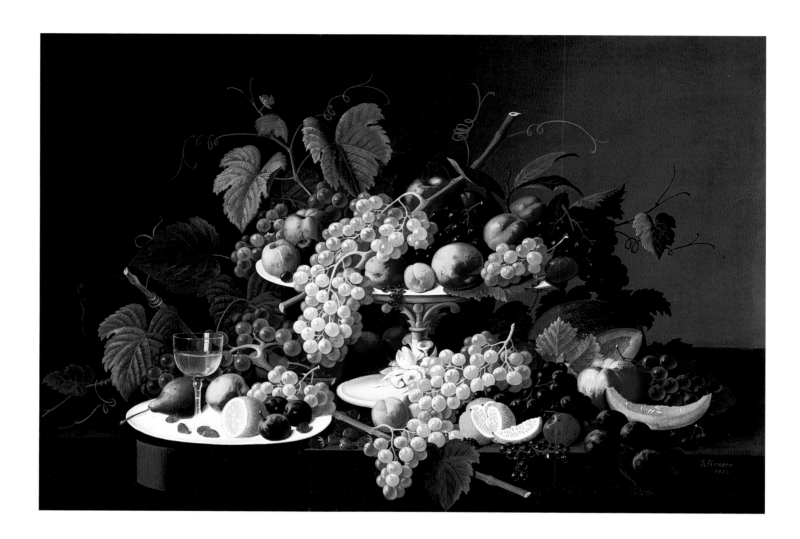

Severin Roesen
(1848–1871)
*Nature's Bounty*
1853
Oil on canvas
30 x 46"
Private Collection, New Jersey

169

Ben Shahn
(1898–1969)
*Remember the Wrapper*
1945
Tempera on paperboard mounted on wood
19 3/4″ x 26 1/4″
Courtesy Hirshhorn Museum and Sculpture Garden,
Smithsonian Institution,.
Gift of Joseph H. Hirshhorn, 1966

Severin Roesen's opulent, large-scale still lifes of flowers and fruit are better known and more celebrated today than when he painted them in New York City and the hill country of north central Pennsylvania. For the past thirty years, art historians have interpreted his visual sense of abundance, even overabundance, as a pictorial manifestation of the promise and plenty of mid-nineteenth century America. Roesen's art certainly parallels the richly decorated taste of the time, particularly epitomized by the curvilinear scrolls and rounded moldings of the Italianate architecture of John Notman, and the naturalistic carvings of rococo-revival furniture by John Henry Belter. That Roesen himself led a life that missed the material rewards of his time underlines a poignancy in the profusion of his elaborate compositions.

Surprisingly little is known of Roesen. He may have been the painter who exhibited flower paintings at Cologne, Germany, in 1847. The following year it is documented that he was in New York City when the American Art-Union purchased two still lifes of flowers. He was but one of a number of German artists who immigrated to New York between 1848 and 1852, part of the voluminous outflow of Germans escaping widespread civil unrest.

By 1850, Roesen had settled on a standard format for his fruit still lifes that he repeated, with small variations, throughout the rest of his career. It is a characteristic arrangement of mixed fruit on a stone or marble ledge close to the picture plane. Inspired by seventeenth-century Dutch prototypes, the different types of flowers were more often botanical specimens which appeared at different times of year than a seasonal grouping of blossoms. The perfection of form, color, ripeness, or bloom, too, reinforces the suggestion that he used botanical prints as models rather than any real fruit and flowers that may have been in season. The image he creates is one of perfectly ripe fruit, flowers at the peak of their bloom, small colorful insects and sparkling dew drops scattered randomly.

In 1857, Roesen abandoned his German-born wife and children, settling in Williamsport, a thriving lumber town on the Susquehanna in the Lycoming valley. He was the only resident artist and found ready patronage from the newly rich lumber barons of the area. A painting dated 1872 is the latest documentation of his work, and thereafter all traces of his life disappear. There is an unsubstantiated assertion that he died in a nearby poorhouse.

His lavish still lifes remain a powerful representation of mid-Victorian life in America. Fresh fruit was a popular, even exotic, dessert at mid-century. Inexpensive fruits were available seasonally, but hot-houses and new transportation systems were beginning to make temperate fruits available for four months or more, and to bring tropical fruit to the table throughout the year.

*Nature's Bounty* celebrates this growing profusion with its artificial mixture. It represents the changing varieties found on the Victorian table throughout the year. To heighten the sense of luxury, Roesen includes a glass of white dessert wine and a Parian compote decorated with floral and architectural forms. A bisque-fired porcelain, "Parian" was invented in the early 1840s and given the name as a sales promotion in a classically minded age. The best marble of ancient Greece came from the island of Paros, and the new ceramic, with its grainy white texture, adopted its name. Thus Roesen was able to tempt his patrons through both their appetites and their interest in material possessions.

The Victorian exuberance, based on evidence of expanded wealth and a faith in continued prosperity that was apparent in Roesen's paintings, was shattered by the sobering experience of two World Wars and the Great Depression. Along with many other artists of his generation, Ben Shahn agonized over the plight of the victims of these disasters. They felt a responsibility to rectify the political, social, and economic inequities of the times. As social realists, they believed art was a potent tool, capable of both instilling in its viewers moral indignation and, ultimately, instigating action.

Influenced by Rouault and Dufy, Shahn began his mature career in 1931 with a series of gouache paintings dealing

with the Sacco-Vanzetti case. Another gouache series about labor leader Tom Mooney impressed Diego Rivera, who hired Shahn to help paint the ill-fated *Man At The Crossroads* mural at Rockefeller Center. It was later destroyed because of its political content.

With the outbreak of World War II, Shahn joined the Graphic Arts Division of the Office of War Information, producing propaganda posters. But as the war developed, he began to work on a series of paintings that reflected his anguish over the destruction of Europe. He concentrated on Italy, a country he knew well and loved, and *Remember The Wrapper* is one of the works from this period.

Completed during the last year of the war when Italy was in a state of rubble, the work shows an American G.I. handing out gum to a group of youngsters who reach high in the air for the Juicy Fruit. A symbol of American prosperity, the longed-for gum presents an ironic contrast with the background of destruction and decay.

Plenty and want are placed in direct juxtaposition by the American, who towers over the imploring children. He is the giver of a treat, and this minor food item is a symbol of the prosperity of the entire nation which he represents. The impoverished children begging for a little sweet personify the vanquished state which is bereft of everything but the memory of its past glory. Ironically, the soldier who offers the coveted piece of gum is also responsible for the irreparable destruction of their country. Yet, when he offers them a material reward, and particularly when that reward is food, he becomes the hero of the enemy nation as well.

Philip Evergood, like Ben Shahn, protested inequality and injustice. He expressed it in a unique way, blending direct observation, an intentionally childlike drawing technique, and a reliance on invented symbols, dreams, and other irrational imagery. As a result, he mingled realism with expressionist techniques to create an impassioned chronicle of the times.

Evergood's commitment as a social painter evolved from his response to the economic crisis during the early 1930s, when the depression was at its height. As he told Jack Baurs in a 1959 interview, "I didn't methodically go out and try to become a social painter . . . the real urge to paint America . . . came when the Depression came, and people were actually sitting on the curb with their tongues hanging out."

Like other social realists, Evergood's subject matter presents a critical commentary on racial discrimination, unemployment, labor-management struggles, the effects of war, corruption in government, and capitalistic exploitation. Always a little too caustic to be fashionable, Evergood shared little with his fellow social realists, and consequently his work was less readily acceptable. Its rawness often offended people, but it was a rawness which reflected the artist's view of American society. His men and women may not resemble any people we have ever seen; they are awkward creatures with distorted faces, but they effectively mirror the upheavals of twentieth-century life.

The man in *One Meatball* is such an example. Gaunt and scrawny, with a collar now too large for his neck, the subject in Evergood's quintessential painting of the Great Depression sits in a hospital-like atmosphere before one meatball and a few strands of spaghetti. His vacant, hopeless eyes are red-rimmed, and his bald head and bony hands signal the look of approaching death. Shown not eating, but with knife and fork poised mid-air, the stoop-shouldered subject symbolizes the despair and defeat felt by many disenfranchised members of American society during the 1930s. Through brutal characterization, Evergood captures the isolation of the man's predicament and the loneliness of his circumstance, emphasizing it even further by showing the disconcerned waiter at the rear. If food is the sustenance of life and associated with survival, then *One Meatball* is not about life force, but about the loss of the will to live. It is a moment in the life of an ordinary man, and elevated through art to the level of universal truth. His hunger is profound and extends deep into his soul.

David Gilhooly was an infant when Evergood and Shahn were producing paintings that embodied the plight of the

171

172

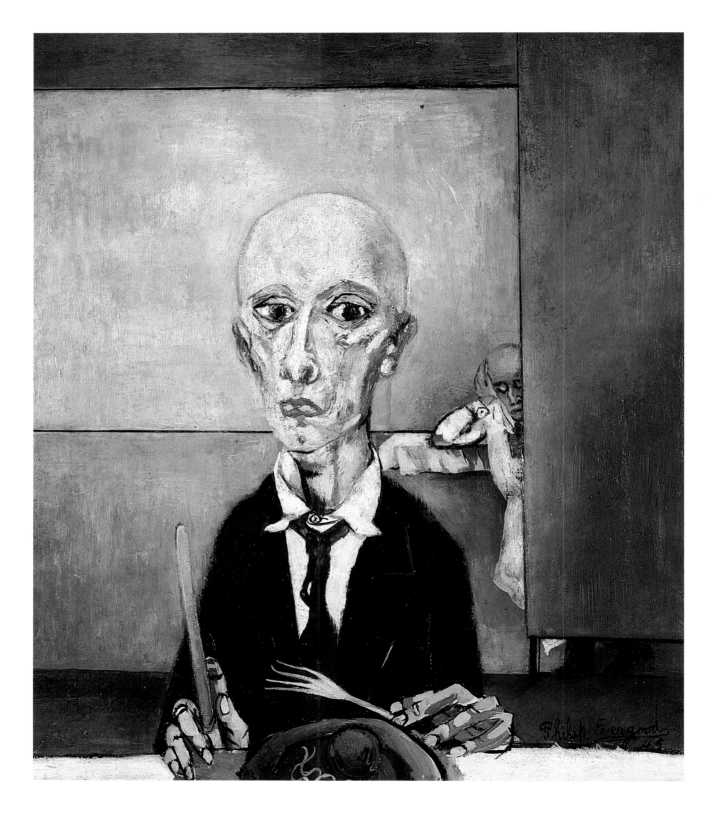

Philip Evergood
(1901–1973)
*One Meatball*
1945
Oil on canvas
24 x 20"
Courtesy Dr. Henry Kaufman

impoverished during World War II. Like them, Gilhooly's art is formed in response to the reality of his social and economic environment. The differences between their art can be traced to the changes in the material state of their society. By the time he matured, abundance had become as extreme as want had been the generation earlier.

One of the original members of the California Funk movement, Gilhooly extracts humor from the social habits he observes in the world around him. In fact, he casts his cheerful and satiric eye upon the entirety of western civilization. His earliest witticisms consist of nothing less than the retelling of the history of the world. He rebuilds its greatest monuments and recreates its historic moments in terms of a civilization populated by fat, frolicking ceramic frogs: Founding Father frogs, Tantric Buddha frogs, Ten Commandment frogs, Queen Victoria frogs, Nofretete frogs—spirited amphibians mocking quintessentially human follies.

Gilhooly systematically addresses religion, education, government, our heroes, our villains, and the most ordinary of our citizens. He does not neglect the subject of food. How and what we eat, and our attitudes regarding food have all been subjects of his satiric scrutiny.

Gilhooly presents a world that long ago has ceased to think of food as sustenance. In several of his pieces the frogs are barely visible behind a great mountain of supermarket merchandise. In others they are surrounded by a dizzying swirl of submarine sandwiches. In another series, Gilhooly creates individual items of food, their shape, color, and texture meticulously molded in clay—donuts, bagels, cookies, pizza, candy, vegetables, and this superstuffed sandwich. It serves as a symbol of lunches across America, the casual gluttony in which bigness has replaced fineness, gulping has supplanted tasting, and eating with fists instead of fingers has become common. Gilhooly's spoof transcends mere exaggeration. He has actually utilized the techniques of this economic order, applying the habits of wholesale consumption to the elitist world of art. Gilhooly has sold the individual pieces of ceramic food inexpensively, a populist move which is consistent with the boisterous celebration of bounty represented by this loaf-sized bulging sandwich.

By the 1960s, most Americans had solved the problem of nourishing themselves. In the process, they had created a reverse problem—disciplining their consumption. Promulgators of fashion and beauty and design were defining the ideal in terms of a fat-free aesthetic. Everyone was pressured to remain close to the bone. This new lifestyle is apparent in the painting, *Supper*, by Alex Katz. It reflects the American obsessions with appearance and style, particularly among the upper-middle class, which is Katz's subject.

The individuals here are young, slim, neat, and casually dressed. The table is fine teakwood, the placemats are woven of natural grasses, and the tableware is simple and handsome. A meal appropriate for such a table is light, healthful, and calorie-conscious.

Two women and a man sit around the dining table, which is set for four. The figures are strangely quiet and self-contained; the awkwardness of a social encounter is suggested by their stiff poses and the missed connections of gesture and eye contact. The blonde woman, who is the woman without a partner, has apparently finished her meal while the others are without silverware or food. A bottle of white wine on the table is half empty, but none of the wine glasses holds any liquid.

173

Katz was a pioneer in the return to realist painting. His realism, however, combines traditional subjects with contemporary techniques of abstract painting. Katz's works are often heroic in scale, a link to the mural-sized canvases of the abstract expressionists, but his subjects are treated as flat, non-gestural cutouts laid on a field of color.

In the 1950s, Katz developed his manner of painting based on his understanding of what constituted a "high art style." He believes that high art is art that reflects its age and remains continually new. His realist vision is defined by photographs, films, television screens, and advertisements, from which he derives his large-scaled, sharp-edged, cropped images and flattened space.

As a genre painter for our time, Katz is a keen observer of society. Through its style and its objective point of view,

174

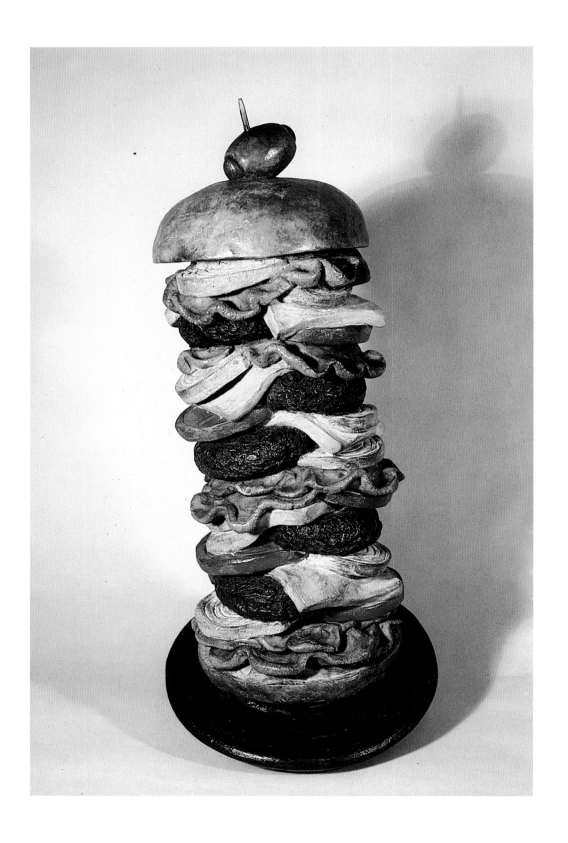

David Gilhooly
(b. 1943)
*Tall Burger*
1989
Bronze and patinas
24 x 10"
Courtesy the artist

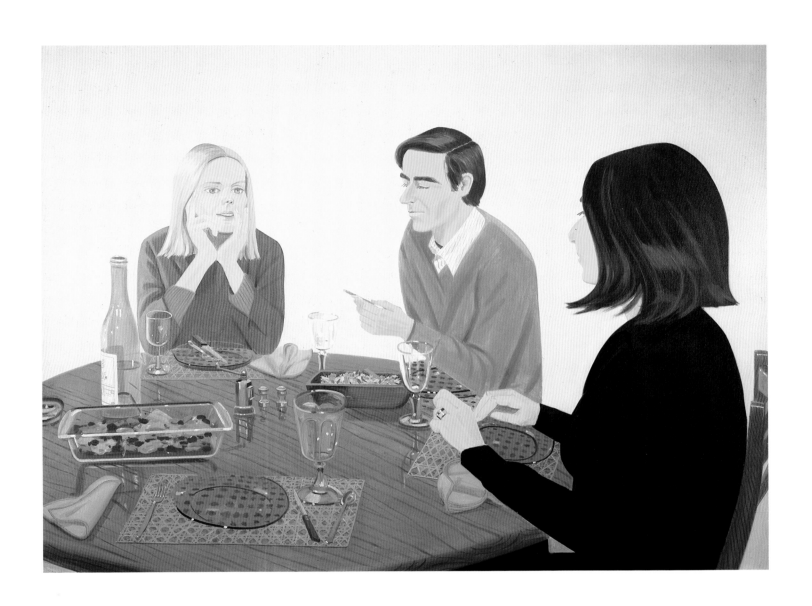

175

Alex Katz
(b. 1927)
*Supper*
1974
Acrylic on canvas
73″ x 98″
Courtesy Hood Museum of Art,
Dartmouth College, Hanover, New Hampshire,
Gift of Joachim Jean Aberback

176

Eleanor Antin
(b. 1935)
*Carving: A Traditional Sculpture*
1972
Photographs
5 x 7″ ea.
Courtesy Ronald Feldman Fine Arts, New York

*Supper* captures current American obsessions with health, appearance, and youth. Eleanor Antin expresses this concern in a manner that brings art into life in a most literal way. Like Katz, she has observed that for most people in the United States acquiring food has become less a concern than resisting it.

Today's environment is a popped-flaked-buttered-carmelized-cornucopia. Not only are supermarket shelves laden with opportunities to make mealtime an endlessly varied experience, but also innumerable tasty treats now exist to occupy us between those mealtimes. The snack is an invention of the modern world. Nutritionists have estimated that from the beginning of civilization through the nineteenth century, human beings had three food contacts per day. Today we average seventeen. It is the exceptional person who eats when hungry, stops when full, and spontaneously prefers wholesome food to junk food. For the rest, the abundance of edibles permits us to feed not only our bodies, but our neuroses as well. Eating is often a substitute for satisfying appetites that are unrelated to our stomachs, needs originating from sexual frustration, insecurity, domestic distress, and so forth.

There is little historic precedent in Western culture for overeating. Fasting has a much stronger tradition. It has been used to signal urgent political protest and an intense spiritual quest. Both associations apply in an ironic way to Eleanor Antin's *Carving, A Traditional Sculpture.* Antin went on a diet and called it art. Every morning for a month she stood in front of a closed door and was photographed nude from four points of view as she rotated. During this period she lost ten pounds.

Antin has stated that the piece was intended to satirize the traditional techniques of sculpting. She carved her body instead of a piece of wood or a block of marble, creating a more ideal form. She reinterpreted the sculptor's role according to the modes of art-making that emerged in the 1970s:

Process art—Antin documented the gradual transformation of her body, allowing the viewer to perceive the means of changing form, not just the end product.

Body art—the piece is so self-referential that both the psychological elements and the material transformation are confined to the artist's self.

Feminist art—Antin whittled away her flesh in an attempt to approximate a standard of beauty promoted by advertising, fashion, Hollywood, and pop music—sleek, long-limbed, and hipless.

It is ironic that although ideals may vary, they consistently isolate our least achievable goals. The rotund Venus figurines were the model of female perfection in hunting and gathering, subsistence economies. Svelte silhouettes haunt women in today's land of plenty.

Antin is fasting to atone for her sin (of overeating), to honor her god (media-induced values), to cleanse her spirit (of guilt). As an artist, the private act of dieting is elevated and assumes symbolic and aesthetic meaning. Antin demonstrates that our attitudes toward food are an amalgamation of a complicated interface between economic, social, sexual, and psychological issues. Prosperity has bestowed upon us the luxury to overeat while society has proliferated techniques and devices to help us refrain from eating. Miss America pageants co-exist with NOW conventions, anorexia is increasing along with Weight Watcher chapters, fitness centers, diet pills and diet books. This does not, however, deter the relentless boom in the production of cookies, crunchies, snack-packs, and goodies.

# Eating Out

Restaurants were rare in mid-nineteenth century America. Food was available at taverns, inns, and hotels, but the diners in these establishments tended to be travelers. The typical American ate every meal at home or, perhaps, took a lunch pail to the field or factory. The demand for food to be served outside of the home emerged in the newly developing urban centers, where the place of employment tended to be distant from the workers' living quarters. In the competition to attract customers, taverns and inns with a barroom began to offer free soup at lunch. Some even presented elaborate tables of meat, fish, and vegetables, attentively guarded by waiters and bouncers.

Then, as now, men with common interests tended to habituate particular gathering places at lunch. This is most likely the case recorded in Edmund D. Hawthorne's *The Interior of George Hayward's Porter House.* Hawthorne is a little-known painter who came to New York City from England in 1863. He exhibited at the National Academy of Design the following two years and is listed sporadically at various addresses in the city directory until 1876, when all record of him disappears.

George Hayward's Porter House is better known. A small brick house on what is now the southwest corner of Sixth Avenue and Thirteenth Street, the structure was a celebrated tavern in the nineteenth century. It specialized in serving porter, a mixture of beer and ale that was invented in London about 1730. There were two public rooms, the second of which, the smoking room, is the elegantly finished classical interior depicted by Hawthorne.

When first built, the structure stood in open country and was a favorite haunt for people wishing to eat and drink outside. Over the years, there were several owners. George Hayward was the proprietor from 1847 to 1855. His brother David, who later became a picture restorer and artist, ran the tavern until 1862. George resumed proprietorship until

1864. Later owners named the building the Woodbine Cottage. In 1878 *Frank Leslie's Illustrated Newspaper* reported, "It is safe to say that the Woodbine, from 1840 to the present time, has been the social resort of more distinguished New Yorkers than almost any place in the city." Hayward's name can be seen in the painting on a plaque below the clock.

One of the distinctions that set Hayward's Porter House apart from other taverns was its collection of paintings that was hung in the ancient barroom and the adjoining smoking room. The collection, which may well reflect David Hayward's interests, included an original Gilbert Stuart portrait of George Washington, visible in Hawthorne's depiction of the smoking room, as well as copies of works by Van Dyck, Hogarth, Rembrandt, and others.

The careful delineation of the patrons suggests *The Interior of George Hayward's Porter House* was a commission to record a specific group of people. It is dated 1863, and from the view out the window, it is summer, when the Civil War was raging and the Union army had experienced several major victories, including the Battle of Gettysburg. The man having his shoes polished holds a copy of *The New York Herald,* and this may have some bearing on the identity of the group. Although originally pro-Southern, recently the paper had switched sides and was now proclaiming Lee's imminent surrender. Officers and soldiers from several different regiments are among the patrons.

While most of the activity concerns smoking and drinking, two men are availing themselves of the free soup at the end of the bar. One is eating from a bowl, while the other pours from a ladle. Temperance leaders long inveighed against the barroom enticements of free food, but the tradition survived up to the time of prohibition. The painting is a rare document of mid-century customs, when barrooms became the lunchrooms of city life.

Although Edward Hopper studied with Robert Henri and Kenneth Hayes Miller at the New York School of Art, he rejected his teachers' interest in the bustling activity of urban life, and concentrated instead on the alienation of its

inhabitants. The people in his paintings rarely relate to each other, and their isolation reverberates throughout his work, giving an impression of absolute composure in a frozen composition.

Restaurants fascinated Hopper, and, while he was still in his early teens, he began to observe people in dining places. *Table for Ladies*, like so many of his paintings of this subject, establishes a somber paradox, portraying the psychological distance between people within a setting that is designed for convivial gatherings.

In this case, the painting is a document of the economic circumstances during which it was created. The restaurant is sparsely populated because there were few paying customers in the first years of the Depression, when this work was painted. The paucity of patrons is dramatized by a tantalizing abundance of food in the foreground. Ironically, no one in the painting is actually eating. The provisions are isolated behind the window of the restaurant and appear artificial, produced for display rather than for consumption.

The title of the painting suggests a social custom that has long disappeared. This is a table for ladies, a designated area where women are seated, separated from the bar. It represents an intermediary step between today's acceptance of unescorted women in restaurants and bars and the nineteenth-century custom which excluded women from many public establishments.

There exists a great diversity of means that can be summoned by painters in pursuit of a common artistic goal. Both Edward Hopper and Jacob Lawrence represent melancholy restaurant environments in which there are few customers, and those that are present appear to be isolated and dejected. But despite their common theme, the work of these two artists has little stylistic similarity.

Born in Atlantic City, New Jersey, in 1917, Jacob Lawrence, one of America's best-known Black painters, moved to Harlem with his mother in 1929. There, in the onslaught of the Depression, he was able to study with Charles Alston in the Harlem Art Workshop classes given at the 135th Street Public Library. During this period, Lawrence learned the rudiments of his craft, mounting his first one-man show at the Harlem YMCA in 1938.

Lawrence's primary focus has always been people, presented in a highly stylized and abstracted form. In *Café Scene* that stylization enables him to convey the overall feeling of isolation that permeates the work. To the left, a couple sits at a table barren except for the remains of their meager meal: they have each eaten one small fish, down to the bones and the head. An equally isolated man, the café's only other eating customer, hunches over his plate of food as if to ward off any interlopers. A solitary cat drinks milk from a dish in the center corridor. It is wartime, and the café and these people have seen better times.

The emotional emptiness of the scene is underscored by the scarcity of food, the dearth of customers, and the isolation between the three diners who make contact with neither each other nor the viewer of the painting. This restaurant meal is far removed from the warmth and intimacy of one eaten at home. Even the architecture obviates convivial gatherings: the tables are isolated in cubicles, one of which appears to be covered with metal bars.

This is history painting of sorts, concentrating not on the great events and great people, but on the lives of ordinary individuals. Lawrence developed a narrative style that records daily life in terms of pattern and design created out of simplified shapes, colors, and lines. But although the style is austere, Lawrence's people are never subjugated to the bold patterning.

Sometimes labeled a primitive because of his flat surface, angular line, and stylized gesture, Lawrence was actually influenced by the work of the early Renaissance painters—Carlo Crivelli, Giotto, Biagio de Antonio and Sandro Bottecelli. The small dimensions of some of their works, their jewel-like colors, and their strong sense of narrative struck a chord in Lawrence. Through his symbolic shorthand, the contemporary human drama is reenacted on the surface of his paintings.

The students eating in the Joseph Delaney's *Art Students League Cafeteria* are a boisterous mob. Their banter and laughter create a kinetic excitement that is the opposite of

181

182

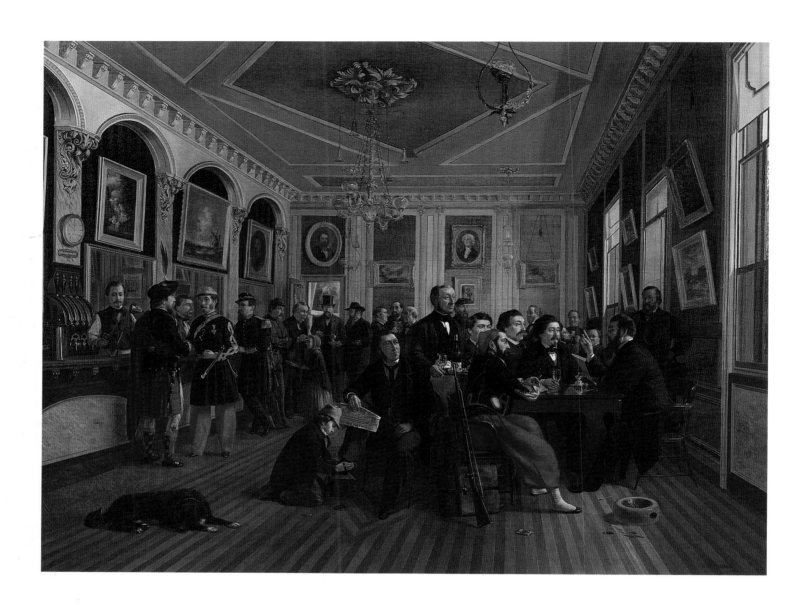

Edmund D. Hawthorne
(fl. in U.S. 1858–1876)
*Interior of George Hayward's Porter House, N.Y.C.*
1863
Oil on canvas
36 x 47 "
Courtesy New-York Historical Society, New York;
The Watson Fund, 1961

183

Edward Hopper
(1882–1967)
*Table for Ladies*
1930
Oil on canvas
48 1/4 x 60 1/4 "
Courtesy Metropolitan Museum of Art,
George A. Hearn Fund, 1931 (31.62)

Hopper's sedate restaurant interior and Lawrence's grim cafe. The art students crowded into this painting are black and white, standing and seated, eating and drinking, chatting and arguing, their individual forms barely discerned within the lively welter of commotion that fills the room. The visualization of this concentrated activity is achieved through loosely defined contours and the merging of the colors of the clothing and bodies of the figures.

The location of this painting is the cafeteria at the Art Students League in New York. Delaney studied at the league during the Depression, and was certainly familiar with its animated atmosphere. While there, he befriended Jackson Pollock, and together they studied under Thomas Hart Benton, who taught them both the use of spiraling forms. Pollock applied these forms to the new language of abstraction, but Delaney maintained an interest in the people and the settings that he observed.

Delaney developed a distinctive style in which energetic figures were compacted within a limited space. His brush is loose and his palette is light. The mask-like faces of his figures are often grotesquely exaggerated, giving his work a satiric edge. The painting combines a tense sexuality as well as the conviviality of shared food, conversation, and confraternity of spirit.

The baroque exuberance of city life is also the subject of Red Grooms's *Blue Restaurant*. Grooms, born in suburban Nashville in 1937, came to New York in 1956, where he invented an art form that captured the dynamic urban environment. One of his contributions to the history of the period was the City Gallery, the first alternative space in New York, which he opened in 1958 with his friend, Jay Milder. The City Gallery provided exhibition opportunities for the younger artists, and both Claes Oldenburg and Jim Dine had their first one-man shows there.

184

The free-spirited interplay between theater, musical composition, and visual art that fueled the experiments of the late 1950s gave way to the cool irony and objective viewpoint of Pop Art in the '60s. Nevertheless, Grooms maintained a lively interest in theatrical production. His environments—*The City of Chicago*, 1968; *Ruckus Manhattan*, 1975; and *Philadelphia Cornucopia*, 1982—function as stage sets, site-specific sculptures, and outrageous parodies of contemporary American life. Grooms describes his style as "proletarian," and aims to create an art that breathes the air of everyday life.

*The Blue Restaurant* is a painting that, in the same manner as Grooms's installations, captures a specific place and time. Similar to much of his art, this painting is autobiographical, documenting a recent visit made by Grooms and a companion to Eleuthera, an island in the Bahamas. The artist and his companion dine at a table covered with a yellow checked cloth, while the other patrons dance, drink, and play pool. The subject of *The Blue Restaurant* is a personal one, yet the image speaks of the luxuries of late-twentieth-century life. Increased prosperity and technological advances have made long-distance travel a common occurrence, but they have also been responsible for the spread of American popular culture throughout the globe. *The Blue Restaurant* shows two Americans who have traveled to an exotic land to experience its cuisine and culture. Paradoxically, the island culture has been saturated with American popular culture, and Grooms makes this clear by accurately reporting details such as screenprinted T-shirts and brand-name beers. While the setting is exotic, the customs are not.

Grooms enjoys working in and against the history of art, and many of his works contain references to masterworks of the past. *The Blue Restaurant* may relate to Vincent van Gogh's *Night Café* of 1889. Van Gogh's painting is an oppressive image, intended, as the artist confided to his brother, Theo, to represent a place where a man might go mad. By contrast, Grooms's image conveys a relaxed, informal atmosphere. *The Night Café* is painted with ragged strokes of acid

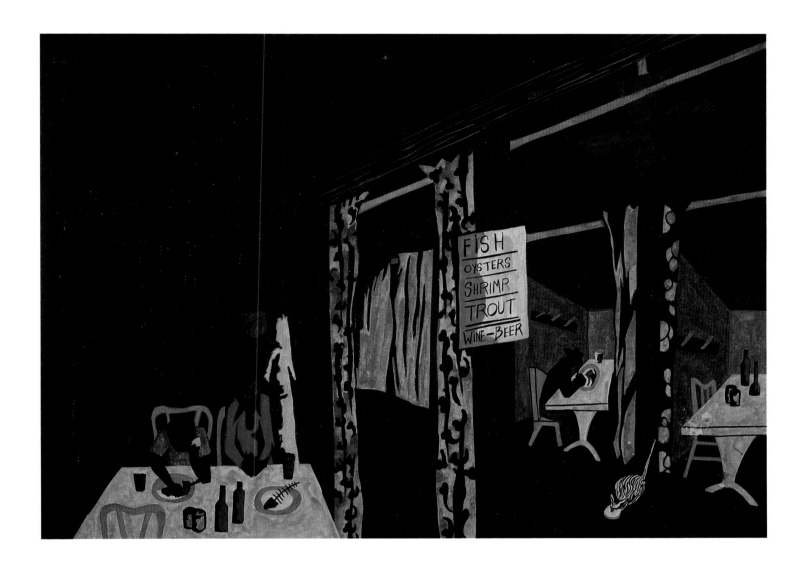

185

Jacob Lawrence
(1917–1989)
*Cafe Scene*
1942
Gouache on paper
14 x 19 3/4″
Courtesy University of Arizona
Museum of Art, Tucson,
Gift of C. Leonard Pfeiffer

greens, yellows, and violent reds; the perspective rushes back at a dizzying rate, and the proprietor stands ominously alone beside a vacant pool table. In *The Blue Restaurant,* blues and yellows are the focus of the color construction; the perspective, while exaggerated, enhances the openness of the space, and all the individuals are occupied in social intercourse of one sort or another.

Both *The Night Café* and *The Blue Restaurant* illustrate an artist's experience with society. In Grooms's painting, the artist is a fully integrated member of a leisured class, visiting a world of which the working poor are the inhabitants. In van Gogh's painting, the artist is one of the disenfranchised, on the outer fringe of society.

The restaurant, which extends the function of serving food and socializing to a setting outside of the home, is a powerful backdrop for describing these circumstances. In this case they emphasize the dichotomy between the avant-garde artist of the nineteenth century who struggled to achieve recognition and the meteoric rise of the artist who works in today's fast-paced, news-hungry environment.

186

Dining out has become increasingly popular in America. It has been estimated that by the year 2000 two out of three meals will be consumed in public places. The restaurant, as an alternative to the home, transforms eating into a public event commanded by a socially codified form of etiquette and specific rules of decorum. Mealtime, particularly in an elegant restaurant, becomes an exercise of manners rather than one of intimate social exchange. The artifice of public dining, complete with props, role-players, and a décor designed to convey luxury, mediates the character of human intercourse that takes place within this setting.

Robert Yarber has created a luxuriant setting for the meal depicted in *Untitled: Diners With Thrown Forks*. In this framework, actions are expected to be disciplined and civil. The meal eaten in this setting is typically conducted in a convivial and leisurely manner, for the pleasure of the company as much as for the refinement of the cuisine.

Outbursts of emotion and the impulsive behavior they spur are precisely those actions that are normally banished from this genteel setting. Ironically, this dinner has exploded into a confused fray. Despite the formal table setting, with its high-rent view of the Golden Gate Bridge, forks are being jettisoned in a manner oddly reminiscent of a Nazi salute. It is difficult to determine if a quarrel has precipitated a confrontation or if the couple has thrown their forks in an act of ecstatic abandonment. In either case, the quiet decorum has been violated. The contrast between expected behavior and the depicted moment is startling.

This encounter occurs at dusk, that critical moment when the crimson spectacle of the setting sun, the brilliant array of city lights, and the glow of a single candle all coexist. The figures are bathed in an eerie light that heightens the passion of the moment. Yarber substitutes the measured behavior appropriate to this restaurant setting for the instant when mindless violence erupts, the world spins out of control, and the figures teeter on the balcony in the midst of a dizzying delirium.

Throughout his work, Yarber concentrates on the way in which people in the modern world act out their desires, fears, and hostilities. In this painting he violates the ceremonial aspects of public dining and transforms the setting into an arena in which social roles are defined and individual emotions explode into reality. Mealtime has become the context in which the raptures and casualties of human relationships are enacted.

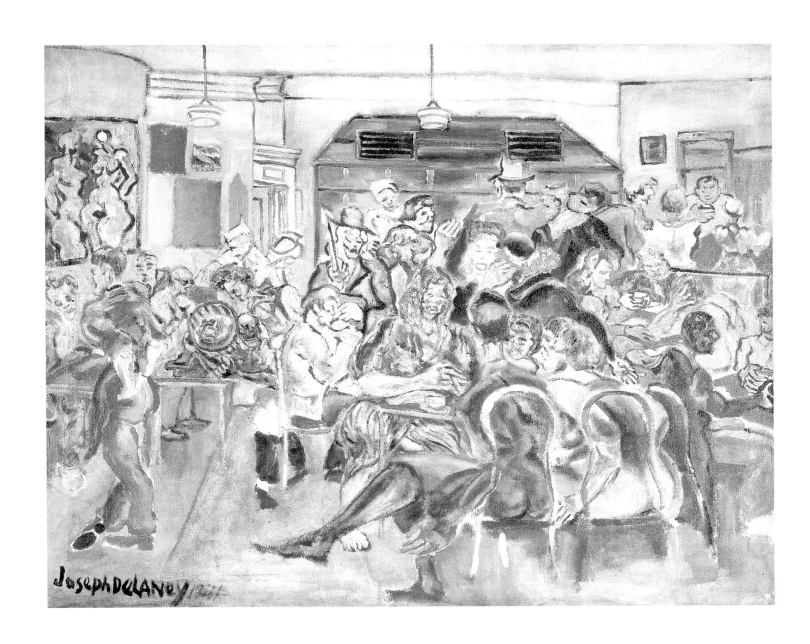

187

Joseph Delaney
(b. 1904)
*Art Student's League Cafeteria*
1941
Oil on canvas
28 x 35"
Courtesy Michael Rosenfeld Gallery,
New York

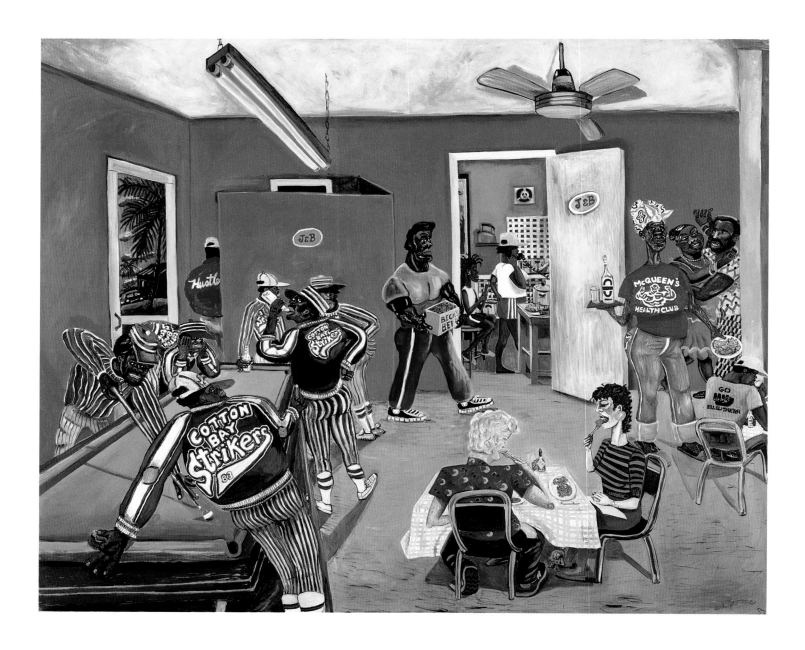

188

Red Grooms
(b. 1937)
*Blue Restaurant*
1983
Oil on canvas
90 x 74″
Courtesy Frederick R. Weisman
Art Foundation, Los Angeles

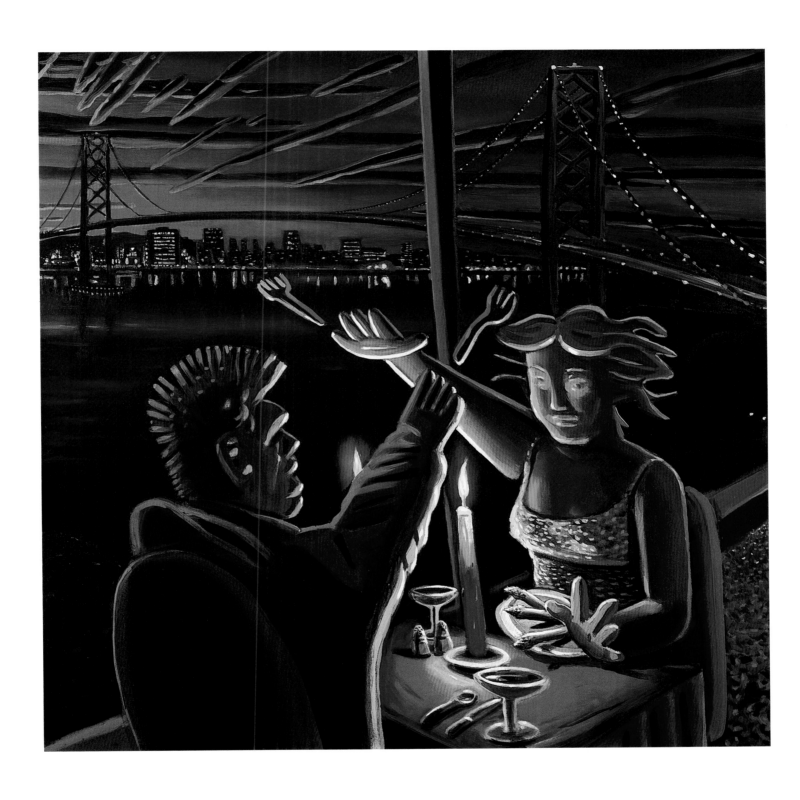

Robert Yarber
(b. 1948)
*Untitled (Diners With Thrown Forks)*
1990
Oil, acrylic on canvas
66 x 66 x 2"
Courtesy Sonnabend Gallery, New York

**Donna Gustafson** is a doctoral candidate in Art History at Rutgers University. Since September 1989, she has been an Exhibition Coordinator at The American Federation of Arts in New York. Before joining the AFA, she worked at the Jane Voorhees Zimmerli Art Museum in New Brunswick, New Jersey.

**Nan A. Rothschild** received her doctorate in Anthropology from New York University in 1975. Since that time she has been involved with prehistoric and historic archaeology, focusing on gender, food, and ethnoarchaeology. Her book, entitled *New York City Neighborhoods, the Eighteenth Century,* is published by Academic Press. Currently, Dr. Rothschild is an Assistant Professor at Barnard College, Columbia University.

**Kendall Taylor** is Academic Director of the Art and Architecture Program at The American University's Washington Semester Program, and is a member of the fine arts faculty there. She holds a Ph.D. in Interdisciplinary Humanities and an MA in both Art History and Literature.

She is currently writing a textbook on American art, *Turbulent Decade: Art and Activism in the Thirties*.

**Gilbert T. Vincent** is a freelance writer, curator, and lecturer in the American arts. An American history major at Harvard College, he received master's degrees in fine arts and architecture at Cambridge University and in early American culture at the Winterthur Program in Delaware. He subsequently completed his doctorate in American art at the University of Delaware. Between 1979 and 1987, he taught in the Cooperstown Graduate Program in Museum Studies. He is currently writing a history of the art collection at the New York State Historical Association in Cooperstown, New York.

**Linda Weintraub** After receiving her Master of Fine Arts degree from Rutgers University in 1970, Ms. Weintraub spent seven years teaching studio and contemporary art at Muhlenberg, Cedar Crest, and Lafayette Colleges. In 1978 she became the Director of the Philip Johnson Center for the Arts at Muhlenberg College, and in 1981 she was appointed Director of the Edith C. Blum Art Institute at Bard College.

190

Ivan (Le Lorraine) Albright (1897–1983)
Eleanor Antin (b. 1935)
Richard Artschwager (b. 1924)
Milton Avery (1893–1965)
Michael Bidlo (b. 1953)
Isabel Bishop (1902–1987)
Hyman Bloom (b. 1913)
Samuel Marsden Brookes (1816–1892)
Mary Cassatt (1844–1926)
Buster Cleveland (b. 1943)
Sue Coe (b. 1951)
Dorothy Cogswell (b. 1909)
Lucille Corcos (1908–1973)
Konrad Cramer (1888–1963)
Joseph Delaney (b. 1904)
Frank di Gioia (b. 1900)
Harvey Dinnerstein (b. 1928)
Francis William Edmonds (1806–1863)
Richard Estes (b. 1936)
Philip Evergood (1901–1973)
Janet Fish (b. 1938)
John Francis (c. 1810–1885)
Ruth Gikow (1915–1982)
David Gilhooly (b. 1943)
Hendrik Glintenkamp (1887–1946)
Red Grooms (b. 1937)
George Grosz (1893–1959)
Al Hansen (1887–1946)
Edmund D. Hawthorne
(active 1858–1876)

Joseph Hirsch (1910–1981)
Hans Hofmann (1880–1966)
Edward Hopper (1882–1967)
Robert Indiana (b. 1928)
Jasper Johns (b.1930)
Alfred Jones (1819–1900)
Mervin Jules (b. 1912)
Alex Katz (b. 1927)
Albert King (1859–1934)
Mark Kostabi (b. 1960)
John Lewis Krimmel (1789–1821)
Pat Lasch (b. 1944)
Jacob Lawrence (1917–1989)
Roy Lichtenstein (b. 1923)
Charles Cole Markham (1837–1907)
Alfred Maurer (1868–1932)
Kathleen McCarthy (b. 1953)
William McCloskey (1859–1941)
Ed McGowin (b. 1938)
Brad Melamed (b. 1948)
William Sidney Mount (1807–1868)
Walter Murch (1907–1967)
Peter Nagy (b. 1959)
Bruce Nauman (b. 1941)
Alice Neel (1900–1984)
Claes Oldenburg (b. 1929)
Alton Pickens (b. 1917)
Alexander Pope (1849–1924)
Levi Wells Prentice (1851–1935)
Mel Ramos (b. 1935)
Abraham Rattner (1895–1978)
Severin Roesen (1848–1871)
James Rosenquist (b. 1933)
Christy Rupp (b. 1949)

Henry Sargent (1770–1845)
Andres Serrano (b. 1950)
Ben Shahn (1898–1969)
Simka Simkhovitch (1893–1945)
John Sloan (1871–1951)
Lilly Martin Spencer (1822–1902)
Steven Stokley (b. 1956)
Donald Sultan (b. 1951)
Arthur F. Tait (1819–1905)
Wayne Thiebaud (b. 1920)
George Tooker (b. 1920)
Andy Warhol (1928–1988)
Robert Watts (1929–1989)
Idelle Weber (b. 1932)
E.K.K. Wetherill (1874–1929)
David Wojnarowicz (b. 1954)
Joseph Wolins (b. 1915)
Thomas Waterman Wood (1823–1903)
Robert Yarber (b. 1948)
Brenda Zlamany (b. 1959)
Rhonda Zwillinger (b. 1950)

191